# RENAISSANCE PORN STAR

## THE SAGA OF PIETRO ARETINO, THE WORLD'S GREATEST HUSTLER

Mark Lamonica

Copyright © 2012 Mark Lamonica

All rights reserved. No part of this book may be used or reproduced by any means, graphic, electronic, or mechanical, including photocopying, recording, taping or by any information storage retrieval system without the written permission of the publisher except in the case of brief quotations embodied in critical articles and reviews.

ISBN: 1456598791
ISBN-13: 9781456598792

Library of Congress Control Number: 2012911233
CreateSpace Independent Publishing Platform
North Charleston, South Carolina

To the working girl

# Contents

Preface . . . . . . . . . . . . . . . . . . . . . . . . . . . . . . . . . . . . . . . . . . . . . . . . . i

Part I . . . . . . . . . . . . . . . . . . . . . . . . . . . . . . . . . . . . . . . . . . . . . . . . . 1
A Whore's Secret . . . . . . . . . . . . . . . . . . . . . . . . . . . . . . . . . . . . . . 3
A Writer's Secret . . . . . . . . . . . . . . . . . . . . . . . . . . . . . . . . . . . . . . 7
Breaking News . . . . . . . . . . . . . . . . . . . . . . . . . . . . . . . . . . . . . . 13

Part II . . . . . . . . . . . . . . . . . . . . . . . . . . . . . . . . . . . . . . . . . . . . 17
The Invention of the Human . . . . . . . . . . . . . . . . . . . . . . . . . . . 19
The Divine Comedy . . . . . . . . . . . . . . . . . . . . . . . . . . . . . . . . . 23
Wandering Humanists . . . . . . . . . . . . . . . . . . . . . . . . . . . . . . . 33
Cosimo de' Medici . . . . . . . . . . . . . . . . . . . . . . . . . . . . . . . . . . 39
Il Magnifico . . . . . . . . . . . . . . . . . . . . . . . . . . . . . . . . . . . . . . . 49
Kabbalah Krazy . . . . . . . . . . . . . . . . . . . . . . . . . . . . . . . . . . . . 59
The War of Fornication . . . . . . . . . . . . . . . . . . . . . . . . . . . . . . 65

Part III . . . . . . . . . . . . . . . . . . . . . . . . . . . . . . . . . . . . . . . . . . . 75
Roots . . . . . . . . . . . . . . . . . . . . . . . . . . . . . . . . . . . . . . . . . . . . 77
City of the Gods . . . . . . . . . . . . . . . . . . . . . . . . . . . . . . . . . . . 83
Paradigm Shift . . . . . . . . . . . . . . . . . . . . . . . . . . . . . . . . . . . . . 91
The Happy Pope . . . . . . . . . . . . . . . . . . . . . . . . . . . . . . . . . . . 97
Satanic Verses . . . . . . . . . . . . . . . . . . . . . . . . . . . . . . . . . . . . 105
Let's Get Ready to Rummmble! . . . . . . . . . . . . . . . . . . . . . . . 111
Gluteus Maximus . . . . . . . . . . . . . . . . . . . . . . . . . . . . . . . . . 117
The Devil . . . . . . . . . . . . . . . . . . . . . . . . . . . . . . . . . . . . . . . 123

Part IV . . . . . . . . . . . . . . . . . . . . . . . . . . . . . . . . . . . . . . . . . 127
The Chameleon . . . . . . . . . . . . . . . . . . . . . . . . . . . . . . . . . . 129
Christ's Blood . . . . . . . . . . . . . . . . . . . . . . . . . . . . . . . . . . . . 135

Rumor . . . . . . . . . . . . . . . . . . . . . . . . . . . . . . . . . . . . . . . . . . . . . . . 143
Kama Sutra Italian Style . . . . . . . . . . . . . . . . . . . . . . . . . . . . . . . . . 147
David . . . . . . . . . . . . . . . . . . . . . . . . . . . . . . . . . . . . . . . . . . . . . . . 155
Vendetta. . . . . . . . . . . . . . . . . . . . . . . . . . . . . . . . . . . . . . . . . . . . . 159
Cognac . . . . . . . . . . . . . . . . . . . . . . . . . . . . . . . . . . . . . . . . . . . . . 165

Part V. . . . . . . . . . . . . . . . . . . . . . . . . . . . . . . . . . . . . . . . . . . . . . . 169
Lucifer Rising . . . . . . . . . . . . . . . . . . . . . . . . . . . . . . . . . . . . . . . . 171
The Devil's Nightmare Regiment. . . . . . . . . . . . . . . . . . . . . . . . . 177
Prelude to a Massacre . . . . . . . . . . . . . . . . . . . . . . . . . . . . . . . . . 183
The Setup. . . . . . . . . . . . . . . . . . . . . . . . . . . . . . . . . . . . . . . . . . . 187
Massacre of the Innocents . . . . . . . . . . . . . . . . . . . . . . . . . . . . . 193
Epilogue. . . . . . . . . . . . . . . . . . . . . . . . . . . . . . . . . . . . . . . . . . . . 205
Bibliography . . . . . . . . . . . . . . . . . . . . . . . . . . . . . . . . . . . . . . . . 207
Acknowledgments. . . . . . . . . . . . . . . . . . . . . . . . . . . . . . . . . . . . 209

# Preface

This is a strange story about a notorious Italian genius by the name of Pietro Aretino (1492-1556). I consider him the best-kept secret in literature. Aretino pioneered the commercial porn industry. He was also the most famous writer of the sixteenth century. Today he is virtually unknown. I created this book as a tribute to his forgotten legacy. Before we begin, I would like to quote a passage from the great statesman, philosopher and writer, Sir Francis Bacon: "Read not to contradict, nor to believe, but to weigh and consider." In the end, you can decide what to believe or not to believe. However, believe this: You will never read Shakespeare the same way again. I guarantee it!

# Part I

# 1

# *A Whore's Secret*

*God is love—I dare say. But what a mischievous devil love is!*

—Samuel Butler

Let's begin with a book Pietro Aretino wrote that happens to be the most outrageous book ever published, entitled *Il Ragionamento della Nanna e della Antonia*, "The Rationalizations of Nanna and Antonia" (1534). The English translation of the book is known as *Dialogues*. The story follows the adventures of a *femme fatale* who methodically mind-fucks male chauvinist pigs, making it the world's first radical feminist novel. Whatever objections may be made against the work (because it's classified as extremely obscene) I love it. First, the story answers Sigmund Freud's quintessential question: *What do women really want?* Actually, as Aretino's *Dialogues* trenchantly points out, they clearly want money, and lots of it. More importantly, they want to be acknowledged as being equal to men. Second, it's as good as anything Shakespeare ever wrote. The author Raymond Rosenthal points out in his excellent translation of Aretino's novel (*Aretino's Dialogues*: 1971), "This is one of the greatest impersonations in literature; to be set alongside Defoe's *Moll Flanders* and Zola's *Nana*." The work is classified as a comedy but it's much more; in fact, it's the most penetrating psychosexual study of Rome during the

height of the Italian Renaissance when Rome was the most decadent city in the world.

The story is told in the first person, in dialogue, by a very high-class whore (in Rome they're called courtesans) named Nanna, and a sassy low-class whore named Antonia. The plot begins when Nanna is confronted with the dilemma that every mother sooner or later faces: How to guide her child on the right vocational road in life. After discussing the matter at length with Antonia, the various merits and pitfalls of which road to follow, Nanna concludes that she has three choices she can offer to her voluptuous teenage daughter Pippa (keen to make a living and capitalize on her own physical assets), and only three choices: One, become a nun; two, become a housewife; or three, become a courtesan. That was it for the sixteenth century. Each road Nanna had traveled in her lifetime. In the sixteenth century, a housewife was a slave to her husband, and a nun was a slave to the Church. On the other hand, a sixteenth-century Roman courtesan was typically a savvy businesswoman. They were the elite females of the period and the most powerful influence on Aretino's career as a writer: his *muses*.

Nanna finally acquiesces to her daughter's desire to follow in her footsteps, concluding that becoming a courtesan was by far the most profitable way for Pippa to make a living in a world ruled by degenerate men. Antonia agrees, and then Nanna proceeds to teach Pippa the tricks of the flesh trade, pointing out: "The cornerstone of a whore's art is to know how to playact…above all study deceit and flattery, for these are the embroideries that embellish the gown of the woman who knows how to get by." Nanna provides a fast-track catalog of "whore wisdom" to her daughter in the form of scams, scenarios, positions, and acting techniques that surround and support the vocation of a competitive whore.

Nanna, a female version of Machiavelli's *Prince*, admits to every crime in the book (including murder) in her quest to survive and prosper as a prostitute. The deadly/hilarious whore tells her daughter a spellbinding story about her life as the most famous hooker in Rome. In the process, the reader gets a meticulous education in the art of sexual subterfuge, as well as a guided tour of Rome—the people, the places, the customs, the food, the fetishes—nothing is left out. We experience the Eternal City through the eyes of a seasoned courtesan who

possesses a lifetime of experience studying men and women, their motives and means, their doubts and fears, their cunning plots and schemes, their very *raison d'être*. Aretino writes in the preface of his groundbreaking work:

> *I hope that my book will be like a scalpel, at once cruel and merciful, with which the good doctor cuts off the sick limb so that the others will remain healthy.*

Aretino, one of the greatest moral critics to ever wield a pen, used comedy as a form of shock therapy for the soul. He sheds a blinding spotlight on the courtesans' art, and at the same time he exposes the demonic dark side to human nature. In this sense, his book is a perverted religious masterpiece. I highly recommend reading it. I mean, who wouldn't want to be privy to a beautiful whore's secrets? I'm certain Shakespeare would! As the English poet laureate John Masefield wrote about Shakespeare, "Sex ran in him like the sea." Did the Sweet Swan of Avon read Aretino's *Dialogues*? More importantly, did he use the pornographic work of literature as a model for his own characterizations of human sexuality, specifically in his choice of language? Aretino's *Dialogues* was published in London in 1588, right about the time the English were developing their own unique version of Italian melodrama. More on this later.

The most compelling evidence to support my hypothesis that Shakespeare read the *Dialogues*, is: One: Aretino was a bestselling author in London in Shakespeare's day. Two, Shakespeare is famously known for ransacking Italian works of literature. And, three, Shakespeare's writing style has a great deal in common with Aretino's, specifically, his incisive use of bawdy phrases and sexual metaphors: *Blow; come; screw; prick; balls; piss; load; dildo; velvet dish; making the beast with two backs; the deed of darkness; the heaven that leads men to hell; the Neapolitan bone-ache; Lady Tongue; King-Urinal; the virgin-violator; passion's slave; three-inch fool; the dribbling dart of love; lusty pudding; sweet bottom-grass; incestuous sheets,* etcetera. Many of the penetrating coital terms and bizarre neologisms that *the King of Codpieces* utilized in his works were actually adapted from Aretino's *Dialogues*. A. L. Rowse (Shakespeare's preeminent biographer), called him "the sexiest great writer in English Literature." That's because Shakespeare had the greatest whoremaster in the world as a teacher.

# 2

# *A Writer's Secret*

*The purpose of art is to conceal itself.*

—Ovid

Like most people, I never heard of Pietro Aretino. I discovered him serendipitously while deciphering a mysterious passage in Shakespeare's play, *The Winter's Tale:*

> *That rare Italian master, Julio Romano, who, had he himself eternity, and could put breath into his work, would beguile Nature of her custom, so perfectly he her ape.*
>
> (5.2.95-99)

Shakespeare crafts the stunning climax of *The Winter's Tale* around the story of a beautiful statue of a woman that comes to life, based on Ovid's tale of the Greek legend of *Pygmalion*. Pygmalion was a sculptor who crafted a statue of a beautiful woman and then fell in love with his own creation. He then made offerings to the goddess of love, Aphrodite, praying that she would give his statue

life. Aphrodite granted his request, whereupon the statue comes to life, and he marries her.

In Shakespeare's *Tale*, the statue in question could have only been sculpted by someone who "could put breath into his work," someone like Michelangelo or Donatello or maybe Cellini, but no! Shakespeare chose above all others "that rare Italian master, Julio Romano." What makes the passage so important is that Julio Romano (by the way, his real name was Julio Pippi; he changed it to Romano, I presume because *pippi* means "little prick" in Italian) was the only factual Italian artist Shakespeare mentioned by name in his work, which I found intriguing. What's truly intriguing is that Julio Romano was Pietro Aretino's partner in the execution of the world's first commercial pornographic book: *The Positions* (1524). Naturally, Shakespeare doesn't mention this; but he connects himself to Romano with a sublime accolade that one would bestow only upon a god or a genius, something he rarely (if ever) did with his male characters, which only made the passage more provocative. In fact, no factual character, not even his beloved Ovid, receives such praise, which further fascinated me and propelled me to investigate Julio Romano's amazing life. That's how I serendipitously discovered his partner in crime, Pietro Aretino.

The consensus among scholars, biographers, critics and sleuths who study Shakespeare (and are aware of the tantalizing Julio Romano passage in *The Winter's Tale)*, is that they have absolutely no clue *why* Shakespeare, a man who chose his words like a Hasidic diamond dealer, would bestow upon Romano such rare distinction selecting him to create a statue in one of his plays. A statue, I might add, that miraculously comes to life, making it, as some scholars suggest, Shakespeare's greatest illusion. To quote the prestigious *Norton Shakespeare*, "It's not clear why Shakespeare chose to lavish such praise upon this particular artist [Julio Romano] or whether, in fact, he had ever seen his work." The famous Shakespeare sleuth Charlton Ogburn stated, "How and where he [Shakespeare] got the name [Julio Romano] Lord only knows." The preeminent literary critic Northrop Frye adds to the enigma in his book *on Shakespeare*, "Romano was an actual painter, widely touted as the successor of Raphael, but the reason for mentioning his name here [*The Winter's Tale*] eludes us: perhaps there was some topical reason we don't know about." We will in a minute.

*The Winter's Tale* is an extremely deviant play that revolves around the delusions of a Sicilian psychopath who is convinced that his wife is committing adultery with his best friend (she's not). I suggest Googling the play to read a detailed synopsis. Shakespeare chose Julio Romano to sculpt a statue of the psychopath's wife because the majority of the people in Shakespeare's audience (what the Puritans referred to as "The congregation of lechers and fornicators....") knew exactly who Julio Romano was. An insider's joke, if you will. The joke was that *the rare Italian master* was known in London for his racy pornographic pictures coupled to his partner Pietro Aretino's hysterical X-rated texts. Contemporary Shakespeare scholars fail to apprehend this because they weren't living in London in Shakespeare's day. Incidentally, Shakespeare's Globe Theatre was located in the red-light district of Southwark where cock-devouring whores plied their trade.

The Puritans considered actors no better than prostitutes and playhouses: "colleges of transgressions, wherein the seven deadly sins are studied." The lack of moral principle and the predisposition to seek out the obscene were the typical charges leveled by the Puritans in their continuing battle against the theatres. Acclaimed Shakespeare biographer, Marchette Chute, articulates in her epic work *Shakespeare of London*: "To a Puritan, soberly intent upon the saving of his soul, there could hardly be a worse sin than to indulge carnal desire by going to see a play where young men in glittering costumes portrayed licentious women committing 'swelling sins and enormous infidelities' on a stage for money, and in time the Puritan movement gathered sufficient force to destroy the theatre of England entirely."

In 1612, the vociferous English critic Henry Peacham complained that "it was lewd art most often enquired after in the bookstalls than any other." He was referring to the immense interest that Italian pornography generated in the bookstalls at Paul's Walk (situated in the churchyard of Old St. Paul's Cathedral), the center of London's thriving publishing industry, where Romano and Aretino's stunning pornographic works were sold to many of Shakespeare's friends and colleagues who were discerning connoisseurs of erotica. To say that Shakespeare was unaware of Julio Romano's work (as contemporary scholars suggest), is tantamount to saying that Shakespeare knew nothing of Italian literature. And we know that this was not the case.

The English were fascinated with the Italian people and their amazing Epicurean culture. Italian poetry, painting, pornography, music, drama, fashion, wine, women, cheese, anything *Italiano* was a premium commodity in London during Shakespeare's day. English playwrights were absolutely mesmerized by Italian dramas, specifically comedic sexual melodramas; that is why they wrote so many plays about the shenanigans of the Italian aristocracy. Incest, cross-dressing, adultery, debauchery and vendetta were all major themes in English comedies, clearly modeled on the fantastic antics of Italian high society.

When it came to comedic sexual melodramas, Pietro Aretino was the undisputed king of smut. In 1588 the enterprising English printer John Wolfe reprinted four of Aretino's sexual melodramas along with his notorious *Dialogues*. Placing this in context with Elizabethan comedies, which are classified as either Shakespearean or Jonsonian (named after their respective authors), we begin to see (that is, if we dare to look through the forbidden peephole of time) the power of Aretino's influence on English comedy.

Shakespeare's friend, rival, and, in my opinion, the superior comedian, Ben Jonson, was one of Aretino's biggest fans in London, and so was the illustrious poet, satirist, lawyer, cleric and member of Parliament, John Donne. The notorious dramatist, satirist and pamphleteer, Thomas Nashe, referred to Aretino as "the wittiest knave God ever created." Nashe, whose forte was satire, fancied himself as an English Aretino. "Of all styles," he emphasized, "I must affect and strive to imitate Aretine's." The preeminent Elizabethan literary critic Gabriel Harvey considered Aretino to be one of the greatest writers of all time and placed him in the same class as Dante, Petrarch, Rabelais, Machiavelli, and Luther. The point is, Aretino was an iconic literary figure in London and widely read by many of Shakespeare's friends and colleagues.

One might be wondering how an English playwright such as William Shakespeare, goes about reading an Italian work of literature. The answer is he would have read an English translation of the work. There were numerous Italian translators and teachers living in England in his day, including an entire Italian expatriate community that worked in London in various capacities as doctors, scholars, merchants, book dealers, printers, hookers and so on.

When I translate Italian into English (I speak Italian fluently), I find that many English words that Shakespeare utilized in his famous works have a similar spelling in Italian. For example, I just used three different English words derived from Italian to create the preceding two English sentences: *famous (famoso)*, *preceding (precedere)*, and *utilize (utilizzare)*. The point, or *punta*, I would like to make is not how similar these English words are to Italian, but how dissimilar they are to Latin. Latin was the academic language taught in Elizabethan schools and the prescribed written language of the educated class. The Italian translations that I have italicized in parentheses are quite different from Latin. For example, in *Cassell's Latin-English Dictionary* (third edition), the English word *famous* is listed as *(prae) clarus, inlustris, celebrer*, and the word *preceding* is listed as *prior, superior;* and so on.

The very *processo* of translating Italian literature into English introduced a multitude of Italian words and phrases into the English language. More importantly, the translation of Italian literature introduced such ingenious Italian literary inventions as blank verse, the sonnet, the semicolon and italic script. In no way am I trying to minimize the immense contribution that Latin, and for that matter, various other foreign tongues have made to the English language over the course of millenniums. What I am trying to do is emphasize the equally profound influence that Italian (especially Aretino's dynamic vernacular prose) had at the precise moment *(preciso momento)* the English were replacing Latin as the prescribed language of writers in Shakespeare's day.

In the sixteenth century English lacked definition. Let me explain: In Shakespeare's day, there was no such thing as an "English dictionary" *(dizionario)*. Simon Winchester (author of a *New York Times* 'notable book' *The Professor and the Madman: A Tale of Murder, Insanity, and the Making of The Oxford English Dictionary*) pointed out, "Whenever he [Shakespeare] came to use an unusual word, or set a word in what seemed an unusual context—and his plays are extraordinarily rich with examples—he had almost no way of checking the propriety of what he was about to do." Shakespeare could not, as the saying goes, "look something up." So what did Willie boy do when he needed to define a word? Good *questione!*

During Shakespeare's day, Greek, Latin (Roman) and Italian plays were the models that English playwrights used to create their own distinct theatrical dramas. Let's put Greek and Latin aside for the moment. Let's talk about Italian

drama because it was the most popular of the three models utilized by English playwrights. When Shakespeare needed to define an Italian word he would have used Giovanni Florio's famous Italian-English dictionary (like many of his friends and colleagues did), or he would have asked someone proficient in the language to translate whatever he was reading for him. I can think of at least three people close to him that had a respectable command of the Italian language. First and foremost was his flamboyant patron, the third Earl of Southampton, Henry Wriothesley, not to mention his famous Italian-language tutor Giovanni Florio; the versatile Italian scholar, Robert Armin (a distinguished member of Shakespeare's acting company); and of course there was Ben Jonson, who seemed to know every *fucking* dirty word in the Italian language. This brings us back to Pietro Aretino, or as Gabriel Harvey referred to him in his writings, "Angelus Furious was the most eloquent Discurser and most active Causer in all Christendom, yea even the whole universal world."

Contemporary Shakespeare scholars fail to comprehend the magnitude of Aretino's influence on Shakespeare because he is never mentioned as a major source of influence in his writings. But they have no problem acknowledging other iconic Italian literary figures such as: Ariosto, Bandello, Boccaccio, Cinthio, Machiavelli, Masuccio, Petrarch, Sannazaro, Straparola, Tasso, et al, as important influences in his works. Aretino eclipsed all of them as a stylist and comedic genius, which tells me that contemporary scholars don't know diddlysquat about Shakespeare's sources.

At the time I discovered Julio Romano I had no idea he was one of the greatest artists of the sixteenth century. Nor did I know that he would lead me to Pietro Aretino: the Italian genius behind Shakespeare. The real question for the educated reader is not how I am going to connect Aretino to Shakespeare's works; I will, and I believe I already have. The real question is how do I intend to have Aretino take Shakespeare's title of the world's greatest writer away from him? The answer is (as Machiavelli might have articulated) *by whatever means necessary*. The way I propose to do this is by not doing it. Instead, I will simply challenge the Shakespeare scholars to do it for me. I mean, after all, it's their job. My job is to inspire them.

# 3

# *Breaking News*

*Read all about it!*

—Aretino

What actually constitutes a writer's legacy? Is it their words or the actions behind them? To me, a writer's actions will always speak louder than their words. Deeds of heroism, altruism, self-sacrifice, feeding starving people, burying the indigent dead, bailing prisoners out of jail, providing medical care for the sick and injured—these are all things that Aretino not only wrote about but also did, which to me epitomizes Hamlet's decree:

> *Suit the action to the word, the word to action, with this special observance, that you o'erstep not the modesty of nature.*
>
> (3.2.18)

Let's put a writer's actions aside for the moment and focus on a writer's work. What writer, or group of writers, could be said to have revolutionized the ancient style of writing, thus transforming it into the modern style of tabloid writing that we read today? Not an easy question to answer. It's not

like modern art, where we can find a radical genius such as Vincent Van Gogh or Pablo Picasso smashing the ancient classicism that art was shackled to for centuries and liberating it with their own version of creative genius. Was there a writer or a group of writers that did the equivalent? Certainly someone like Giovanni Boccaccio deserves credit for pioneering what amounts to modern prose-style fiction; but I'm not talking just style, I'm talking content: the flesh and bones of great literature.

Marc Weingarten, author of the superb book *The Gang That Wouldn't Write Straight*, accurately maintains that a small cadre of writers, Tom Wolfe, Jimmy Breslin, Truman Capote, Hunter S. Thompson, Joan Didion, and a few notable others, were the first of a new generation of writers who revolutionized writing by changing the way writers perceive reality and, more importantly, how they report it, which ultimately changed the way they created content. Classic examples are Tom Wolfe dropping acid in order to immerse himself into the counterculture world of hippies with his classic work *The Electric Kool-Aid Acid Test*. Hunter S. Thompson riding with the *Hell's Angels* in order to capture their rebel souls. Truman Capote's "experiential reportage," sitting on Death Row with his character giving him a psychological hand-job, in order to execute his magnum opus, *In Cold Blood,* which transformed news reporting into a highly stylized art form. Weingarten's work focuses on a literary movement that emerged during the Vietnam War and the tumultuous sixties, what Tom Wolfe referred to as the *New Journalism Movement*. Weingarten is correct; his gang of writers emphatically changed the way writers write. But in actual fact, it goes back much further. Eric Burns, historian and *Fox News* anchor, in his equally superb book on writers, *Infamous Scribblers*, points out that our founding fathers, Thomas Jefferson, Alexander Hamilton and Ben Franklin were equally gifted muckrakers who helped change the way writers think and create content. What I'm getting at is that none of them invented journalism, although they certainly contributed to what it became. If anyone deserves the credit, it would have to be Pietro Aretino.

Edward Hutton, one of Aretino's critical biographers, pointed out that Aretino, besides being a poet, playwright, philanthropist and pornographer (among other things), was "the founder of the European Press," which translates: he was the father of modern journalism. The author Desmond Seward,

in his splendid biography on King Francis I, described Aretino as: "Pietro of Arezzo, poet, playwright, and pornographer, was the one outstanding publicist of Renaissance Europe, a precursor of cosmopolitan journalism. His gossiping correspondence with European courts commanded an enormous audience." In fact, up until Aretino came onto the scene in the 16th century and transformed Rome into his own version of *Access Hollywood*, there was no such thing as objective journalism as we know it, let alone a European Press, which, in my opinion, is the precursor to the modernization of writing. What I mean by modernization of writing is two things. The first is the creative freedom to write the *news* without the fear of being imprisoned or killed for one's writings. The second is the lifeblood of literature; the ability to earn a living from one's writings. The creative freedom that modern writers/journalists take for granted today and the ability to earn a living from this freedom, in the traditional sense, was simply unheard of.

The operative word for the *news* is (or should be): the truth; i.e., the facts. The truth is dangerous. Reporting the truth behind the news usually got writers killed in the sixteenth century. Aretino was willing to take the risk. His main goal was to become rich and famous *by whatever means necessary*. He succeeded foremost as a businessman. He knew that people would pay for the news and more importantly, his famous contemporaries (Francis I, Henry VIII, Charles V, Pope Clement VII, and Michelangelo, among other notable megalomaniacs) would pay him not to reveal their secrets and by the same token reward him for favorable publicity, whereby he created a lucrative commodity for his writings. Aretino was a mercenary with a printing press. He roused a national spirit of interest in the news through one of the most sagacious inventions known to man—the printing press—and caused to be published the first newsletters on Italian soil. The critic Paul Van Dyke, when analyzing Aretino's editorial letters, pointed out that his strength as a journalist was "that he rarely ever lied." There was no reason to lie. As one of Aretino's characters trenchantly points out in one of his scathing political comedies when asked, "How can I best speak evil of men?" Replies: "By telling the truth—by telling the truth."

Aretino, like George Carlin, or better Bill Maher, used comedy like a lethal injection to deliver what Shakespeare called the *Sweet, sweet, sweet poison for the age's tooth*. Aretino's writings were controversial both for the content and the language

he employed. This is what made him so famous. He had the balls to tell the truth—and tell it in a vulgar language unlike any the world had ever heard before. Aretino didn't just break the rules of writing—he rewrote them! Let me explain; during the sixteenth century, the Italians, those who could write (the rarefied elite), did not write in their own language; some did, but the vast majority wrote in Latin (much as the rest of Europe's literati did). Aretino wrote in the language of the common man: the day laborer, the butcher, baker, blacksmith, housewife, whore, pimp and cocksucker. In other words, he made the *news* accessible to everyone. Aretino transformed writing from an ancient craft monopolized by pedagogues and scholars into a content-driven business, making him the world's first truly modern writer and the principal genius behind the culture of celebrity in which we now live. Where am I going with this? Well, for starters, I am just getting warmed up and wanted to shed some light on the evolution of modern writing and how it actually got started. Plus, I wanted to place Aretino in proper perspective with regard to what should constitute a writer's legacy before I set him loose on Shakespeare.

# Part II

# 4

## *The Invention of the Human*

*Interpretation is the revenge of the intellect on art.*

—Susan Sontag

Most writers know that a good story, or in this case a massacre, requires a compelling antagonist to stir the pot. At this point, I would like to introduce mine. His name is Harold Bloom. Harold Bloom is a Sterling Professor of Humanities at Yale University, Berg Professor of English at New York University and former Charles Elliot Norton Professor at Harvard. Bloom is also a prolific writer and considered to be the foremost literary critic alive in America today. Okay, now that we know who he is, the point I'd like to make is Bloom, who bears a passing resemblance to Rodney Dangerfield, believes (like most people) that William Shakespeare is the greatest writer in the world; but Bloom takes this belief one step further and maintains that Shakespeare actually invented the *human*.

Bloom's book, *Shakespeare: The Invention of the Human* puts forth this bombastic hypothesis. Like a tenacious pit-bull terrier, Bloom argues that Shakespeare is "the first universal author, replacing the Bible in secular consciousness." He goes on to say, "No Western writer, or any Eastern author I am able to read, is equal to Shakespeare as an intellect." Bloom further proclaims, *"The Complete Works of Shakespeare* could as soon be called *The Book of Reality."* I agree with

Bloom. In fact, I am one of his biggest fans, but he is wrong—dead wrong. For Bloom, a world-renowned literary scholar to say in no uncertain terms that Shakespeare is the world's greatest writer is one thing; but to say that he is responsible for *the invention of the human*, that's wishful thinking.

Using Bloom's surreal logic, the event that he ascribes to Shakespeare, *the invention of the human,* happened during the Italian Renaissance in Florence, and not London; he's got it ass-backward. Just to set the record straight, if anyone deserves the supreme title for inventing the human that would have to be God. Putting God respectfully aside for the moment, along with the Greeks and Plato, and for that matter, the Egyptians, technically, Harold Bloom's *human* was invented by an elite group of audacious Italian men. Before I get to them, though, I must briefly address the period in which Harold's *human*, or to be more precise, the *humanism movement* emerged because it is the very mechanism that directs my argument with Bloom: If Shakespeare invented the *human* then who invented Shakespeare? More importantly, how did they do it? The answer to this manifold question is humanism. The *Encyclopedia Britannica* defines Humanism:

> *The term is specially applied to a movement of thought which in Western Europe in the 15th century broke through the medieval traditions of scholastic theology and philosophy, and devoted itself to the rediscovery and direct study of the ancient classics. This movement was essentially a revolt against intellectual, and especially ecclesiastical authority, and is the parent of all modern developments whether intellectual, scientific or social (see Renaissance).*

Sounds pretty scholastic (it reminds me of a scene in Aretino's *Dialogues* where Antonia tells Nanna: *My dear, speak straight and say "fuck," "prick," "cunt," and "ass" if you want anyone except the scholars at the university in Rome to understand you*). Let me simplify it: Humanism was an intellectual movement that formed the inspiration and basis for the Italian Renaissance. At the turn of the 15th century in Florence, a small group of manic Italian writers "crossbred" the finest elements of classical Greek and Roman culture with Christianity to produce a radically *new mode of consciousness* that made man the center of the universe and the measure of

all things rather than a stigmatized piece-of-shit sinner, born to toil, suffer and die because some biblical cunt with a hidden agenda made a deal with a talking snake and brought desolation and death into the world.

Prior to the advent of the humanism movement (long before there were printed books, forks, sanitary napkins, deodorant and toilet paper) a period known as the Dark Ages, the vast majority of the people living in Europe were, to paraphrase Professor William Manchester (author of the definitive book on the Dark Ages: *A World Lit Only by Fire: The Medieval Mind and the Renaissance: Portrait of an Age*), illiterate savages: shackled in ignorance, disciplined by fear and living in an impenetrably mindless world devoid of any semblance of culture.

The average medieval man, for the most part, was an indentured serf to a feudal lord. When he wasn't working for his equally illiterate master at some menial task, he usually did five things on a regular basis: he fucked whatever he could, he shit and pissed wherever he liked, he ate with his hands and fingers (after he scratched his balls and wiped his nose with them), got drunk, oppressed his wife and the women in his life (during the Middle Ages, females were biblically mandated as wholly owned subsidiaries of their men), and intermittently fought his friends and killed his neighbors. The point is, writing, as we know it today, simply did not exist. Freedom of the press was unheard of! Technically, the only people who were authorized to write anything for public consumption were designated members of a bourgeois Roman Catholic bureaucracy which at the time was actually a violent Orwellian organized crime network that dominated and brainwashed the *human* by dictating his every thought and action. And then all Hell broke loose.

# 5

# *The Divine Comedy*

*The world is a tragedy to those who feel, but comedy to those who think.*

—Horace Walpole

    The spark that ignited the humanism movement into a blazing creative inferno that ultimately became the Italian Renaissance was lit by the Florentine politician-scholar Dante Alighieri (1265-1321) when he created his magnum opus, *Commedia (Comedy)*. It was only later that the word *Divine* was added and the work is now known the world over as *The Divine Comedy*. Professor Anthony Esolen articulates in his superb translation *Dante: Paradise: A New Translation*, "Relatively little is known with certainty about Dante's early life, but it is noteworthy that he grew up during the restless period that followed decades of blood rivalry between two Florentine political groups, the Guelfs and the Ghibellines [the pro Papal and Imperial parties, respectively]." Dante was originally a Guelf and in 1289 fought with the cavalry against the Ghibellines at the horrific Battle of Campaldino.

    Fast forward: In 1295 Dante held public office as a city councilman and ambassador to Florence. In the summer of 1300 Dante was named one of the six ruling Supreme Court magistrates in Florence (a position of immense power which he said *was the cause and origin of all his misfortunes*). During this time Dante was involved in a wicked political feud between two rival factions of the Guelf

party: the Blacks (pro Papacy; i.e., Church) and the Whites (pro Imperial; i.e., State). Dante sided with the Whites who were opposed to the machinations of the notorious racketeer Pope Boniface VIII who was attempting to place Florence under papal suzerainty.

In 1301 the Blacks (pro Papacy) seized control of the government and Dante was banished from the city and later sentenced to death if he should ever return. Dante would never see Florence again. Instead, he would spend the rest of his life on the lam surviving on his wits and the charity of his excellent friends and allies. Dante wrote his *Comedy* in exile as a form of vengeance against his political enemies. The *Comedy* was written in the distinct Tuscan vernacular which would later become the canonized language of Italy. Having done so, Dante is now sanctified as the father of Italian literature.

Prior to the *Comedy*, virtually all major works of literature in Europe were written in Latin. Anything that wasn't was considered a joke, hence one reason why Dante entitled his work a comedy. As Dante himself explained, "A comedy is written in the vulgar tongue in which housewives and children speak." Because of the sacred, profane and very political nature of the work, anyone who reads the *Comedy* will have different interpretations of Dante.

Personally, I think the *Comedy* is one of the funniest stories I have ever read, specifically Book One: *Inferno* (Hell). If I had to describe it to someone unfamiliar with Dante's masterpiece, I would use an analogy. I would say: Think of the *Comedy* as a political commentary disguised as a poem written by Bill Maher. Now, make believe Maher is the judge, jury and executioner in Hell. Okay, now think of Maher subjecting America's most corrupt politicians, financial terrorists, liars, hypocrites and traitors to the most horrific forms of torture known to man: Starting with the Bush & Cheney Administration and then working your way backwards with various members of the Senate and Congress, along with such shameful characters as Ken Lay (former CEO of Enron), Hank Paulson (former CEO of Goldman Sachs), Angelo Mozilo (former chairman and CEO of Countrywide) Bernie Madof, Jack Abramoff, Bill Clinton, Charles Keating… etcetera…and basically you would have a modern version of *The Divine Comedy*, minus Purgatory and Heaven.

Dante is second only to Shakespeare as the most studied writer in literature. T. S. Eliot considered Dante the greatest poet in the world, yet Horace

Walpole described Dante as, "absurd, disgusting, in short, a Methodist parson in Bedlam." Recently the author Barbara Reynolds presented an intriguing hypothesis in her book, *Dante: The Poet, the Political Thinker, the Man* (2007). Reynolds maintains that Dante may have been on psychedelic drugs when he created his *Comedy*. I would have to agree. In 1294 Dante became a member of the Apothecaries Guild in Florence, and I can't help but believe he had access to powerful psychotropic plants (opium, hashish, cannabis, henbane and datura were known for their medicinal properties during the Middle Ages), and may have been on something very powerful when he was having (in my opinion) a series of messianic dreams and nightmare visions, which he then adapted into his surreal hallucinatory masterpiece. Like some shaman ingesting peyote and crafting an ancient Indian creation myth, Dante, in the words of William Butler Yeats, became the "chief imagination of Christendom."

*The Divine Comedy* is pure fiction, and yet as Yeats pointed out, it shaped the imagination of the Christian world by transforming fiction into an ultimate reality. You'll see why in a moment. Dante wakes up one day (probably with a vicious hangover) and finds himself inside his *Inferno*, and simply states "How I arrived there, I cannot truly say." Dante's power is that he is very convincing. He grabs the reader by the hand and takes him on an unforgettable seven-day journey (which took him an estimated sixteen years to write) into the *Inferno, Purgatory, and Paradise*, in that order. I will focus on the *Inferno*, which is the foundation of the *Comedy*, and Dante's most famous work. Not to discount *Purgatorio*, which is just a milder version of the *Inferno* (and does not exist in the Bible), and *Paradiso*, which is absolutely abstract; or as the author Harriet Rubin articulated in her enchanting book, *Dante in Love*, "Dante's whole journey in Paradise has been the quest to go beyond language, to see what cannot be written."

Dante's spectacular vision of Hell is a violent landscape of circles, pockets, gulfs, rivers, mountains, lakes of fire, boiling pots of excrement, and torture chambers. This hellacious underworld is inhabited by the most hideous creatures that one could possibly ever imagine: demons, centaurs, harpies, serpents, gorgons, roving bands of hell's angels that dragged sinners through fire, hellish furies that plucked people's eyes out, packs of snarling black mastiffs that chased and devoured sinners' flesh. And because of Dante, as Yeats pointed out, they were

no longer imaginary; they were now part of a collective consciousness that would ultimately become the Italian manic mind-set. Dante, with his "penetrating analysis of sin" and his vision of "eternal damnation," created a collective paranoia by summoning the Devil up from the depths of Hell and establishing him in the cities, towns and villages of Italy, making him a member of the household—and the prick never left.

The *Comedy* surpassed the Bible's version of Hell because it was far more elaborate. Another thing: most people during the fourteenth century could not read Latin, much less understand it; and since the Bible was written in Latin, Hell, for the most part, was a matter of hearsay. The *Comedy* became the chief schematic for artists who chose to depict Hell, specifically Michelangelo, Botticelli, Signorelli, and, of course, Hieronymus Bosch. It also set the stage for writers who chose to write about Hell and its mephitic world of demon-like creatures. Shakespeare's contemporary, John Donne, was so mesmerized by Dante that he created his own devilish version of the *Inferno* with his essay *A Meeting in Hell: Ignatius and his Conclave* (1611). Donne (one hell of a comedian when he wanted to be) placed Pietro Aretino alongside Saint Ignatius Loyola as a candidate to sit next to Lucifer on his throne: Aretino for speaking the truth and Loyola for being a consummate liar (Loyola got the position). Ben Jonson had his own interpretation of Lucifer: *The Devil is an Ass* (1616). Christopher Marlowe made Mephistopheles a leading character in his play *Dr. Faustus* (c.1588). And Shakespeare, well if you ask me, he was the Devil. Dante was unique in this sense, as a devout Christian he became Hell's chief publicist. In another sense, he became the first writer to subjugate and at the same time sublimate paganism within the framework of Christianity.

When it came to paganism, Dante took a middle ground by incorporating the great pagan thinkers of antiquity into his *Inferno*. Men like his master, Virgil, the prolific Roman writer and the author of the *Aeneid*. Virgil serendipitously acts as Dante's "trusty guide" through the *Inferno*, where he introduces him to Homer, Horace, Lucan, Ovid, Socrates, Zeno, Plato and many other famous dead pagans whom Dante masterfully adapts as iconic figures in his work. Most of them, by the way, reside in Limbo, the coolest region in Hell, because they were "virtuous pagans"; their only sin was that they weren't baptized God-fearing Christians—a very powerful advertisement for nonbelievers. According to Dante, if a person is

not a Christian, the best they can expect in the afterlife is a place in Limbo, which is like an air-conditioned suite at the Plaza Hotel, but still in Hell. On the other hand, even if a person is a baptized God-fearing Christian, if he or she happens to be a practicing homosexual, bisexual, lesbian, or someone who commits oral or anal copulation with a member of the opposite sex, that person, according to Dante, is committing a *crime against nature* and they will suffer in the lower regions of the *Inferno* along with legendary gluttons, murderers, thieves, hoarders, traitors, lechers, flatterers and wastrels.

Incidentally, Harold Bloom maintains that Shakespeare invented the *human* because prior to Shakespeare *there was characterization, and after Shakespeare there was character*: i.e., Hamlet, Macbeth, Othello, Cleopatra, et cetera. It appears to me that Bloom somehow overlooked the roster of famous outlaws that reside in *Dante's Inferno*. I can think of at least five of them that are major cocksuckers in four of Shakespeare's plays.

I remember when I was a child my father reciting Dante and scaring the bejesus out of my brothers and me. My little brother was chubby and loved to pig out on junk food, and my father warned him that if he didn't stop eating so much he was destined for the third circle of the *Inferno*, a place Dante reserved for gluttons. Imagine being condemned to eternal damnation because you like to overeat, or because you love to suck pussy! My older brother and I were warned that if we weren't careful, we were heading for the ninth circle, the worst place in *Dante's Inferno*—a place reserved for those that betrayed their parents and benefactors, where Lucifer reigns "devouring the shades of Judas, Brutus, and Cassius." Every Italian family knows the story; at least my generation did.

A new age was born with the *Comedy*, the birth of the neurotic Italian neo-Christian, a Christian who thinks outside the box and sees their fantastic pagan past for what it *was* and Papal Rome for what it *is*. In Dante's eyes, the Papacy was the wellspring of all the evil that plagued Italy in his day. Dante relishes his vengeance upon a slew of nefarious popes and devious clergymen by condemning them to the fiery depths of his *Inferno* for their appalling abuses of power and their blatant disloyalty to the duties assigned to them by Christ.

What makes Dante so spectacular, besides sending racketeer popes and politicians to Hell, is that he sets up our subplot—the battle between Church and

State—a separation battle that continues to this day. He did this by indicting the Roman Emperor Constantine I, the man who was instrumental in making Christianity the state religion of the Roman Empire in his *Inferno*. Why would Dante judge Constantine in Hell? Those who have read *The Da Vinci Code* (*DVC*) must be laughing. Those who haven't, let me just say that Dan Brown makes Constantine a bad guy in his book. Dante also makes him a bad guy: his own version of a *draconian devil*.

Here is why he did this and the first clue to why Rome will fall like Lucifer by the end of this work. Prior to Constantine I, Christianity was a religion based on Christ's teachings, specifically the separation of Church and State. According to Christ, His Church was never intended to have political power. The Church's power was supposed to be solely spiritual. The minute Emperor Constantine I granted supreme temporal power to Pope Sylvester I (313-335) in the fourth century over all of Western Europe in gratitude for curing him of leprosy the Church acquired immense prestige, political power, and wealth. Dante writes in canto 19 of his *Inferno*:

> *Oh Constantine! What evil did you sire, not by your conversion, but by the dower the first rich father once received from you!*

In Dante's mind, Constantine corrupted the Church of Christ and that is why he judged him in Hell. *The Divine Comedy* set the stage for the greatest writers of the fourteenth century, notably the poet laureate Francesco Petrarca (1304-1374). The consensus among Renaissance scholars is that Francesco Petrarca, better known as Petrarch, was the father of Renaissance humanism. Petrarch was born in Arezzo, Italy on July 20, 1304. Without getting into all the vicissitudes of Petrarch's life, I'm just going to cut to the chase: Petrarch grew up in Tuscany, moved to France and was groomed by his officious father for a career in law. In 1326, Petrarch abandoned his legal studies to pursue a career as a writer. To support himself as a writer he took minor orders in the clergy and spent much of his life in the service of the Italian aristocracy, traveling, lecturing and writing. Petrarch wrote predominately in Latin but he is ultimately known for his vernacular love sonnets to a mysterious woman called Laura, which deeply influenced all subsequent love poets after him—specifically Shakespeare.

Like a modern-day archaeologist, Petrarch initiated what is now known as the *revival of antiquity*. He did this by digging up the proverbial graves of his famous dead Roman ancestors: Caesar, Cato, Cicero, Scipio, Virgil, Quintilian, Seneca, Tacitus, Livy, Ovid, et al, and in the process, he rediscovered the roots of Italy and resurrected her rich intellectual past. As he once said, "What is history but the study of Rome."

The study of Imperial Rome gave the Italians back their national identity. They were the descendants of demigods, world conquerors, writers, poets, philosophers, architects and innovative engineers who created the most powerful and sophisticated civilization on earth. Petrarch would change the course of history by reviving the genius of classical thought and reverse engineer a curriculum that today is the foundation for modern academic scholarship. From Avignon to Florence, the celebrity poet/scholar was the guest of Christian nobility: the King of France, the Doge of Venice, the Prince of Padua, the Duke of Milan, the Marquis of Mantua and the King of Naples (some even believe he visited England). All eagerly awaited his arrival and listened to his lectures on Roman antiquity and his spellbinding speeches on how to rule as great statesmen. Petrarch would emerge as the first bona fide Christian humanist of the fourteenth century because he emphasized and continually demonstrated that classical antiquity could add a stunning brilliance to humanity in the form of its fantastic body of literature.

Many of the great classical works of pagan literature that we take for granted today were lost or were rotting away in some forgotten place. Petrarch set a precedent by trying to find them. On his extensive travels through Europe he sought and bought ancient manuscripts; the ones he couldn't buy he copied with his own hand. By his example he inspired a whole new generation of scholars to search for them—specifically many of the great classical works that inspired Shakespeare to write: *Venus & Adonis*, *The Rape of Lucrece*, *Julius Caesar*, *Antony & Cleopatra*, *Coriolanus*, etc., and that's all you need to know to follow this story. Trust me.

Meanwhile in Florence, Petrarch's protégé, the manic-depressive comedian Giovanni Boccaccio, was perfecting modern prose-style fiction. Giovanni Boccaccio's name translates to *Johnny filthy mouth*, a name he rightfully earned because he wrote the first vernacular *pornografia* stories in Italy. Boccaccio loved women

and like Aretino, he loved to write about lustful nuns and the kinky sex lives of Catholic housewives. Then one day, he found God. The day he found God, he stopped writing the filthy stuff that made him so famous and seriously considered giving up writing. The reason he found God was that a sexually repressed monk by the name of Pietro Petroni predicted that he (Boccaccio) was shortly going to die and burn in Dante's Inferno because he created amoral literature—specifically his bawdy masterpiece *Decameron*. The *Decameron* is a work about flesh-and-blood people involved in day-to-day situations with a particular pro-feminist position: the first work of its kind.

The *Decameron* takes place in Florence during the Plague, the Black Death (1348-50). Seven very liberated women and three young noblemen flee the city and head into the nearby hills of Fiesole in order to escape the plague. It is there that they gather at a luxurious villa to reflect upon the meaning of life and death; what Boccaccio called *umana cose* (human things). Each character tells one story a day for ten days, which ultimately comprise the one hundred novellas that make up the monumental work of literature. One novella (Aretino's favorite) is about a handsome young man by the name of Masseto who learns that there is a job opening for a gardener at a convent full of nubile nuns and one ugly-ass mother superior. Boccaccio writes, "Masseto from Lamporecchio pretends to be a deaf-mute and becomes a gardener for a convent of nuns, who all compete to lie with him." The sisters spy on the glistening sweating young man tending their land (who also likes to sunbathe in the nude) and they succumb to nature and have sex with him, not to mention give birth to his children. Masseto gets his voice back (the nuns maintain it was a miracle) and they all live happily and discreetly ever after.

Although some readers might find Boccaccio obscene, we must remember that he wrote the *Decameron* during the world's worst biological disaster: "The Black Death," which claimed an estimated fifty-million lives in Europe and nearly wiped life in Florence off the face of the map. Boccaccio writes, "The violence of the disease [a combination of bubonic and pneumonic plagues] was such that the sick transmitted it to the healthy that came near them, just as fire catches anything dry or oily near it." The Black Death can be recognized as the true turning-point in the evolution of literature and as a direct precursor to the modern age, with Boccaccio's *Decameron* setting the gold standard in modern prose-style fiction.

The authors Indro Montanelli and Roberto Gervaso describe in their work, *Italy in the Golden Centuries*, that Boccaccio's *Decameron* is "a song of resurrection, a vengeance of life over death, a statement of faith over despair, broad laughter to drown the sobbing of survivors." As D. H. Lawrence, author of *Lady Chatterley's Lover* (and Boccaccio devotee) put it, "What is pornography to one man is the laughter of genius to another." Or to paraphrase the preeminent critic Susan Sontag, *Pornography isn't about sex, it's about death*. The *Decameron* defied death by encouraging life through the joyous pursuit of pleasure. It was man's way of telling the Grim Reaper and the Church, to fuckoff! Against this horrific backdrop, the Black Death, the Middle Ages were obliterated and the Renaissance was born.

In sum, the *Decameron* defined what it meant to be a human being (specifically a woman) during the tumultuous fourteenth century. The monumental work became a cult classic and an international inspiration for a *generazione* of subsequent writers/comedians who chose to create radical works of literature that empowered the human condition; no matter *la conseguenzas*.

Will Durant, the preeminent Pulitzer Prize Renaissance scholar and author of the superlative book *The Renaissance* (1953) pointed out that once Petrarch found out his beloved friend Boccaccio was contemplating giving up writing, he "besought him to take a middle course: to turn from the writings of amorous Italian poems and novelle to the earnest study of the Latin and Greek classics." Boccaccio took the advice of his "venerable master" and became "the first Greek humanist in Western Europe."

*To make a long story short*, (a phrase coined by Aretino) the two great writers pioneered the humanism movement and died within a year of each other. Petrarch passed away in 1374 with a copy of *Virgil* by his side and was buried with his cat. Boccaccio died shortly thereafter. Durant condenses what happened next: "For fifty years now Italy would lie fallow, till the seeds that these men had planted would come to flower."

# 6

# *Wandering Humanists*

*Wisdom is supreme; therefore get wisdom.*

—Proverbs 4:7

I have used numerous history books on the Italian Renaissance as source material in the course of creating this work. One was Will Durant's masterpiece *The Renaissance*, to which I am deeply indebted. However, Durant overlooked, omitted or somehow forgot to mention something. I shouldn't even bring it up because I am also guilty of missing, omitting and overlooking things. It's an occupational writing hazard, as any historian (if they're honest) will attest. In Durant's defense, when he came up with his *fifty-year fallow mark*, I'm sure he meant the aesthetic component of humanism, which in fact did begin fifty years after the death of Boccaccio and Petrarch when the great Florentine artist Masaccio painted the first Renaissance frescoes in the Brancacci Chapel at Santa Maria del Carmine in 1425. Masaccio is perhaps most noted for his epic masterpiece, *The Tribute to Money*, which set the financial tone for the Italian Renaissance: i.e., "Render unto Caesar the things that are Caesar's; and to God the things that are God's." (Mark 12:17)

Professor Denys Hay points out in his book, *The Italian Renaissance*, Masaccio's frescoes "anticipate—if they do not determine—the whole course of later

Italian and Western painting, and often reflect if they do not sometimes anticipate the architecture which would soon arise in Florence." Many people get confused with the political and artistic components of humanism; nobody is perfect. For the purpose of this work, you can't have an Italian Renaissance: i.e., "rebirth" without Italian humanism: i.e., revival of antiquity, which Petrarch and Boccaccio unequivocally initiated in the fourteenth century (albeit both men were profoundly inspired by the audacious writings of Dante Aligheiri).

To set things straight, when Will Durant stated that Italy would "lie fallow [for fifty years], till the seeds that these men [Petrarch and Boccaccio] had planted would come to flower," he was wrong. Italy was actually reinventing itself against a volatile backdrop of chaos and political upheaval. The *seeds* that Petrarch and Boccaccio planted were sprouting like poppy fields all over the peninsula of Italy because they had devoted disciples tending them. Durant failed to mention two disciples in particular, which is really no big deal. In fact, many of the authors of the detailed history books on the Renaissance that I have used in the course of creating this work, including Sir John Hale, William Manchester and the eminent Jacob Burckhardt who wrote the first definitive book on the period, *The Civilization of the Renaissance in Italy* (1860), fail to mention them.

I am not casting aspersion on these great men, these modern-day humanists and their works. On the contrary, I am deeply indebted to them. The reason I pointed out Durant's error is to illustrate how identical historical events can be interpreted differently. That being said; Petrarch and Boccaccio had devoted followers who carried the humanism movement forward. I was just lucky enough to discover two of them in an archive library in a book written in 1883 by another expert on the Italian Renaissance, John Addington Symonds, who wrote *Renaissance in Italy*. Symonds points out that Petrarch's secretary was a classical scholar by the name of Giovanni Malpaghino, a.k.a. Giovanni da Ravenna. Malpaghino traveled to Florence, Padua, and Venice among other cities and principalities in Italy, transmitting the sacred fire of humanism to the elite men of letters, politicians and educators of his day. Men such as Vittorino de Feltre, Poggio Bracciolini, Guarino da Verona, Francesco Filelfo, Carlo Marsuppini and Leonardo Bruni. To paraphrase Symonds, Giovanni da Ravenna deserves, therefore, to be

honored as the link between the age of Petrarch and the golden age of the Medici as the vessel chosen to communicate humanism to the courts and republics of Italy. Shakespeare's suave character Lucentio does the same thing in *The Taming of the Shrew*.

> *To see Padua, the nursery of the arts, I am arrived for fruitful Lombardy, The pleasant garden of great Italy....Here let us breathe and haply institute a course of learning and ingenious studies.*

So says Lucentio, only he uses his knowledge as a wandering humanist scholar to charm a woman (as if there were any other reason to get a good education).

Boccaccio's protégé was a visionary Augustine monk by the name of Luigi Marsigli. Marsigli was famous for turning the monastery of Santo Spirito in Florence into a humanistic temple of learning where a visionary group of Florentine aristocrats and men of letters gathered to worship and imitate the great classical writers of Roman antiquity. It should be noted that when Boccaccio died, he left his personal library to Santo Spirito, which became (in my opinion) the first modern secular library in Europe. Petrarch, on the other hand, left his extensive library to the city of Venice, where it was cannibalized by greedy collectors.

Professor Ernest Hatch Wilkins articulates in his book, *A History of Italian Literature*, "The excitements of humanism so lured Italian men of letters into the exclusive or almost exclusive use of classical Latin throughout the period that relatively little writing was done in Italian." (Meaning, the dynamic vernacular prose made famous by Dante, Petrarch and Boccaccio was, for all intents and purposes, put on the shelf.)

In art, a decisive break with the medieval Gothic tradition occurred in Florence with the development of geometric linear perspective, which made it possible to represent a three-dimensional space on a flat surface. The larger-than-life works of the architect Filippo Brunelleschi and the painter Masaccio are dazzling examples of the uses of this radically new technique of representation by which the Florentines initiated the Italian Renaissance and changed the art world forever.

In 1396, Marsigli's star pupil, the chancellor of the University of Florence, Coluccio Salutati, invited the Byzantine scholar Manuel Chrysolaras of Constantinople, to come to Florence to teach Greek. In 1397, Chrysolaras became the first professor of Greek language and literature in Italy. Chrysolaras remained in Florence until 1400 and then moved on to teach Greek in Venice and later in Rome. His contribution to classical scholarship is considered second only to Petrarch and Boccaccio. I should point out that it was actually Boccaccio who established the first Greek Chair at the University of Florence, but the problem was there was no one qualified to fill it. Greek was a dead language in Italy prior to the arrival of Chrysolaras. As Professor Emeritus of European History, Ferdinand Schievill, author of *A History of Europe: from the Reformation to the Present Day*, points out "Greek had become an unknown language to the people of the west during the long mental twilight of the Middle Ages, and classical literature in Petrarch's day was exclusively limited to the literature of Rome." How could Dante, Petrarch and Boccaccio know so much about classical Greek literature when classical literature in their day was limited to Latin? That's the thing about history: it doesn't have to make sense. Take George W. Bush. The 43rd President of the United States was able to blatantly lie to Congress, fist-fuck the American media, start a bogus war with the wrong country, sanctify torture, contravene five of the Amendments in the Bill of Rights and nearly destroy everything America stands for and he still managed to get reelected. Notwithstanding, Bush wasn't supposed to be elected President in the first place. I suggest reading Vincent Bugliosi's shocking book on the appalling ass-rape of the American people: *The Betrayal of America: How the Supreme Court Undermined the Constitution and Chose our President*.

Among Chrysolaras's distinguished pupils may be mentioned all the members of Marsigli's core group that gathered at Santo Spirito. Men such as the visionary statesman Coluccio Salutati, the theologian Ambrosio Traversari, the Hebrew scholar Gianozzo Mannetti and his trusty rabbi sidekick; we don't know his name, but we know he was there (that's another thing about history: the best parts are usually omitted), the polymath/whoremaster Poggio Bracciolini, the manic bibliophile Niccolo de' Niccoli, the antiquarian manuscript-hunter/dealer Vespasiano da Bisticci, the classical scholars/writers Roberto de' Rossi, Leonardo

Bruni, and Carlo Marsuppini and others that have escaped recognition, who were instrumental in shaping humanism into what would become the secular philosophy of the Florentine State. Later, the same principles of humanism would lay the foundation for the Constitution of the United States of America: liberty, justice, the pursuit of happiness, religious freedom… and everything else we take for granted today.

Besides being classical scholars and accomplished Latinists, Salutati, Bruni, Manetti, Marsuppini and Bracciolini were also major political figures in the Florentine government. According to John W. Higson, Jr., author of *A Historical Guide to Florence*, "They revived the political and philosophical ideals of the Roman period and many of the educated class were introduced to the pleasures of classical research." As politicians/scholars, they were able to marry their humanistic visions with the art of statecraft and produce a series of original writings (which were adaptations of classical models) in the form of political manifestos, civil dissertations, administrative letters, essays, biographies and treaties that constitute modern historiography as we know it. All of them saw the independent state of Florence as a modern Roman republic based on the writings of antiquity which would set the standard for a political basis to humanism. These visionary men, John Addington Symonds articulated, "formed the literary oligarchy that surrounded Cosimo de' Medici." Cosimo de' Medici was the wealthiest investment banker in Europe: we'll get to him in the next chapter.

The accepted theory behind the Italian humanism movement is that it began in the fourteenth century, with Dante, Petrarch, and Boccaccio. Technically, what these men did is revive the ancient world of antiquity with their writings, thus spawning a small nucleus of enthusiasm, which grew into a group of eclectic intellects centered in Florence. This tiny latter group spawned at Santo Spirito morphed into an elite cadre of wisdom seekers who searched the world for the meaning of their existence. They found it hidden in the ancient culture of Imperial Rome. But the wisdom seekers wanted more. They wanted Utopia. And they found it in the ancient culture of Athens. The intense interest in pagan antiquity expressed itself in a fanatical and successful search for classical Greek manuscripts. Plato's *Dialogues*, the histories of Herodotus and Thucydides, and the works of illustrious Greek dramatists, poets, politicians, and philosophers

were being rediscovered by avid Florentine manuscript hunters, and critically analyzed and edited for the first time. The Greeks offered the Italians, especially the Florentines (who constituted the vanguard of the humanism movement in Italy), a radical alternative to the draconian theology of the Roman Catholic Church. Although the Greeks were very spiritual people, there was no such thing as "original sin" in Greek Culture. The only sin was being ignorant. Greek philosophy encouraged intellectual freedom. Will Durant: "They [the ancient Greeks] asked questions about everything; they stood unafraid in the presence of religion or political taboos; and boldly subpoenaed every creed and institution before the judgment seat of reason."

The Greeks opened up a totally new realm of ideas to the Florentines. Far-reaching concepts such as democracy, geometry, theosophy, the nobility of same-sex love, the perfection of the body through strenuous exercise, the "atom," the "idea," art for art's sake, and the greatest kick of all, fame! Something every Italian man craves like wine, women, and song.

Professor Charles G. Nauert, Jr., articulates in his book *Humanism and the Culture of Renaissance Europe*: "This notion of fame was inseparable from the humanists' conception of themselves as the men who were initiating simultaneously a new age in history and a profound moral regeneration of modern society." To achieve something—to excel—to be successful and famous would become the ultimate goal of Italian existence.

The early pioneers of the humanism movement were a small group of men centered primarily in Florence; and, as such, in no way did they pose a threat to the Roman Catholic Church, let alone be capable of reinventing the very meaning of religion and sexual consciousness (the two are connected like the *69* position). That would happen with the intervention of the powerful Medici banking family; without them, the humanism movement (i.e., Italian Renaissance) would never have happened the way it did. In fact, it would have never happened at all. And today Barack Obama would probably be a janitor in the White House rather than the President of the United States.

# 7

# *Cosimo de' Medici*

*When it is a question of money, everybody is of the same religion.*

—Voltaire

Before we address the fantastic Medici family, I must emphasize that one cannot accurately tell Pietro Aretino's story without them. The reason is that they were his illustrious super patrons, and every major character in this story revolves around them. Think of the Medici *famiglia*, as the *motore* that drives this story like a Ferrari to its crash-and-burn climax. Let's begin with Cosimo de' Medici, the boss of the family (*la capo della famiglia*).

In 1433, Cosimo was the CEO of the largest banking empire on earth and the leading sponsor of the humanist movement in Florence. He had everything a man could possibly desire: power, a perfect wife, a sturdy mistress, a stable of exotic slaves and Arabian stallions, not to mention all the prosciutto and melon a man could possibly eat; but paradise can have a dark side. A rival family, led by the powerful politician Renaldo degli Albizzi, wanted to destroy Cosimo because he believed he was dangerous and posed a threat to his family. Tim Parks, author of *Medici Money*, condenses what happened: "Albizzi was opposed to Cosimo's humanist friends, the historian Christopher Hibbert explains, because he saw them dangerous for Christianity." Why would Renaldo degli Albizzi think that

Cosimo and his humanist friends were dangerous for Christianity, when he himself was a patron of the humanist movement? We will address this baffling question shortly.

Albizzi orchestrated an elaborate coup based on false testimony extracted by torturing two of Cosimo's colleagues, who confessed that Cosimo "sought to elevate himself above others," and was planning on overthrowing the government. Albizzi demanded that Cosimo be executed for treason. Cosimo wasn't the kind of guy you could easily frame on a trumped-up charge; he was a billionaire by today's standards (there was scarcely a business deal in Europe that his international banking firm did not have a hand in). It didn't hurt that he counted Pope Eugenius IV (1431-47) as a personal friend. In fact, Cosimo was his banker. He also counted the Doge of Venice, as well as the most powerful lords and dukes in Italy as personal friends and banking clients. Many of them were shocked by the charges brought against him and demanded that he be released from prison. Albizzi stood fast and refused to drop his charge. Cosimo, with his powerful friends' influence coupled with a colossal bribe, managed to have the order of his execution rescinded. Albizzi compromised with the court's decision, reversing the execution order and settled with having Cosimo, along with key members of his family, banished from Florence. Cosimo relocated to Venice to plot his next move.

Long story short: the brilliant banker waited for the executive branch of the Florentine government (*Signoria*) to elect eight new Pro-Medici priors (judicial magistrates on his payroll) and one *gonfaloniere della giustizia* (head of state and standard bearer of justice) and they exonerated Cosimo of any wrong doing. The result: Renaldo degli Albizzi and his supporters were now the ones forced into exile. In one fell swoop, Cosimo orchestrated the greatest coup d'état in Florentine history.

In 1434, Cosimo returned from Venice (a year after he was exiled) and was welcomed like a Roman Emperor returning from a long battle. Technically, he now owned the government, whereby proxy he became the de facto ruler of Florence.

It should be noted that it was only after Cosimo and his cadre of capo régimes took control over Florence that the humanism movement was able to

fully blossom into the most magnificent period of civilization—a period we know as the Italian Renaissance, or as the great Renaissance scholar Jacob Burckhardt put it: "The birth of civilization."

The early pioneers of humanism got the ball rolling for Cosimo, and he took it to the next level. In fact, it was only after Cosimo (and the powerful men who feared and emulated him) managed to turn humanism into a capitalist enterprise that the Italian Renaissance really took off. Italy, I should point out, did not exist as a unified nation during the fifteenth century. (America is older than Italy as a nation.) For the purpose of this work, I will refer to the five distinct Italian city-states—Florence, Papal Rome, Milan, Venice, and the Kingdom of Naples—as "Italy" during the Italian Renaissance, unless otherwise specified.

In 1899, K. Dorothea Ewart wrote *Cosimo De' Medici* and compared him to the Greek General Pericles and compared Florence to Athens. A sterling analogy! Florence, she maintains "was more than a state, she was even in miniature an empire." Ewart further states, "The parallel can only be rough and superficial, yet we may remember that each [Cosimo and Pericles] founded his power upon the 'people,' as opposed to the 'aristocracy'; that each first rose to supremacy upon the abortive attempts of enemies to ostracize them, resulting in exile of the enemies themselves."

The magic behind the humanism movement was money—and lots of it. This is what made Cosimo de' Medici so important to the humanism movement: he was instrumental in bankrolling it. The early humanists were passionate, but they lacked serious capital, and, more importantly, they lacked the business sense to effectuate what amounted to the greatest Cultural Revolution in the history of civilization. Cosimo, on the other hand, was the most powerful banker in Europe. He knew there was only one reality in this world and that was cold hard cash! The power of kings, the destiny of nations, war and peace, love and sex, religion, art and literature: all of it revolved around money and he was one of the few people in the world who controlled the flow of it. As one of his contemporaries stated "It is Cosimo de' Medici who controls everything…without him nothing is done."

The gold standard for currency in Europe was the 3.5 gram, 24 carat gold coin: the Florin, named after the city of Florence where the coin was minted.

From London to Rome, merchants, bankers, hookers and thieves figured their losses or gains in terms of Florins. Banking, commerce, private enterprise and a sophisticated cash economy based on Florentine coinage made the Medici Bank the most lucrative financial institution in the world and the most powerful corporation behind the Italian Renaissance. In 1433 there were more than 70 Medici banks scattered throughout the European continent. So significant were these institution to the Florentine economy, that the firm earned the sobriquet of the "Fifth Estate."

Cosimo had all the Florins in the world, but what he craved most was power—*Knowledge is power*. Cosimo was obsessed with acquiring the knowledge contained in ancient manuscripts. Finding exceptionally rare manuscripts and purchasing them required considerable knowledge and cash (not to mention great karma), but Cosimo was convinced they held the secrets of the future. Money was no object.

Like a modern-day Aristotle Onassis, Cosimo, with his vast army of exchange agents, brokers, speculators and fleet of leased ships searched the world for the most valuable commodities on earth: diamonds and sapphires from Russia, rugs from Persia, jasmine from Damascus, zibeline furs from Slavonia, tapestries from Bruges, crude silk from the Orient (which was made into fabric at Cosimo's Florentine factories), aromatic resins and spices from Egypt, gold, silver, copper, ivory, leopard skins and slaves from Africa, etc. The visionary venture capitalist brokered his commodities on the European market for an exorbitant profit and then reinvested his monetary gains into monumental civic and private enterprises that transformed Florence into the ultimate work of art and the quintessential symbol of capitalism.

As Cosimo was transforming Florence into a Wall Street version of Athens, Lorenzo Valla (the leading iconoclastic scholar of his day) was hired by King Alfonso I of Naples (then at war with Pope Eugenius IV), to challenge the authenticity of Emperor Constantine I (Dante's *draconian devil*) conferring to Pope Sylvester I (314-335) supreme temporal power over Western Europe. Valla dissected the textual veracity of ancient document known as: "The Donation of Constantine" upon which the whole claim of the Papacy's temporal power had been based, and proved the document was a forgery. Meaning it never happened.

"The Donation of Constantine" was the world's greatest con. This meant that the King of Naples, theoretically, no longer had to acknowledge the Pope's temporal power. It was illegitimate or no more legitimate than any other power-crazed dictator or warlord who attains power and keeps it—*by any means necessary*—including forging documents, fraud, bribery, extortion, terrorism and murder.

The most valuable cargo on board Cosimo's ships were the ancient manuscripts from faraway places that contained brilliant dissertations on architecture, philosophy, history, astronomy, geography, botany, medicine and, more importantly, mathematics. As a banker, Cosimo was obsessed with numbers, specifically the sacred esoteric meaning found in them: from Euclid's *golden ratio* to the mind-altering meaning of the Hebrew *gematria*. Cosimo and his crew were unlocking the mysteries of the universe. To borrow William Blake's line, "opening up the doors of perception" as they discovered, translated and unraveled the amazing mathematical works of antiquity—specifically Plato, and his "theory of everything." In his treatise *Timaeus,* Plato puts forth his theory of recombinant solids, beginning with the triangle, which ultimately revealed the mysterious "fifth element," the very building block, the dodecahedron, that God himself (according to Plato) used to create everything in the universe.

Cosimo ran Florence like a corporation (which is basically what it was). He gathered an inner circle of experts consisting of the foremost navigators, mathematicians, classical scholars, spies, scribes, copyists and ancient manuscript hunters of his day. Plato would have called them *elements*. Their purpose was to find ancient manuscripts and the knowledge they contained and then take this knowledge and use it to reengineer the very meaning of the Florentine mindset: i.e., the *human*. Will Durant stated: "The age of Cosimo was therefore a period of devoted scholarship rather than creative literature. Grammar, lexicography, archeology, rhetoric, and the critical revision of classical texts were the literary glories of the time. The form, machinery, and substance of modern education were established in Florence; a bridge was built by which the legacy of Greece and Rome passed into the modern mind." A secular education industry was spawned in Florence from the ancient literary works of the Greeks, Romans, Arabs, and Hebrews, which were then translated into Latin and made available all over the peninsula of Italy and beyond, over the Alps

and the Dolomites. In sum, Florence took the lead and assumed full direction of the epic process of reeducating the human species.

Cosimo de' Medici had a *thing* for classical scholars (he collected them) and when the ferocious twenty-year-old Ottoman Sultan Mehmed II (1432-81), conquered Constantinople (the capital of the Byzantine Empire) in 1453 and converted it into Istanbul, he actually put the humanism movement into overdrive. Many Byzantine scholars fled to the sanctuaries of Venice and Florence, and with them, they carried their secrets and personal libraries i.e., ancient manuscripts hitherto unknown in Italy. Cosimo welcomed them as distinguished guests and gave them jobs as teachers and translators. He once said that, "Poet, classical scholar and artist were all links in one chain," and that chain constituted the very mechanism that pulled the Renaissance forward like a secular chainsaw.

Cosimo's obsession with rare manuscripts resulted in creating what Professor J. R. Hale in his book *Florence and the Medici*, noted as "what was in effect the first capacious public library in Italy." Poggio Bracciolini, one of Cosimo's premier scholars and manuscript hunters (later Pope Nicholas V's secretary), discovered the Roman engineer/architect Vitruvius's treatise on design, *De Architectura* (first century BC), which was the most important manuscript ever discovered on the science of art and architecture based on mathematical formulas derived from the ancient Greeks. Vitruvius learned "sacred geometry" and "linear perspective" from the Greeks, and he, in turn, through his work, reintroduced it to the Florentines. The ancient Greeks maintained that the human body was the measure of all things. It contains in its proportions all the geometric and geodesic measures and functions that underlies the structure of the universe. (*The Da Vinci Code*, embodies Vitruvius' perfectly proportioned mathematical male nude portrayed as Leonardo's iconic image sprawled out on the floor of the Louvre as a dead man.) This celestial notion explains the Greek attitude that a perfectly proportioned naked male body was the apotheosis of perfection and beauty rather than the locus of shame. The "nude," as the art scholar Daniel J. Boorstin reminds us, "is an art form invented by the Greeks in the fifth century B.C.." This sacred pagan ideal was exemplified by the father of Renaissance sculpture, Donatello (1386-1466), when he transformed the heroic biblical figure, David, into a striking statue of a beautiful naked teenage boy standing over the severed head of his victim, the

philistine giant Goliath, signifying Florentine civic pride, independence and the triumph of *arte* over *ignoranza*.

The *David* established a groundbreaking precedent as the first freestanding bronze statue of a male nude to be created since antiquity. According to Will Durant, the statue was commissioned by Cosimo in 1430; other experts maintain it was more likely between 1431 and 1432. Either way, Donatello's *David* would have been cast in bronze before 1433. In other words, shortly before the tyrant Renaldo degli Albizzi hatched his scheme to destroy Cosimo because he felt that he was a threat to Christianity. Why would Albizzi think such a thought? Could the statue have had something to do with it? The Law of Leviticus perhaps?

Let's speculate. The provocative statue was the talk of Florence and the *definitivo* work of art of the millennium. The unveiling of the *David* would have been a mega-event. There is no doubt that Albizzi saw the polished bronze statue defiantly standing, in the words of Camille Paglia, (America's foremost feminist art critic) shimmering like a "frozen wet dream" in the courtyard of Cosimo's palazzo. Paglia maintains in her magnum opus, *Sexual Personae*, "The beautiful boy is homosexuality's greatest contribution to western civilization. Un-Christian and anti-Christian, he is an iconic formulation of the relation between the eye and reality. Repeated in a thousand forms in Italian painting and sculpture, he is the ultimate symbol of Renaissance art." According to Medici expert Tim Parks, "It is hard to think of a better advertisement for homosexuality than this life-size naked youth in polished bronze who slays a giant to place a dainty foot on the severed head and assume an erotic pose." Albizzi may have, *come si dice*, snapped, when he witnessed Florence paying obeisance to a homoerotic idol disguised as a biblical figure. And maybe that is why he perceived Cosimo de' Medici as a dangerous threat for Christianity and decided that he should rid the world of him.

Was there a secret message behind Donatello's *David*... something in the fantastic realm of *The Da Vinci Code*? The eminent art historian Sir Kenneth Clarke maintains that "Donatello paid a direct tribute to the ancient concept of physical beauty in his bronze David, whose head is derived from the Roman Emperor Hadrian's beloved Antinous [the most beautiful cocksucker in the Roman Empire], although with a sharper Florentine accent that makes it far more attractive."

A number of Renaissance scholars suggest that Donatello was gay. Follow me: right after David slays Goliath he meets Jonathan, the eldest son of King Saul, and the two young warriors fall in love. Numerous gay Bible scholars (yes, there are gay Bible scholars, and they adamantly maintain that there is a distinct difference in the way gays and lesbians read the Bible) make a very convincing argument, based on the distinct Hebrew words used to describe David and Jonathan's extraordinary relationship, that the love between David and Jonathan was far more intimate than a Platonic friendship and that they were same-sex lovers. Was Donatello implying that the biblical David was gay—much as Leonardo da Vinci was implying Jesus Christ and Mary Magdalene were lovers?

The point I'm getting at is that the *David* revolutionized the meaning of art and religion by exemplifying the ancient Greek concept of physical beauty as the embodiment of Eros's (the Greek apex god of love) presence on earth through his greatest creation: Man. The Greeks worshipped beauty, specifically the beauty embodied in a perfectly proportioned naked male body. Moses, on the other hand, took the Greek adoration of the male nude and transformed it into obscenity tantamount to devil worship. (That's why you will never see a stiff prick on a billboard for *Viagra*.)

Design giants employed by the Medici Bank and their various constituents and super clients, used Vitruvius's book to *reverse engineer* the very meaning of creation in Italy. Filippo Brunellesco, Lorenzo Ghilberti, Leon Battista Alberti, Luca della Robbia, Michelozzo di Bartolommeo and their numerous queer assistants set the gold standard in architecture based on the divine measurements of the male body. These amazing disciples of Vitruvius believed they were building "God Machines" based on occult principles that teleported man into the heavenly realm through the vector of architecture. Government buildings, banks, hospitals, libraries, monasteries, pharmacies, palazzos, tombs (funerary art constituted the greatest body of sculpture in the history of the Italian Renaissance), villas and churches were built/upgraded and then decorated by the greatest sculptors, artists, and craftsmen of the period.

As Cosimo's banking empire grew exponentially, so did Italian culture; he was creating culture by importing it. He used his international banking firm, with hundreds of Medici agents scattered like special forces all over the known world, to search and bring back by the boatload rare statues, manuscripts, coins, gems,

cameos, medals, maps, swords, shields, tapestries, relics and many other rarities, which were then housed in his Medici Palazzo and garden of San Marco, thereby creating what can be considered the world's first art museums.

Cosimo cornered the antiquities market by creating a lucrative commodities exchange whereby the wealthy Italian aristocracy, the actual patrons of the artists and humanists, aggressively competed with each other, emulating Florence in their quest to enrich their own courts with culture. Each respective court vied for the most talented artists, the latest copy of Cicero, a Pharaoh's ring, an exotic wild animal, a beautiful African slave girl, Persian rug, artifact or an erotic Greek statue to adorn their monstrous mansions and palatial estates. Image was power—and power is what they craved. That's how the Italian Renaissance flourished: it became the ultimate manifestation of capitalism. (How does that saying go? *The one with the most toys—*)

Cosimo's crowning achievement was the creation of the first Platonic Academy in Italy, an *Accademia* where the greatest minds in Europe could assemble to study and decipher the mysteries of the universe based on precise scientific principles rather than theological bullshit theories (you know, the sun revolves around the earth, women should be seen and not heard, pork chops are bad for you, homosexuality is an abomination, et cetera and so on—*ad absurdum*). In the words of Eugenio Garin, an expert on the Italian Renaissance, "Platonism became the tone of civilization…" and Plato would emerge as the unofficial messiah of the Italian Renaissance and the father of a new generation of man: i.e., Harold Bloom's *human*. In fact, if I were Harold Bloom, I might even be tempted to say that Cosimo de' Medici was the inventor of "the Renaissance man." He wasn't. But I will say that the Italian Renaissance invented Cosimo, and, for that matter, Harold Bloom, based on the wisdom they derived from classical antiquity.

In 1464, after transforming Florence into the cultural capitol of the world, Cosimo de' Medici died peacefully in bed, wearing a toga, listening to his physician and spiritual teacher, Marsilio Ficino, read Plato's discourse on the soul to him. Posthumously the visionary venture capitalist received the title that, I guess you might say, says everything: *Pater Patrie*—"Father of his Country." This brings us to his famous grandson, "The Magnificent" Lorenzo de' Medici, the man who would, in the words of the eminent Will Durant, "Take the Italian Renaissance to its 'purest excellence'."

# 8

# *Il Magnifico*

*Balls, Balls, Balls*

—Medici motto

In 1469, Cosimo's son and successor, Piero de' Medici, a shy yet capable humanist ruler, died after ruling Florence for five years. He left an empire to his then twenty-year-old son Lorenzo. A contemporary described Lorenzo accordingly:

> *He was considered the finest of the youth of his time. Skillful in the practice of arms, riding horses, and playing musical instruments, as well as the pursuit of letters and the arts, he was dedicated to understanding the most difficult things and eagerly embraced whatever might bring him fame and fortune.*

By the time Lorenzo assumed his father's shadow position as the Lord of Florence, the High Priest of the Platonic Academy Marsilio Ficino had already molded him into Plato's version of the ultimate "philosopher-king." Miles J.

Unger, author of *Magnifico: The Brilliant Life and Violent Times of Lorenzo de' Medici* (2008) stated:

> *In this scenario Ficino and Lorenzo worked hand in glove to craft an intellectual framework for a regime bent on undermining the republican traditions of the city . . .. The perfect society, elaborated most fully in Plato's The Republic, furnishes the would be ruler with a model of good government.*

Lorenzo gravitated to Plato like a shark to blood. He worshipped him and surrounded himself with like-minded individuals from the Platonic Academy. Plato referred to these individuals as *guardians of the state*. These *guardians* assisted the young statesman in ruling Florence as the ultimate version of an Italian philosopher-king. (Think of him as Michael Corleone with a Ph.D. in philosophy.)

Illustrious members and associates of the Platonic Academy included such phenomenal beings as the incredible Michelangelo, the mindboggling Leonardo da Vinci, the dazzling Kabbalah scholar Count Pico della Mirandola, the celebrated Venetian senator Bernardo Bembo, the polymath scholar Angelo Poliziano, the super-wealthy Roman baron Rinaldo Orsini (Lorenzo's brother-in-law), the powerful statesman Bernardo Rucellai (another one of Lorenzo's prominent brothers-in-law), the wealthy merchant Francesco di Tommaso Sassetti, the unfathomable artist Sandro Botticelli (Lorenzo's favorite painter), the comedic Pulci brothers, the treacherous Jacopo Bracciolini, the Byzantine scholar John Lascaris, the renowned Hebrew scholar Elijah del Medigo, the eminent professor Cristoforo Landino, the celebrated Greek scholar Demitrius Chalcondylus and many other influential humanists and members of the Medici dynasty (too numerous to mention) who carried the genius of classical thought to the far corners of Italy and beyond. Lorenzo and his crew of visionary thinkers were creating radically new assessments of *God, man, destiny, time, love, beauty, language, art, music, theater, literature, politics, what you will*—laying the foundation for a modern freethinking society as we know it today. Hallelujah!

Have you ever wondered how the English became, so, how shall I say, *sofisticato*? Many famous Englishmen studied in Florence, considered "the school of the

world," and various other Italian cities that maintained prominent universities and hotels during the fifteenth century. The English were fascinated by Italian culture. That was because the Italians were the premier educators and connoisseurs of the human race and the English were their most devoted disciples. For example, the preeminent Oxford scholar, "Kings' Physician," and founder of *The Royal* College of Physicians, Sir Thomas Linacre (1460-1524) obtained his medical degree in Padua (as did William Harvey, the English Einstein of Medicine) and studied in Florence with the Medici crew. Linacre returned to Oxford and became the first qualified Englishman to teach classical literature there (his most famous pupils were King Henry VIII, Erasmus and Sir Thomas More). A number of Linacre's distinguished Oxford colleagues were the scholars: William Latimer (c. 1467-1545), John Colet (1466-1519), and William Grocyn (1449-1519); all of them studied in Florence and were disciples of various members of the Platonic Academy. These "Italianized Englishmen" (as they were sometimes referred to) returned to London as thoroughly indoctrinated humanists and introduced classical thought into English literature thus setting the foundation for the upcoming English Renaissance that would ultimately reach its zenith with Shakespeare & Company.

It is imperative to understand that Shakespeare wasn't born a writer. No one is born a writer. A person becomes a writer, as Aristotle emphasized, through the process of imitation. In order for a person to become a writer they must first learn how to read (easier said than done in the sixteenth century) and then they must learn the basic fundamentals of writing: spelling, grammar, punctuation, and structure. It is only then that they can develop their own style and voice. Shakespeare became a professional writer by following the archetype perfected by Italian writers (specifically Aretino), which transformed very clever English savages into scholars, poets, and dramatists.

The most challenging question for Lorenzo and his gang of radical wisdom seekers was *la questione della lingua* (the question of language). There was no *questione*: it was Latin. Whereas Lorenzo's grandfather Cosimo, and father Piero, and the army of scholars and scribes they employed were instrumental in sustaining the Italian Renaissance, their minds (and more importantly, their pens) were still hopelessly stuck in Medieval Latin. This posed a colossal obstacle in the evolution of Italian literature, as well as the evolution of civilization because, I reiterate, only the

elite could read Latin. Dante took the Tuscan vernacular and infused it with various southern Italian dialects, notably Neapolitan and Sicilian, whereby it slowly became the "canonized language" of Italy. This unique hybrid language became the basis for Petrarch and Boccaccio. Each of them wrote their most famous works in their native vernacular but failed to displace Latin as the language of writers in Italy. They were actually mocked for writing in what was considered *un volgara dialetto* (a vulgar dialect).

Lorenzo succeeded where Dante, Petrarch, Boccaccio, and others failed; he did this by challenging Latin. He started early, at the age of seventeen, writing his first serious dissertation in defense of the distinct vernacular Tuscan. He would continue to write in the vernacular and produce a phenomenal corpus of literature in the form of essays, sonnets, letters (an estimated 10,000), ballads, religious hymns, novellas and comedies. In essence he turbocharged the Tuscan language because of his unbelievable power and prestige as a Medici. Tuscan would eventually become the basis of a distinctly peninsula-wide language adopted by writers, mainly in Florence, then later by the rest of Italy. This has to be the single most important event in the evolution of Italian literature, and by diffusion, English literature as well. Let me explain: During the fifteenth century, the English literati were also hopelessly stuck in an abysmal Latin inkwell. It was only later, by copying practically everything that the Italian men of letters did, that the English literati replaced Latin with their own vulgar language. One could actually say that if Lorenzo de' Medici had not personally challenged Latin and delivered the language its first serious blow (Aretino delivered the *coup de grace*) there might never have been an English writing Shakespeare. Let me put another way, Sir Francis Bacon, who many educated fools believe was the real author of Shakespeare's plays, wrote his most important books in Latin because he believed that Latin was far superior to English as a linguistic medium for writers to express their thoughts and ideas. It was only in the seventeenth century that the Brits finally developed an English dictionary (and a pitiful one at that).

Lorenzo's genius in legitimizing the vernacular Tuscan began with his own magnificent writings, but the ultimate vector that transmitted the romance language throughout Tuscany and beyond were his bawdy songs and folk ballads. Plato's famous *Symposium* was a banquet where a group of friends gathered to drink and dance to music in a free exchange of ideas and love. Following

Plato's lead, Lorenzo sponsored his own private symposiums (that's a given), but he took the idea up a notch and transformed an elite drinking party into a way of life that oscillated across the Italian landscape. He did this through the magical power of music and alcohol, combining the two in the form of Mardi Gras-like carnivals, pageants, processions and raucous musical extravaganzas (think Woodstock).

Imagine thousands of inebriated people dancing in the streets of Florence to the sound of *soul* music (Ficino maintained that music was to be understood as a "heavenly spirit" sent to earth like manna in order to enrich man's spirit and release him from his base ignorance) emanating from fifes, harpsichords, lutes, cellos, violas, horns, drums and zings. Let your mind run wild. "Imagine," as Shakespeare said when he wanted to convey a particular moment. In this scene envision a troupe of dazzling clowns (*zanies*) dancing and rapping to the rhythm of drums; masked merry makers (the original precursors to the famous masque performers that would later overwhelm the continent) clanging tambourines. In your mind's eye, picture an ornately constructed stage in the center of a giant piazza; bright flags, banners, and guild pennants stream the golden Tuscan skyline—the omnipresent white and gold emblem of the Papacy fluttering in the breeze next to the banner of the Medici. Hear the flourishing sound of trumpets announcing visiting celebrities from Milan, Ferrara, Siena, and Arezzo—dashing secular princes riding sleek Estense racehorses (the Ferraris of their day), prancing in the piazza for a race. Witness sleek Medici noblemen wearing fat gold chains around their necks, their sophisticated ladies sparkling in gemstones and covered in zibeline furs overlooking the action from their decorated balconies. Hear the chaotic reverberation of the crowd below screaming and cheering: *Palle, Palle, Palle . . . Bravismo! Ciao bella! Ciao Lorenzo. . . Eh, figlia de puttana! . . . Way Cornuto! Meraviglioso! Stronzo, Ancora . . . .* All of it accentuated with the sweet taste of Tuscan wine and apple-mascarpone tarts.

The titillating lyrics that comprise the *carnivale* songs were written predominantly by Lorenzo, and then married to musical scores created by some of the most celebrated composers of the fifteenth century. Men such as the great Antonio Squarcialupi, Heinrich Isaac and Marsilio Ficino. Some of the members of the clergy were put off by the promiscuous lyrics of Lorenzo's Zappa-like ballads

53

and perceived them as an excuse for moral perversion. A classic example was Il Magnifico's ode to Bacchus, the Roman god of sex, drugs, and rock and roll:

> *Ladies and gay lovers young!*
> *Long live Bacchus, long live Desire!*
> *Dance and play, let songs be sung;*
> *Let sweet Love your bosoms fire;*
> *The future come what may!*
> *Youths and maids enjoy today!*

In Lorenzo's mind, partying was an act of bliss ordained by the gods through the magical power of joy and ecstasy. In order for Lorenzo's kingdom to thrive he encouraged his people to procreate. That's because Florence was only as strong as its population—a population that was at the mercy of epidemic plagues, viruses, and horrific civil wars that threatened to obliterate whole cities and towns in Europe during the fifteenth century. Lorenzo's bawdy songs and folk ballads were the ultimate way to promote a vulgar language that would ultimately define the Italian Renaissance. I believe, in his totality, Lorenzo de' Medici was the greatest writer of the fifteenth century (especially when you couple his writings to his actions) and the most important patron of literature the world will ever know.

While Lorenzo was living the *charmed life*, making music and creating Utopia in Florence, a gruff, power-crazed toothless pope with a big head by the name of Sixtus IV (Francesco della Rovere) was approached by his nephew, a fat, greasy psychopath cardinal by the name of Girolamo Riario. Accompanying Riario, was his sidekick, the sociopath archbishop of Pisa, Francesco Salviati, and key members of a powerful Florentine banking family by the name of Pazzi, who joined forces because they despised Lorenzo and wanted to kill him in order to take over Florence and his banking empire. But they needed the pope's blessing. After carefully thinking it over, the power-crazed pontiff agreed to the idea, with one condition: It had to be a double-murder. Lorenzo had to be assassinated with his second-in-command: his younger brother Giuliano. To remove one without the other would be a disaster. The surviving brother would seek a *vendetta* that would make Lucifer proud. Everyone agreed, resulting in the most heinous mass murder in Florentine history, now known as "The Pazzi Conspiracy."

The accepted version of the pontiff's role in the plot to destroy Lorenzo de' Medici is that he came to despise him because he felt that he was insubordinate and had thwarted his plans to expand his papal empire into Tuscany (Dante castigated the earlier popes who did the same thing.) Sixtus sanctioned his nephew's plot, authorizing him to remove the Medici brothers from power by any means necessary. After months of plotting and scheming to get the two brothers together, inviting them to lavish banquets, dinners and other social events in order to kill both of them at the same time, the conspirators failed. With time running out, paranoia set in like a shot of crystal meth and the desperate psychopaths came up with a last minute plan: They would arrange to have the two Medici brothers assassinated in church.

On April 26 1478, the Sunday before Christ's Ascension, Cardinal Riario's henchmen succeeded in having Lorenzo's younger brother Giuliano butchered to death in front of the High Altar in the cathedral of Santa Maria del Fiore, during the Elevation of the Host, the prescribed signal for the double-kill. Lorenzo was on the opposite side of the massive cathedral when Pazzi assassins unleashed their fury and stabbed Giuliano nineteen times in the head and chest. The cathedral erupted. Simultaneously two power-crazed priests, Antonio Maffei and Stefano da Baglione (replacing the professional killers hired to execute Lorenzo who refused at the last minute to commit sacrilegious murder in a church) made their move. One of them lunged at Lorenzo from behind, grabbing him by a shoulder, in order to spin him around for the kill. Lorenzo instinctively moved forward, and the would-be assassin over extended his thrust and only managed to graze Lorenzo in the neck with his dagger (just below the right ear, near his jugular vein). In that miraculous split *secondo*, as if choreographed by God Himself, Il Magnifico spun around with his sword in his hand and fought his attackers off like Spartacus. Thousands screamed in horror at the sound of clashing steel. Lorenzo's men rushed to his aid. One of them was run through the heart with a dagger. In the melee, Lorenzo managed to vault over the low rail which encircled the choir to escape into the sacristy. The bronze doors were slammed shut. Pandemonium set in. The church bells began ringing and then the hunt for vengeance commenced.

Within forty-eight hours, Lorenzo's death squads had located several co-conspirators involved in the plot to destroy his family and they slaughtered them like pigs in a frenzy of bloodlust. Only three got away: Sixtus, Cardinal Girolamo Riario, and Bernardo Bandini Baroncelli, (the principal killer of Giuliano de' Medici). Bar-

oncelli wisely fled to Istanbul and Sixtus and his psychopath nephew were comfortably untouchable in Rome.

The other killers had no such luck. The Pazzis, along with the two priests who tried to kill Lorenzo and several other members of the clergy involved (including the archbishop of Pisa, Francesco Salviati) were stripped naked and mutilated with hooks and daggers before being hung from the balconies of the Palace of Justice. A nine-year-old Machiavelli watched in horror as Leonardo da Vinci sketched the perpetrators dangling from ropes bleeding to death, and legend has it that Lorenzo stood below the balconies and wrote macabre death odes to his victims. (I suggest watching director Ridley Scott's fantastic re-adaptation of the shocking event in the movie *Hannibal*, set in Florence, 2001.)

A livid Sixtus charged Lorenzo with the sacrilegious murder of the clergy, excommunicated him and then demanded that Florence surrender him to papal authorities to stand trial. The Florentines told him to die. Sixtus went ballistic and laid the Republic under ecclesiastical interdict, banning Catholic Mass, weddings, baptisms, and burials. He then made an alliance with the ferocious King of Naples, Ferdinand I, and various other mercenary captains (*condottieri*), declared war on the Medici Regime and attacked Florentine territories. Fighting ended only after Lorenzo, in what most believe was the most dangerous act of his illustrious career as a ruler, met with his enemy, King Ferdinand I, unarmed and, for all intents and purposes, alone. To put things in perspective: Ferdinand I was a homicidal maniac who enthusiastically killed his adversaries and then had their bodies embalmed and kept in a special "mummy museum" in his castle to further torment them. The meeting between the two warlords was ultra secret. Only key members of the Florentine government knew of Lorenzo's mission, and they were dead set against it. The back-story on Ferdinand is he once counted Lorenzo de' Medici as his banker, an ally, and an important friend. The vicious Neapolitan king knew that Lorenzo was a serious opponent. More importantly, he knew that Lorenzo was a friend and trading partner of his arch-rival, the mighty Ottoman Sultan Mehmed II, who had recently attacked the Italian territory at Friuli, waging a protracted naval war with Venice in a never-ending quest for maritime supremacy.

Lorenzo's principal allies in his battle with the Church of Rome were the states of Milan, Ferrara, and the sovereign republic of Venice— currently at war with the Ottoman Turks. In the spring of 1479, the sultan's agents had located Baroncelli hiding in Istanbul. News of his capture reached Florence and Lorenzo threw one of his famous mega banquets; he was finally going to get the devious motherfucker that killed his little brother. There was a catch, though; the sultan knew that Baroncelli was a priceless negotiating tool and he didn't just send him back to Italy neatly gifted-wrapped. He held on to him because he knew that Lorenzo would do anything! I mean anything to get Baroncelli—including inducing the Venetians to stop fighting with him not to mention have the great Venetian painter Gentile Bellini sent to Turkey in order to paint Mehmed's portrait (as the sultan had requested).

In the summer of 1479, the Venetians expediently made peace with the Turks, and Mehmed sent Baroncelli in chains to Venice, and the Venetians sent Bellini to Istanbul. Lorenzo's agents retrieved Baroncelli from the Venetians and he was escorted back to Florence to be executed for murder. Sixtus and Ferdinand, as well as the rest of the major warlords in Italy, were well aware of this and they were naturally stunned. Lorenzo was equally stunned by the sultan's monumental *mitzvah* (good deed) and ordered Bertoldo di Giovanni, a master sculptor and medalist, to cast a special medal to commemorate the mighty sultan. The medal was sent to Istanbul, along with gifts and Lorenzo's verses of appreciation. Recent analysis of the medal by the numismatic experts Ludwig Deubner and Emil Jacobs, suggests, astonishingly, that encrypted in the design of the medal is Mehmed and Lorenzo (superimposed) riding a chariot ostensibly conquering Italy. Was Il Magnifico sending a message to his Muslim friend?

On December 6, 1479, Lorenzo traveled to Naples to negotiate a truce with Ferdinand I; his timing was perfect. Lorenzo knew that the mighty sultan was taunting the Neapolitan king, promising him that he would shortly attack Naples and cut his heart out. Mehmed was Lorenzo's trump card, so to speak, and he played him like a master gambler and won Ferdinand over with a colossal bribe and the promise of allying Florence against the formidable Turk in the event of an imminent attack, which was about to hit the Kingdom of Naples like a tsunami. Sixtus was outraged by Ferdinand's betrayal and plotted another vendetta.

In August of 1480, like clockwork, Mehmed II initiated an apocalyptic invasion of southern Italy. Was Bertoldo di Giovanni's coin right? Did Lorenzo and Mehmed, with the covert assistance of the formidable Venetian navy think they could successfully conquer Italy? On the morning of Friday, August 11, Mehmed would try, and the southern Italian city of Otranto fell to the Turks. The sultan's ferocious forces annihilated the entire male population—killing Bishop Steven Pendinelli, sawing him in half on the steps of the high altar in the Cathedral of Otranto in front of his horrified congregation. Panic gripped the inner sanctum of the Vatican. From Otranto, the Turks began their brazen quest to conquer Italy, moving inward, raiding the cities Lecce, Brindisi, and then onward to Taranto in the west. Thousands were slaughtered, and thousands of young nubile women were loaded onto ships and taken away to Albania, where they were transformed into slaves and concubines.

At this point, the balance of power had shifted. Sixtus recognized Lorenzo's strength as an ally and lifted the interdict against Florence and the bull excommunicating him. I want to give credit to Mehmed because no one else that I am aware of has, not even the brilliant historian Lauro Martines who wrote the definitive book on the Pazzi Conspiracy, called *April Blood* (2003). Martines failed to acknowledge the significant role that Mehmed played in the whole fiasco, which I found odd, and once again demonstrates how identical historical events can be interpreted differently.

On May 3 in 1481, Mehmed the Conqueror died under suspicious circumstances. One theory suggests that his Jewish doctor, the Venetian Jacopo Gaeta, a.k.a. Jacob Pasha, poisoned him as a *mitzvah* for the Venetian Doge (for a fee, of course). Another theory suggests that Mehmed's eldest son and successor, Bayezit II (1447-1512), poisoned him. Roger Crowley articulates in his superb book on Mehmed: *1453: The Holy War for Constantinople and the Clash of Islam and the West*: "Despite numerous Venetian assassination attempts [on Mehmed's life] over the years the finger of suspicion points strongly at his son, Bayezit." In fact, the Turks matched the Jews and Italians when it came to playing the Machiavellian game of statecraft. Their specialty, in regard to supremacy, were sultans often killing ambitious sons and ambitious sons killing their fathers (not to mention their brothers), by whoever struck first. In any event, Bayezit, facing a serious challenge from his brother Cem over the throne of the Ottoman Empire ordered the Turks to evacuate Italy and return to Istanbul in order to solidify his position as the new Sultan. If he didn't, today, St. Peter's Basilica would be a mosque.

# 9

# Kabbalah Krazy

*O God, O highest good, how is it that I seek thee only I never find thee?*

—Lorenzo de' Medici

The moment I became mesmerized by Lorenzo de' Medici, I became haunted by the pope's role in the plot to kill him. Let me play the devil's advocate: The accepted version of the Pazzi Conspiracy maintains that Pope Sixtus IV sanctioned the plot, but he never sanctioned murder, much less a massacre in a church. In fact, he insisted that no one was supposed to die. Absurd! Lorenzo would never relinquish his power without a fight to the death. Although religion is never factored in as a motive for the elimination of Lorenzo de' Medici, to rule out religion would be naïve. (Let's not forget, we are talking about a pope, a cardinal, an archbishop, not to mention the two dagger-wielding priests who failed to terminate Lorenzo's life.)

I believe Sixtus was actually motivated more by his Catholic faith rather than his personal quest for power. And I think that this was the primary reason his cardinal nephew was able to convince him to sanction the plot in the first place. The pope would have considered Lorenzo de' Medici a radical pagan heretic and many of the members of the Platonic Academy as dangerous apostates

who threatened the very foundation of the Catholic faith. This factor is never addressed as a really legitimate motive for murder.

I can imagine Sixtus on his knees, praying to God, crying, "Oh Lord! What shall I do about Lorenzo and his gang of cocksucker philosophers who threaten the very foundation of my Church? Give me a sign." Then maybe it began to rain, or a candle blew out, and the crazy fuckin' pope took it as a sign from the Almighty. All kidding aside. A sign did appear; and, in my opinion, it came from within Lorenzo's inner circle.

Some of the members involved in the conspiracy were also distinguished members of the Platonic Academy, specifically the classical scholar, Jacopo Bracciolini. Bracciolini was a personal secretary to one of the pope's cardinal nephews, Raffaele Sansoni Riario, who had nothing to do with the conspiracy. He was innocently assisting the Mass on the day of the murders and was eventually set free by Lorenzo. Bracciolini (executed for his role in the conspiracy) may have revealed Lorenzo's secret agenda to the pontiff, which was the reinvention of the Catholic faith based on neo-Platonic principles. Sixtus may have become paranoid, and that is why the philosopher-king had to go. If Lorenzo got his way with his heretical-thinking academy, he might be able to galvanize the other powerful Italian warlords. Many, such as the mighty Sforzas, were his allies and shared similar secular beliefs, one being primarily the separation of Church and State. Let's just say they might stop paying taxes to the Vatican (unless otherwise specified, when I refer to the Vatican in this work, I am referring to the Holy See: the central governing body of the entire Roman Catholic Church, which is situated in Rome on the Vatican Hill), and maybe even unite as a nation, a nation that gave people the freedom to choose their own destiny and religion—with or without the Church's approval. For this reason I believe Sixtus, with an absolutely clear conscience, sanctioned the hit on the Medici brothers. But that's just the Devil's opinion.

In any event, what the gangster pope did alienated many devout Florentines from their Catholic faith. People were completely unhinged by the demonic actions of the clergy. I believe after the horrific massacre in the cathedral of Santa Maria del Fiore, Lorenzo de' Medici desperately sought God now, more

than ever, and secretly converted to a very esoteric form of Judaism known as the Kabbalah.

After the tragic events that shook Lorenzo's faith in God and the natural death of Pope Sixtus IV in 1484 (his body was found stripped naked on a table, and his papal apartment ransacked), a miracle would draw Lorenzo back to God. The miracle appeared as Count Pico della Mirandola (1463-94). On the record, the count was an independently wealthy polymath scholar; off the record, he was a kabbalist who translated the Jewish *Zohar* ("Book of Radiance") into Latin, thus championing the Kabbalah into the Italian mind-set. It is beyond the scope of this work to try and explain the Kabbalah. That would be the equivalent of trying to explain the mind of God. (I just explained the Kabbalah.) In a nutshell, the Kabbalah is an encyclopedic set of esoteric writings and practices that augment traditional Jewish interpretations of the Old Testament. The Zohar is a metaphor for the soul. As one kabbalist said in the seventeenth century, "We have no recourse to comprehend the mysteries of the Zohar, except by means of metaphor." The author Harry Gersh points out in his book, *The Sacred Books of the Jews*, that, "The secrets of the Kabbalah are not arrived at through contemplation, logical deduction, or rational speculation . . . the secrets come out of the psychic experience of those who attempt to pierce the mysteries." Those who try usually go insane in the process. In fact, if religion is the opiate of the masses, then the Kabbalah is crack cocaine.

Really, what is the Kabbalah? Joseph Dan, professor of Kabbalah at the University of Jerusalem, articulates in his precious little book, *Kabbalah: A Very Short Introduction*—"there is no answer to this question." Every person who comes in contact with the Kabbalah has his or her own interpretation of what it is. To Lorenzo de' Medici, it was magic. To Pico della Mirandola, it was the missing link in Christianity. Harold Bloom equated it with literary criticism. Somerset Maugham described it as "extraordinary and ridiculous." Shakespeare described it as the Promethean fire sparkling in a woman's eyes. Carl Gustav Jung saw in it the universal soul of mankind. Lenny Bruce saw a nightmare in the daytime. The Zohar comes close to explaining what the Kabbalah is: "When the prophets were no more, their place was taken by Sages, who, in a sense excelled the prophets; and, in the absence of Sages, things to come are revealed in dreams."

Some theologians maintain that Moses introduced the Kabbalah to the Jews. Others maintain that the Jews traveled to the Far East in the first century CE and learned it from Buddhist sages. Others maintain the Jews learned it from Hindu sages. Others say the Sufis, and still others maintain the Jews stole it from the Greeks… who stole it from the Egyptians. No one knows for sure. All you need to know is that Pico discovered the joy of the Kabbalah and Lorenzo and his crew ate it up like lasagna.

In August 1487, a papal bull (an official document issued by the pope) condemned a portion of Pico's kabalistic teachings as heresy, and inquisitors demanded that he be brought to the Vatican to stand trial. Pico fled to France and then later to the sanctuary of Florence where Lorenzo made him a premier member of his Platonic Academy. Pico had a seraphic knack for finding, interpreting, and translating the word of God in different languages, specifically Hebrew. Marsilio Ficino condensed what Pico did when he proclaimed: "All wisdom speaks God!" Pico simply listened. Lorenzo also listened. "To him [Pico]," Lorenzo proclaimed, "all knowledge and all religions were a revelation of God." This line crystallizes Pico's existence, and has to be the most monumental hermeneutical sentence ever written, as it provides a solution to the religious madness we are experiencing today in the 21$^{st}$ century.

According to Pico, the great law-givers Moses, Jesus, Mohammed, Pythagoras, Zoroaster, Maimonides, Akiba, Averroes, Avicenna, Socrates, Aristotle, and Plato, among others, were all preaching (albeit in different styles, languages, and dialects) the same thing—wisdom. What *Webster's* defines as: "Understanding what is true, right, or lasting. Common sense." By following the teachings of Plato, I mean Pythagoras, I mean Buddha; Jesus Christ! I always mix them up; I mean the Kabbalah (reverence for life, kind deeds and acts, intense prayer, study, chanting, and meditation), man can evolve and rise up the "cosmic ladder" (*sephirot*) and return to his original state of excellence and attain communion with his Creator. That was it! Man's spiritual purpose in life is to *receive* and *share* the universal wisdom of God, crystallized in Shakespeare's line:

> *Ignorance is the curse of God, Knowledge the wing wherewith we fly to heaven . . . .*

<div align="right">Henry VI, Part Two, 4.7.75</div>

The trick, according to Pico, was to have an open mind, and loving heart, in order to *receive* (which is the root meaning of the Hebrew word *Kabbalah*) "what is true, right, or lasting"—regardless of what language it is spoken in. Pico wrote the most groundbreaking religious manifesto of the Italian Renaissance, titled *Oration on the Dignity of Man*. The *Oration* distilled man's true purpose in life, besides chasing pussy (something, by the way, Pico was a master at). The ultimate purpose of life was to get wisdom. It didn't matter where you got it—just get it! Get it from Jesus, from Plato, Akiba, Mark, John, Luke, Ringo, Aristotle, Nanna, or the Buddha. Find it hidden in a grain of sand—hear it in the chants of a Native American Indian chief—see it in the contour and symmetry of a beautiful stripper's body—*receive* it in your soul. As the Good Book says:

> *Wisdom is supreme; therefore get wisdom. Though it cost you all you have, get understanding. Esteem her, and she will exalt you; embrace her, and she will honor you. She will set a garland of grace on your head and present you with a crown of splendor*
>
> Proverbs 4:7

In conclusion: The Medici family was instrumental in bankrolling the humanism movement by sponsoring the artists, architects, rabbis, philosophers, mathematicians, classical scholars, and more importantly, what the preeminent *professore* Harold Bloom calls the "wisdom writers" that created the fantastic body of literature that we (along with Shakespeare and the vast constellation of English writers before and after him) now read, absorb, cherish and use to comprehend what they did. Using Harold Bloom's surreal logic, the Medici invented the literary human: a *human* that knew the difference between fanatical religious fiction and sublime spiritual knowledge. Or as Bloom articulates in the last sentence of his truly enterprising book *Where Shall Wisdom Be Found?*:

> *Truth, according to the poet William Butler Yeats, could not be known but could be embodied. Of wisdom, I personally would affirm the reverse. We cannot embody it, yet we can be taught how to*

*know wisdom, whether or not it can be identified with the Truth that might make us free.*

Free? Free from what? Free in what way? Free from political oppression? Free from a nagging wife? Free? How free? The most influential literary critic of the twenty-first century, a Bible scholar, and the world's foremost Shakespeare expert, writes a book on wisdom (and does an psychological autopsy on Plato, Homer, St. Augustine, Socrates, Shakespeare, Bacon, Freud, Cervantes, Nietzsche, Goethe, et al.) and ends his book with one of most elusive sentences ever written on wisdom, trying to identify it with "the Truth that might [no guarantee] make us free." There is no such thing as the *truth*. One man's truth is another man's nigthmare. Ask a Jehovah's Witness to define the truth. Then ask a Muslim…, a Jew…, a Christian, a Hindu, a Buddhist, an atheist, and you will get seven different versions of the truth. Truth is reality. And the only reality that can make us free is love. According to Plato:

> *And so Eros* [a fancy word for love], *which we first approach as the desire to possess sexually the body of another being, turns out to be a desire for immortality, for wisdom, and for the contemplation of an object that is not in any way bodily or physical* [in other words: God].

It's no wonder why men love to go to strip clubs. Knowing *why* is "the Truth that might make us free." But that's a journey every man must make on his own before he ever attains the wisdom that leads to nirvana.

# 10

## *The War of Fornication*

*A White devil, a radiant daughter of sin and death, holding in her hand the fruit of knowledge of good and evil, and tempting the nations to eat: this is how Italy struck the fancy of the men of the sixteenth century.*

—J. A. Symonds

On April 8, 1492, Lorenzo de' Medici died in his sleep. Twelve days later, fifty-three miles southeast of Florence in a little city called Arezzo, a city known for producing more poet laureates (notably Petrarch) than any other city in the world, Pietro Aretino was slipping out of his mother's womb. Simultaneously, Christopher Columbus was beginning preparations to sail to India; then, liked crazed mad dogs, King Ferdinand II and Queen Isabella of Spain turned with a vengeance on the Jews, ordering them to convert to Christianity or be exiled from their homeland. The Jews who refused conversion had till July 31st to vacate their homes and businesses. They were forbidden to take any gold or precious stones with them. Anything left behind became the property of the Spanish Crown.

On August 3, 1492, Columbus's fleet left Spain, and the Spanish waterways were clogged with a flotilla of Jewish vessels fleeing. Three hundred thousand Sephardic Jews—and some estimates suggest as many as five hundred thousand—were scattered across the European continent, and beyond, as far as Istanbul where

they were welcomed as guests by the sultan who empathized with his brother's tribe after the fall of Granada in January of 1492.

A week after Columbus left Spain, an incredibly rich, sixty-year-old Spanish cardinal by the name of Rodrigo Borgia became pope, adopting the pontifical name of the great pagan conqueror Alexander, thus becoming forever known as Pope Alexander VI.

The name Borgia is synonymous with evil. The family was particularly well known in London as the apex predators of the Italian Renaissance. Incidentally, Shakespeare's notorious colleague Barnabe Barnes wrote a wicked anti-Catholic tragedy entitled *The Devil's Charter: Concerning the Life and Death of Pope Alexander the Sixth* (1607). The play was performed at court by Shakespeare's acting company, The King's Men (formerly Lord Chamberlain's Men) before the flamboyant King James I, on February 2nd 1607. (I can imagine Shakespeare playing the part of Alexander the Sixth and King James laughing.)

Like most Renaissance popes, Alexander the Sixth had his fair share of vices. It was no secret that he had a clan of bastard children with a slew of beautiful Italian mistresses (they found him irresistible). The Borgia legacy is a classic example of history being largely "a lot of bunk" as Henry Ford once said. Or as Tolstoy put it, "History would be a wonderful thing—if it were only true." For centuries, historians have portrayed Alexander VI as a sadistic, Antichrist psychopath whose smile concealed a taste for human blood. This is a biased, imprecise portrait of him. And I'm not saying that he was a saint. Marc Anthony's line in *Julius Caesar* says it best:

> *The evil that men do lives after them; the good is oft interred with their bones.*
>
> (3.2.75)

No line, in context, captures what Alexander VI accomplished as one of the greatest popes of the Italian Renaissance. For starters, he actually reduced crime in Rome. He was instrumental in strengthening a weak and very vulnerable Papacy. He instituted a system of reform that would eventually lead to the Counter-Reformation. He adjudicated the division of the New World between

Spain and Portugal and circumvented a barbarian invasion that nearly turned Italy (in one of her darkest hours) into an appendage of France. However, the majority of the Italian scribes of his day despised him like they despised all foreigners (specifically "haughty Spaniards"), and they made him the most despicable pope to ever wear the coveted papal tiara. That's why his true legacy is buried with his bones.

The minute Rodrigo Borgia became Pope Alexander VI, he established a stronghold for his family (like his papal predecessors before him did), bestowing upon members of his large clan prestigious positions as cardinals, bishops, and prelates. He then strategically married off his illegitimate children into royal families to further strengthen his papal dynasty. No different than the previous pope, the rapacious, sex-crazed pontiff Innocent VIII (1484-92), who did the same thing with his estimated seventeen *bastardo* offspring. *Power is always perpetuated in the womb.* According to Machiavelli, Pope Innocent VIII (Giovanni Battista Cibo) was a bisexual psychopath who loved to burn witches. Renaissance scholar, John Addington Symonds, adds: "Pope Innocent VIII was a master of sanctified extortion—nepotism, graft, bribery, murder, embezzlement, and terrorism were the stock tools of his pontificate… in corruption he advanced a step beyond even Sixtus IV." The point is: Innocent VIII made the heterosexual Alexander VI look like a bad altar boy.

With Alexander VI and his large detested Spanish clan at the helm of the Holy See (the central governing body of the entire Roman Catholic Church), the peninsula of Italy was about to experience what amounted to an Italian holocaust. In 1494, three major events occurred in Europe that would completely change the Italian landscape. One, syphilis emerged; and, with no cure, it spread like the plague, causing madness and death. The consensus amongst paleopathologists is that Columbus and his crew brought the disease back from his first voyage to the Americas. The other event was the horrific "Italian Wars" (1494-1559), which began when a hideous-looking, twenty-three-year-old sex-fiend French king by the name of Charles VIII decided to invade Italy in order to reclaim the throne of Naples based on his legitimate right as a descendant of the Angevin rulers who once ruled the kingdom. This led to a series of cataclysmic battles that created a distinct polarized control of the Italian peninsula between France and Spain.

Before we proceed with the French invasion of Italy, I should point out that it was Pope Sixtus IV who instigated Charles's father, King Louis XI, to come to Italy with an army in order to conquer the Kingdom of Naples and Sicily, "because," the Pope said, "it belongs to him." Sixtus did this as a vendetta against the King of Naples, Ferdinand I, because he switched his allegiance to Lorenzo de' Medici in the aftermath of the horrific Pazzi Conspiracy. In any event, Louis XI died in 1483 and Sixtus IV died in 1484 and nothing came out of it. That is, until Pope Innocent VIII got involved. Historian Will Durant condenses what happened, "In 1489 Innocent VIII, quarreling with Naples offered the Kingdom to Charles VIII if he would come and take it. Alexander VI forbade Charles, on pain of excommunication, to cross the Alps; but Alexander's enemy, Cardinal Giuliano della Rovere [Sixtus's nephew: a conniving, power-crazed prelate who would stop at nothing to destroy Borgia in order gain the papal throne for himself]—came to Charles and at Lyons, and urged him to invade Italy and depose Alexander." Simultaneously, the warlord Lodovico Sforza [the regent of Milan], fearing attack from Naples, egged Charles on and offered him money and safe passage through the territory of Milan whenever Charles should undertake a campaign against Naples. And that's when Charles VIII decided to make good on his Neapolitan inheritance.

On September 2, 1494, the degenerate French monarch led an estimated 30,000 heavily armed soldiers, the largest army of the time, equipped with the first mobile horse-drawn artillery cannons, in European warfare across the Alps into Italy for the ultimate rape, pillage, and plunder fest. The military historian Christopher Duffy pointed out that the French invasion of Italy "was the blitzkrieg of its day." One Italian city after the other succumbed to the French and was stripped of its treasures, specifically some of the finest pussy in Italy. The Spanish writer and Borgia expert, Vincente Blasco Ibanez, referred to Charles VIII's campaign as "The War of Fornication." And that it was. Many beautiful Italian women were sodomized by the French monarch and his rapacious officers. By the same token, many libidinous Italian ladies were eager to please the suave conquerors and willingly spread their legs open to the rolling debauchery that overwhelmed the Italian peninsula like a giant French dildo.

On December 31, at three o'clock in the afternoon, the invading French army began their march toward Rome. News reached the Vatican and Alexander

wisely fled into the impenetrable walls of Castle Sant' Angelo. Jules Michelot writes in his epic work *History of France*: "The army of Charles VIII entered Rome and the passage of its marching files was prolific and continued far into the night by the light of torches. There followed in rapid succession thirty-six bronze cannons, each weighing thousands of pounds. All this was to be seen in the light of the torches reflected on the walls of Roman palaces and in the depths of the long streets with faint silhouettes larger than life, sinister and mournful in effects." Charles made his grand entrance into the Eternal City riding a golden chariot. A cheering crowd of thousands welcomed him as a liberator from the detested Borgias. The monarch demanded to see the pontiff and threatened to raise havoc if he did not show his face and sanction his claim on Naples. Alexander stood his ground in his fortified castle. That night intense negotiations began between the pope's agents and the French king's ambassadors. Debates were held, and concessions and terms were bantered about. Meanwhile Charles commandeered several choice palaces in the Borgo, and then made a tour of the city's famous brothels while his commandos selectively pillaged various establishments in the city. And there was nothing the Romans could do about it (except maybe run and hide).

After a week of controlled rape and mayhem, Alexander finally met with Charles and ostensibly sanctioned his claim on Naples. He then held a Royal Mass and blessed the French monster in front of a crowd of thousands. To ensure that the Pope's word was his bond (it wasn't) and his blessing was genuine, Charles took valuable hostages including the Pope's son, nephew, mistress, and four hundred mules laden with gold, silver, and priceless artwork. The French king then marched toward Naples, leaving Rome in shambles. One version has it that before the degenerate conqueror left the Eternal City, he had a few token Jews murdered and then hung from temple columns to show the Italians that he meant business.

In February of 1495, Charles VIII conquered Naples without a fight. In the meantime, as the hideous French king and his men were living *la dolce vita*, pile-driving their French cocks into Neapolitan girls' glistening vaginas, giving them the French disease (syphilis)—Alexander VI put together a colossal army of his own (known as a Holy League), hired an equally audacious warlord by the name of Francesco Gonzaga II to lead it, declared war on Charles VIII, and chased

the French out of Italy at the Battle of Fornovo (July 6, 1495). Charles narrowly escaped capture and withdrew to France with what was left of his once-invincible army. Two and-a-half-years later, a then twenty-seven-year-old Charles, accidentally (according to French historians) banged his head on a doorjamb and died from a subdural hematoma (What may have really happened is that his estranged wife, Anne of Brittany, hired someone to crack his fuckin' skull open because she was horrified of the hideous syphilitic monster.)

The last event that completely changed the Italian landscape was the fall of the illustrious House of Medici. The accepted version of the event, according to Francesco Guicciardini, the premier Medici expert of the sixteenth century, is that the Florentines despised Piero de' Medici (Lorenzo de' Medici's heir) because he was a tyrant with a cold, violent, and vindictive disposition; and so they banished him—just like that. No other explanation was necessary. Such is the fickle nature of *Fortuna* (the Italian goddess of luck). The Florentines used Charles VIII as an excuse to overthrow the Medici regime because Piero de' Medici let the degenerate French monarch march through Tuscany without a fight. The spineless tyrant was supposed to defend the passes of the Apennines (and should have) but instead rode into the French camp and surrendered the keys (without the authority of the government) not only to Florence but to the critical port cities of Pisa and Livorno to Charles, thus opening the way for the French conquest of Naples. Historian John Addington Symonds:

> *The Florentines, whom Piero had hitherto engaged in unpopular policy, now rose in fury, expelled him from the city, sacked his palace, and erased from their memory the name Medici except for execration.*

As Machiavelli articulated, time and again: *Fortuna* is a fickle bitch goddess who changes men's fate like the wind: Charles got his ass kicked and his skull cracked open; Anne of Brittany would later go on to marry her dead husband's cousin and successor King Louis XII (who may have been behind the hematoma), and the Medici were banished from Florence, only to return with a vengeance (albeit eighteen years later). Let's get back to the Borgias, who meet a

similar fate with the bitch goddess of fortune, but not before they wreak havoc on the Italians.

The Roman cardinals and barons were alarmed by Alexander's uncanny ability to circumvent their combined efforts to destroy him by assisting Charles VIII in his campaign against him. Alexander had taken it all in stride, but then it got personal. On the night of June 14th, 1497, the Pope's son (by his favorite Italian mistress, Vanozza dei Cattanei), Juan, Duke of Gandia, Captain General of the military forces of the Papacy, was stabbed to death and his body was dumped in the Tiber River. At first no one suspected anything. The Duke was merely missing. A day went by and the Pope became alarmed. Juan was nowhere to be found. A citywide search was organized and the Duke's body was found floating in the Tiber, with his throat slit. Juan's mutilated corpse was taken to the Sistine Chapel where it was ceremoniously prepared for burial. The Spanish Pope was devastated. Juan was given a state funeral worthy of Julius Caesar. After the spectacular funeral, Alexander came to his senses and inaugurated a killing spree on the Italians that would have made Emperor Caligula proud. Historians reported that not a day, or night, went by that some influential Italian duke, cardinal or prelate was not stabbed, poisoned, or strangled to death by the vengeful pontiff's decree. This brings us to his principal henchman (his other son by Vanozza): the strikingly handsome, fiercely protective, blue-eyed serial killer, Cesare Borgia.

Before we address Cesare, I need to point out that before Juan's murder, Cesare was a cardinal. After Juan's murder, Cesare resigned his ecclesiastical position (with his father's blessing) in order to assume his brother's role as Captain General of the military forces of the Papacy. (Italian legend has it that Cesare killed Juan in order to assume his martial position. There is no evidence to support such an outrageous claim. Plus, if Cesare wanted to kill his brother he would have simply had him poisoned and no one would be the wiser)

In 1498, the bitch goddess *Fortuna* once again shined on the Borgia family: King Louis XII made Pope Alexander VI an offer he couldn't refuse. Louis was seeking a divorce from his wife Jeanne de France because he desperately wanted to marry his cousin's widow, Anne of Brittany. The problem is he needed a papal dispensation in order to get the divorce, and the only way he would ever get it is

if Alexander granted it to him. In return for such a favor, the formidable French king promised to ally France with the Papacy.

Alexander saw Louis's problem as a golden opportunity: a strategic marriage with France would do wonders for the Borgia dynasty by counterbalancing the power of the dangerous Italian cardinals, barons, and warlords determined on destroying his family. In the summer of 1498 a secret agreement was signed between the French King and the Spanish Pope, by which Louis promised to aid Alexander in every conceivable way, including finding a suitable wife for his son Cesare, thereby solidifying the deal through a double marriage. On Oct 1st, Cesare set sail with a spectacular entourage for France to personally deliver the papal bull annulling the French king's marriage to Jeanne de France. In exchange, Louis XII rewarded Cesare with the duchy of Valentinois (a French territory to which the papacy had ostensible legal claim; hence, Cesare's Italian nickname, *Il Duce Valentino*), and then he introduced him to his future wife, the sultry Princess Charlotte d' Albret (the King of Navarre's sister). In May 1499, Cesare and Charlotte tied the knot. The marriage was consummated (four times, the papal envoy assured the pope). Shortly thereafter, Cesare returned to Italy with a ferocious French king backing him. The Italians were now fucked.

The magnificent period in history known as the Cinquecento (1500s) would begin with a loud bang when Cesare Borgia, a.k.a. Valentino, decided to conquer the rich Emilia-Romagna region and carve out a duchy for his father and himself that would rival any of the five Italian super states. On October 15, 1500, Cesare set out with his elite Spanish Bodyguard (the deadliest killers in Italy) along with fourteen thousand heavily armed papal mercenaries, augmented by a division of French cavalrymen commanding heavy artillery, and began his unprecedented reign of terror on the Italians. From Bologna to the coast of the Adriatic, every major Italian city and castle in his sights capitulated. By 1502 Cesare Borgia had totally conquered the Romagna, and was well on his way to unifying a very stratified nation ruled by petty tyrants, despots and dictators (many of whom Cesare personally killed).

Later the same year, the Ottoman Turks resumed their ongoing war with Venice in their quest to control maritime trade. In the summer of 1503, the Spanish and French clashed over the Kingdom Naples and Piero de' Medici drowned

fighting for the French at the Battle of Garigliano River. And then the mighty House of Borgia came crashing down like the Twin Towers. According to the preeminent Italian historian Francesco Guicciardini, Cesare Borgia, in a scene right out of *Pulp Fiction*, accidentally killed his father with poisoned wine meant for a rich cardinal (as if there were any other kind) by the name of Adriano da Corneto in order to relieve him of his title and estates. According to Guicciardini's account, somehow the bottle of poisoned wine got mixed up with a good bottle, and all of them partook in the poisonous libation, and all of them got deadly sick. (Although numerous Renaissance scholars maintain that Alexander VI actually died from malaria rather than poison, J.A. Symonds emphatically points out that, "Nearly all contemporary Italian analysts, including Guicciardini, Paulo Giovio, and Sanudo, gave currency to this [poison] version.") Alexander later died in his chamber and Cesare came close to death; I don't know what happened to Corneto, but I do know that with his father dead, Cesare's luck was changing. Pulitzer Prize-winning professor of European History, Garret Mattingly:

> *It was plain to see that Cesare was finished. Everything really depended on his father being Pope, and as soon as his father died, his allies deserted him, his people rose against him, and his army fell apart as his captains scrambled for the service of some luckier master.*

Again, this is the challenge of interpreting history.... It depends on who is doing the interpretation. Although I respect Mattingly's opinion, Cesare was not finished. He still had powerful political connections, an enormous fortune amassed from his rapacious Romagna campaigns, and the deadliest army in Italy ready to wreak havoc on his command not to mention he controlled most of the cardinals in the Vatican.

On August 20 Alexander VI's mortal remains were interred in the Vatican. A week later a papal conclave convened. On September 22 a new pro-Borgia pope was elected. On October 8, 1503, Pius III was officially crowned pope and he confirmed Cesare's titles as Captain-General of the papal forces and Duke of the Romagnas. Cesare was back. A month later Pius III was dead. Then the impossible happened, like it always does. On November 1, 1503,

Cesare's nemesis, the conniving Cardinal Giuliano della Rovere was elected as Pope Julius II. Julius used Cesare like a bishop on chessboard to solidify his own position as supreme overlord of the Papal States and then had him arrested, in what has to be the greatest double-cross of the Italian Renaissance. It was Cesare that swung the army of Spanish cardinals (eleven of them, appointed by his father) to cast their votes in Della Rovere's favor. And that's how Julius II won the papal election. He tricked Cesare into believing he was his ally and the most viable candidate to advance his political position. According to Machiavelli, it was the only fatal mistake in Cesare's career as the greatest statesman of the period. Nonetheless, Cesare bartered his way out of jail and fled to Naples. In Naples he put together another army; was promptly rearrested and ultimately exiled to Spain. In Spain he escaped captivity and reappeared on the battlefield and was killed fighting for his brother-in-law, the King of Navarre, at the Siege of Viana (March 12, 1507)—marking the end of the Borgia dynasty, and the beginning of the most fantastic period of civilization: the flowering of the Italian High Renaissance. A period that Pietro Aretino would emerge from to become the greatest writer in European history—regardless of what Harold Bloom thinks.

# Part III

# 11

# *Roots*

*A devil, a born devil, on whose nature, nurture can never stick.*

—William Shakespeare

We know little about Aretino's father, except that was a cobbler by the name of Andrea del Tura, who went by the nickname Luca. But Aretino's mother was literally a work of art. Her name was Margeherita Bonci, and everyone in Arezzo knew her as Tita. One noted painter, Matteo Lappoli, compared her beauty to an angel and modeled her as the Virgin Mary in his fresco of the *Annunciation* at the church of San Agostino. The rumor around Arezzo was that Tita was a courtesan. Legend has it that Luca suspected his wife was turning tricks with a rich nobleman by the name of Luigi Bacci. James Cleugh, one of Aretino's biographers, maintains that after Luca found out, "with atypical Aretine impulsiveness, [Luca] seems to have joined a troop of mercenaries and never returned." The fact is, he is never heard from again; Bacci most likely had him murdered and his body disposed of—the custom of the day when rich noblemen wanted to steal other men's beautiful wives. Whether Luca ran away, or Bacci made him disappear, Tita and her three children (she also had two beautiful daughters) became Bacci's adoptive family. Aretino would brag that he was a nobleman's illegitimate son. He wasn't; but that didn't stop Aretino from telling people that he was. We

know from Aretino's letters that he respected Don Bacci, and he referred to his two sons, Gualtiero and Francesco, as his brothers and kept in contact with them throughout his life.

Thomas Caldecot Chubb, another biographer of Aretino's life, maintains that Aretino had two uncles from his mother's side, one a lawyer, the other a priest, and that they helped shape his precocious mind. Aretino's life at Arezzo, we can surmise (considering his extrovert character and his phenomenal history of getting into trouble), was that of a classic Italian child, full of curiosity and mischief. Then, in 1502, something horrendous happened. Florence, the hereditary oppressor of Arezzo, sent a magistrate and a commission of soldiers to Arezzo to arrest sympathizers of the city of Pisa, a breakaway colony of Florence, then at war with the mighty Republic. The citizens in the town square where the soldiers planted themselves began chanting, "Down with the Florentines!"

Arezzo was a city known for its ferocious character; a rumor was spread that the Florentines had come to sack their grain supply. The alarm bells began ringing and the angry citizens banded together like hungry jackals. The young Aretino must have watched as his kinfolk turned on the soldiers and began attacking them. With the taste of blood in their mouths, they then turned on each other. Or rather, they turned on the citizens who were from wealthy and influential families of Arezzo and were Florentine sympathizers. Cleugh describes the dreadful event:

> *They began burning houses, hunting Florentine sympathizers hanging them, some were emasculated with daggers, and some had lighted torches thrust between their naked buttocks....*

It was a wretched scene right out of *Dante's Inferno*. After the massacre a much larger militia of Florentines returned to Arezzo and sacked the city, taking the head citizens as hostages. Suffice to say, the little city of Arezzo, with loved ones locked up in Florentine dungeons, conformed to the demands of her oppressor, at least for the time being.

The young Aretino was never the same. The innocence of childhood was washed away like the crimson blood that ran down the cobblestone streets on that

dark week in Arezzo. It was a haunting image that would follow him for the rest of his life like a shadow.

Sometime between 1504 and 1505, Aretino, now a strikingly beautiful teenager (he inherited his looks from his mother), ran away to the city of Perugia fifty miles south of Arezzo. Perugia was the first big city on the road to Rome, a city known for its magnificent university (the alma mater of Cesare Borgia and his nemesis, Pope Julius II) and its colony of great artists. Once Aretino arrived, he sought the company of other like-minded misfits. The sleek Adonis with penetrating dark-eyes and with that unfinished look of apollonian perfection characteristic of puberty.... Cleugh articulates, "Plunged, with a precocity typical of Italian boys of fourteen then and now, into the wildest life he could find." Although poor, Aretino had the tremendous capacity for making the right friends. It was at Perugia that he met another wild-child: the extremely gifted, Agnolo Firenzuola, and the two bonded together like Jonathan and David.

It is recorded, that the two hot-blooded teens indecently exposed themselves at a window in broad daylight. Agnolo wore only his blouse and Aretino appeared stark naked. Later in life, when the two had gone their separate ways, Agnolo wrote a letter to Aretino: "Do you remember our mad youth?" he wanted to know. Aretino wrote back:

> *I often go back to the foolish deeds that we did. I will never forget the time we exposed ourselves to that old woman who ran off in haste terrified at the obscenities we shouted at her as she spied on us. It was broad daylight. You were clad only in your undershirt and I was stark naked. I also remember the fight I had in the room of Camilla Pisana* [a famous hooker] *when you left me there to entertain her....God, what a devil I was!*

At the age of nineteen, Aretino had his first minor poetry book, *Opera Nova*, published in Venice by Nicolo Zopino. The work implies that he had enough money and the foresight to see into his own future, and according to Chubb, traveled to Venice briefly to oversee its publication. Inside the book was Aretino's bio, which states that he is a talented writer and artist and critical to how

he perceived himself, establishing his pedigree from that point on. Aretino writes of it to a client:

> *If the style does not please you, at least the boldness will.*

Aretino continued searching for himself in Perugia and experimented with different trades. Some early chroniclers of his life maintain that he worked as a courier, pimp, swindler, stableman, shylock, a hangman's assistant and even a traveling minstrel. Chubb referred to him as "a rogue of all trades." And with that keen introspection characteristic of a curious biographer, he muses, "Whom did he swindle as a money lender…who did he help out? What villainies did he see, overhear, or take part in, in various inn chambers? Of what harlotries was he sponsor? What poor quaking wretches did he lead trembling to the gallows?" It's impossible to say. Aretino made a lot of enemies in his lifetime and many of them were jealous detractors who spread vicious lies about him. But Chubb is dead on when states, "During his [Aretino] wanderings he had been able to learn the ways of the whole underside of Italy. This made him something of an authority upon gutter ways—possibly the greatest authority the world would ever know." No doubt, Aretino knew how to survive on the streets. Did he swindle people? It's hard to say. I know that when he became rich and famous he helped a lot of poor people out. Did he lead men to gallows? Again, it's impossible to say, but he did get some of his friends off Death Row. Did he commit crimes? If he did, he never got caught. Did he sponsor harlotries—you can bet your life he did.

While in Perugia, Aretino got a job at a print shop where he would spend hours reading other people's manuscripts, learning the art of making books, much like Mark Twain and Walt Whitman did. When he got tired of printing and binding books, he painted (like Baudelaire did), learning the secrets of the craft and later transforming what he learned into the most vivid literary product of the Italian Renaissance, but not before his career as an artist with an "antic disposition" got him into deep trouble with painting.

According to the Perugian painter Giovan Battista Caporali (1476-1560), Aretino didn't agree with a depiction of a newly painted fresco in the Piazza Grande of Mary Magdalene and Christ. Legend has it in the middle of the night,

creeping like a thief, ladder and paintbrush in hand, he repainted the fresco, depicting Magdalene as a courtesan before her conversion. This, of course, was an utterly outrageous act and not appreciated by the monsignor of the church or the ruling family in Perugia, the murderous Bagliones. Aretino had gotten his fifteen minutes of fame, but at a price—he was banned from the city with a warning never to return. The young up-and-coming artist/writer left Perugia posthaste and headed toward Rome to seek his fame and fortune. In time, he would become the greatest hustler Italy would ever know.

# 12

## City of the Gods

*Rome, asshole of the world.*

—Pietro Aretino

According to Aretino, his first stop on the way to Rome was at a Franciscan monastery near Ravenna. It was there that he got a job working, again, in a print shop, binding books and also taking note of the sexual escapades of the nuns and friars copulating with each other, upon which he based a chapter in his infamous *Dialogues*. This form of hyper-sex was not confined to Italian monasteries. In fact, it was prevalent throughout the European ecclesiastical world, particularly in Germany. Virtually all German priests were despotic whore-masters. In his book, *A World Lit Only by Fire*, Professor William Manchester quotes the famous German abbot and historian, Johannes Trithemius of Sponheim (1462-1516), regarding the conduct of his own monks:

> *The whole day is spent in filthy talk; their whole time is given to play and gluttony....They neither fear nor love God; they have no thought of the life to come, preferring their fleshly lusts to the needs of the soul.*

Another German monk noted that, "many convents differ little from public brothels." The English were as bad as the Germans. Manchester:

> *In London it was not unknown for women entering the confessional box to be offered absolution in exchange for awkward, crammed intercourse on the spot.*

The French and Spanish clergy were equally sex-crazed. In fact, the fastest way to get drunk and laid in the sixteenth century was to become a member of the clergy. And that is why Aretino loved to vilify them. He despised hypocrisy.

No one knows exactly when Aretino arrived in Rome, but it was probably between 1514 and 1516, when he was in his early twenties, in his sexual prime, and when Rome was the center of the world and the most cosmopolitan city in Europe. But before we put him there, we need to address his friend: Rome's greatest artist, Raphael Sanzio (1483-1520), and his super-patron, H.H., (His Holiness), Pope Julius II, a.k.a. the "warrior pope."

Raphael arrived in Rome in the summer of 1508, when Julius II was waging a papal war with the sovereign state of Venice. The Pope's ally against Venice was France, under King Louis XII. After Julius defeated Venice in 1509, he double-crossed Louis by creating a Holy League, which included Venice and Spain as his allies in order to drive the French out of Italy. As a result, the Pope almost got his ass terminally kicked by Louis. Julius was on the battlefield and called out to the French monarch, "Let's see who has the bigger balls?" Louis responded with artillery fire, and the Pope was nearly flattened by a French cannonball. Later the mercurial bitch goddess fortune turned on Louis and his principal ally: Emperor Maximilian I pulled his army out of Italy like *coitus interruptus* and the French king lost half his fighting force. Otherwise Louis XII would have probably conquered Italy; instead, he was routed from the peninsula. Or as one jubilant observer put it, "The soldiers of Louis XII have vanished like mist before the sun."

With the French gone, Julius II was able to transform Rome into his own personal artistic masterpiece. He did this by commissioning the greatest works of art of the period, notably Michelangelo's *Sistine Chapel* and the reconstruction of St. Peter's Basilica—the world's first mega church. Julius II was a Christian

humanist, and as such was a major patron of classical art and literature. The Pope understood the intrinsic value of art as being the ultimate propaganda mechanism to guide the illiterate masses through the fantastic depictions of the Bible. In fact, if it hadn't been for the Papacy's unbelievable commitment in *directing humanities' gaze toward the mystery of God* and their unyielding vigilance and firepower in protecting Christianity from Muslim conquest, today Europe would be a Muslim continent.

In the summer of 1508, Julius II was fighting with Michelangelo over the ceiling frescoes of the Sistine Chapel (built on the exact dimensions of the Temple of Solomon as given in the Old Testament), because Michelangelo was taking too long in completing his commission and nothing the warrior pope did could get the fearless artist to work faster (including threatening to kill him). That's when the frustrated Pope consulted his friend, the preeminent architect/artist Donato Bramante in charge of rebuilding St. Peter's Basilica for Julius, after Julius tore the old basilica down (—the one that Emperor Constantine I had commissioned in 324 AD as tribute to the Apostle Peter, who lies buried under the altar on the site where the Romans crucified him) in order to build the new one. When it came to Michelangelo's ego, he was absolutely delusional; he despised Bramante (who held dominion over all artistic works in the Vatican) perceiving him as a serious competitor and a threat. Bramante equally despised Michelangelo, and suggested to Julius that he should pit another great artist against him. The pontiff was momentarily perplexed; after all, who could ever compete with the incomparable Michelangelo? That's when Bramante recommended his protégé, Raphael Sanzio. Julius was intrigued, and he immediately summoned Raphael from Florence and set him against Michelangelo like Emperor Nero would set a lion against a Christian.

Julius had big plans for his library in the Vatican apartments and worked directly with Raphael in its design, whereas with Michelangelo he couldn't even have a conversation without arguing with him, notwithstanding the stench— Michelangelo rarely took a bath. And so an art war began in the court of the warrior pope. Raphael began frescoing the militant pontiff's apartment in the *Stanza della Segnatura* (room of the signature), where popes and cardinals met to sign important documents, while Michelangelo simultaneously frescoed the ceiling of

the Sistine Chapel. Every day important officials gathered, trying to get a glimpse of the two giants working, which drove Michelangelo deeper into delusion. This could explain why Michelangelo (or as he was referred to: *il terrible*) depicts Adam and Eve as co-conspirators in the Fall of Man—laying the blame on both of them. In essence rewriting the Hebrew Book of Genesis, which lays the charge solely on Eve for having verbal intercourse with the snake.

In another section of the world's most hysterical proto-pornographic masterpiece, Michelangelo encrypts a kabbalistic message (Google Michelangelo and the Kabbalah) by audaciously placing a stunning blond in God's arm. *Who is she? Where did she come from?* No one knows for sure, and no one knows why God—the Creator of the universe has His arm wrapped around her like she's the Queen of Heaven. Does God have a significant *other* we don't know about? Time will tell. In any event, Michelangelo convinced himself that Raphael and Bramante were plotting to destroy him. He writes in one of his many tormented letters:

> *They are determined to see me ruined or worse. Raphael did this on purpose, as whatever he had of art he got from me.*

I recommend reading Ross King's *Michelangelo and the Pope's Ceiling* to fully appreciate the depth of Michelangelo's paranoia.

Raphael's answer to Michelangelo's *Sistine Chapel* was two elaborate frescoes: *The School of Athens* and the *Dispute of the Sacrament*. The noted art historian Kenneth Clark writes of Raphael's frescoes in his monumental work *Civilization*:

> *In so far as civilization consists in grasping imaginatively all that is best in the thought of a time, these two walls* [of the Stanze] *represent a summit of civilization.*

A summit of civilization! In the center of the *Stanza* appears Plato, modeled from Leonardo da Vinci, who was in Rome at the time, and according to Dan Brown, presiding over the Priory of Sion as its Grand Master (which would put a whole new spin on *The Da Vinci Code*; but let's not go there). To Plato's side stood Aristotle. Both philosophers are positioned in the center of an immense

temple surrounded by ancient wisdom seekers from the past. At the base of the fresco sits the phlegmatic Heraclitus, modeled from a brooding Michelangelo; to his right, the mathematician Euclid, modeled from Bramante.

It seems that with the mammoth success of *The Da Vinci Code* the whole world has become obsessed with Dan Brown's theory that Leonardo da Vinci embedded secret messages in his paintings, specifically his *Last Supper* (1495-1497). According to Dan Brown, the figure seated to Christ's right in the *Last Supper* is Mary Magdalene, rather than the Apostle John. It was not uncommon for artists of the Italian Renaissance to infuse hidden messages and symbols in their paintings. In fact, it was done all the time. The classic example is *The School of Athens*. In the center of the mindboggling fresco we see Plato pointing his right hand toward heaven—implying gnosis (which meant that one could find salvation outside the Church), and holding in his left hand his work *Timaeus*. Talk about concealing a message in painting. Leonardo was merely suggesting that Christ was in love with Mary Magdalene. God bless him! Raphael was suggesting that Plato was a secular version of the Messiah!

In the astonishing work of art we see Aristotle standing to Plato's left holding a copy of his *Ethics*, his right hand turned down toward the earth, implying empirical truth (i.e., what you see is what you get). Both men are opposites, as opposite as the hand gestures and color of their robes. Each philosopher has an air of superiority toward the other—as if to say to the group surrounding them, "My philosophy is the ultimate philosophy." The characters in the great hall are clearly enthralled. . . scurrying around or moving away from the two central figures, as other figures in the periphery contemplate what the two sages have revealed—feverishly writing what amounts to the very dialogue of the work: God is a mathematician and *The only verifiable truth was to be found in numbers* (Leonardo da Vinci).

Within the fresco we find the Greek math-wizard Pythagoras amazingly sketching *superstring theory* based on the celestial "music of spheres," which he ostensibly derived from the Kabbalah. Standing over Pythagoras is the world's first notable female mathematician, the beautiful Hypatia, ostensibly modeled from Raphael's next-door neighbor, the most famous hooker in Rome, Imperia de Cugnatis, a.k.a. "born to fuck" (mistakenly identified by art historians as the

Duke of Urbino, Francesco Maria della Rovere, the warrior pope's psychopath nephew—we'll get to him later). To Hypatia's left, stands Bramante (Euclid), measuring a mysterious geometrical figure—clearly substantiating the mathematical Plato as the superior philosopher. The pièce de résistance is the Persian philosopher and astronomer Zoroaster (modeled from the celebrated statesman Baldassare Castiglione) holding a globe in his right hand speckled with iridescent dots illustrating that the earth is merely a planet revolving in a colossal supergalaxy, predating modern astronomy by several centuries. *The School of Athens* had captured the sacred feminine essence of the neo-platonic Christian vision of the Italian Renaissance:

> *Wisdom is supreme; therefore get wisdom. Though it cost you all you have, get understanding. Esteem her, and she will exalt you; embrace her, and she will honor you. She will set a garland of grace on your head and present you with a crown of splendor.*
>
> <div align="right">Proverbs 4:7</div>

*The School of Athens* was painted directly opposite Raphael's *Dispute of the Sacrament*, portraying Jesus Christ, the King of kings, surrounded by the great Christian saints, apostles, theologians and sages of different eras. The two frescos made it official: the genius of classical thought was now completely synthesized within the framework of Christianity. In essence, Pope Julius II, the titular ruler of Christendom, was telling the world that there was more to the Bible than the Hebrew version of the story—making it the single greatest revelation in the history of Christianity.

*The School of Athens* reflected and amplified the Medicis' adoration of antiquity and crystallized Count Pico della Mirandola's daring vision—his lifework, encompassing all philosophies and faiths into a singular grand unification-theory, which was a radical interpretation of the meaning of religion that was way ahead of its time (and, in fact, way ahead of our time), distilled in Rodney King's immortal words: **"Can we all get along**?" Sadly, we can't. Pico was accused of heresy,

but at least his magnificent kabbalistic vision of the future of mankind exploded like a premature ejaculation onto the walls of the warrior pope's apartment.

In a great segue, it was none other than "the devil pope" Alexander VI who exonerated Pico of the charge of heresy. In fact, Borgia may have been the greatest pope in history, simply for the fact that the Italian Renaissance might not have survived the sixteenth century if he hadn't barbecued the radical anti-humanist monk Girolamo Savonarola (1452-1498) who was bent on destroying everything humanism stood for (and almost succeeded).

When Lorenzo de' Medici died in 1492, Savonarola was in Florence as a guest of Pico della Mirandola, and by 1494 Savonarola had completely hypnotized Florence with his spellbinding puritan exhortations against humanism, engulfing the whole city in a cesspool of sin and shame. Savonarola cursed Plato and the Greeks and condemned pagan philosophy as a satanic plague upon Christianity. He blazed from his pulpit like an evangelical version of Adolf Hitler, ordering the people of Florence to repent and abandon their luxuries. The finer things in life—wine, lavish garments, combs, powders, perfumes, jewelry, mirrors, playing cards and any form of art that was nonreligious. In sum: anything that made life interesting and tolerable (including whores, horseracing, dancing, carnivals and gambling). Then, like a pyromaniac, he lit his infamous "Bonfire of the Vanities," where famous Florentine humanists, such as Mirandola, Ficino and Botticelli lost their minds in a religious madness and began burning their rare books and paintings, as though God, the Creator of creators, was upset with them. It was worse than sacrilegious; it was insanity.

It's astonishing how easily the Renaissance might have gone up in flames—that is, if Alexander VI had not interceded and ordered Savonarola burned at the stake at the Piazza dei Signori in 1498 because he denounced him as the Antichrist. I should point out that the devil pope acknowledged the maniacal monk as a great spiritual leader, and was actually very diplomatic with him. He even offered him the coveted cardinal's "Red Hat" if he would tone down his fiery sermons. Savonarola told Borgia, in no uncertain terms, to suck Lucifer's cock, and with no recourse, Borgia, bless his Spanish soul, had the defiant monk incinerated and his ashes thrown in the Arno River.

If Savonarola had not been stopped, *The School of Athens* would never exist. I must add that the fresco was never meant to glorify paganism; no, that would be redundant. It was simply created to show two distinct aspects of truth: empirical and celestial. Thoroughly articulated by the great Lorenzo de' Medici when he stated: "One cannot be a good Christian, without a comprehensive knowledge of Plato." Unfortunately, the veneration of Plato would backfire because of the upcoming religious revolution that another pagan-hating monk by the name of Martin Luther (1483-1546) would later create in Germany.

In 1510, while Raphael was busy frescoing the walls of Julius's apartment (simultaneously screwing courtesans), Martin Luther, a twenty- seven-year-old theology professor at the University of Wittenberg, made a religious pilgrimage to Rome. Seven weeks later, he arrived, only to find that the streets were littered with miscreants, pimps, cock-devouring prostitutes and pseudo-holy men selling religious relics on seemingly every street corner. As Luther would put it in his writings:

> *If there is a Hell, then Rome is built upon it. There is buying and selling, lying, debauchery and villainy, and all kinds of contempt of God that Antichrist could not reign worse.... I freely declare that the true Antichrist is sitting in the temple of God and is reigning in Rome—that empurpled Babylon—and that the Roman Curia is the Synagogue of Satan.*

Luther made an extensive tour of the Eternal City, visiting the primary religious and pagan sites (*whorehouses* as he referred to them), and he may have even caught a glimpse of *The School of Athens* (which was completed right about the time he arrived in Rome), as well as Michelangelo's scandalous cock-obsessed *Sistine Chapel*. Both works were considered major tourist attractions. What drove Luther completely over the edge was the fact that hard-working German Catholics were paying for the frescoes in the form of a monetary spiritual favor i.e., *indulgence* paid to the Church in return for the sacramental absolution of their sins. (Which is actually legitimate; just ask any priest or televangelist.) Either way, the German monk was revolted by Rome and returned to Wittenberg a changed man: a man on a mission that would change the course of civilization forever with the Reformation.

# 13

# *Paradigm Shift*

*During the Renaissance, when they wished to imitate Immortal Greece they produced Raphael.*

—Salvador Dali

Once in Rome, Aretino managed to hustle his way into the palace of a redheaded, fifty-year-old multimillionaire playboy banker by the name of Agostino Chigi—and I mean hustle, with a capital *H*. He admitted that he had to turn tricks for his keep. It was in the Chigi palace that Aretino screwed his way up the ranks to become a courtier. As a courtier Aretino's main function was to serve his master. Every courtier has a distinct talent. Aretino had many. He could act, paint, write, print, fuck like a stud, and more importantly, make very rich old geezers roar with laughter. After years of trying, he had finally entered the inner sanctum of high society. It was the perfect society for Aretino to penetrate. The young Adonis, with his fondness for gorgeous attire and the finer things in life was perfectly at ease with decadent older men, and particularly adept at fulfilling whatever their deviant desires might be (use your imagination) and that is how he made a name for himself among the rich and famous of Rome. In retrospect, Aretino would write, "I always hated the poverty of their wealth; but my destiny, to laugh at me, when I was a mere youth shoved me up against Agostino Chigi,

where I might have died if he had been a mere merchant [as opposed to a perspicacious magnate with a penchant for young talent], but I revived myself with the magnificence, the banquets, the spectacle which often amazed His Holiness Pope Leo X the inventor of the opulence of Popes."

Agostino Chigi maintained the grandest sex-palace on the Tiber (think of it as an Italian version of *The Playboy Mansion*). Upon entering his amazing abode there stood in the foyer a homoerotic statue of a boy being ravished by a satyr, and an inscription in Latin over the main entranceway that tells one what to expect:

> *Whoever enters here what seems horrid to you is pleasant to me. If you like it, stay, if it bores you, go away, both are equally pleasing to me.*

The Chigi palace (now known as the Villa Farnesina) was designed and built between 1506 and 1509 by the preeminent Sienese architect-painter Baldassare Peruzzi. It was there that Chigi would throw his famous parties/orgies for libertine cardinals, bankers, and lecherous millionaires.

What's utterly fascinating about Chigi's place is that it became ground zero for an explosive paradigm shift in classical Renaissance art. It was at the Chigi palace that Renaissance art would begin its startling metamorphosis into the magnificent Mannerism style of art, which was far more individualistic and exaggerated by the artists' personal style or manner (*maniera*). The Florentines were the first artists since antiquity to exalt the female body with art, notably with Botticelli's fantastic portrayals of *Venus*, but the neo-Romans, specifically Raphael and his sterling protégé, Julio Romano, took the *sacred feminine* that Dan Brown so eloquently speaks of in *The Da Vinci Code* to the next level beyond anything ever imagined, much less seen. Raphael would turn the production of art into an industry by employing a virtual army of dedicated assistants deployed as teams who worked all over the city of Caesars on his numerous art projects. In the process, Raphael became fabulously wealthy and the most famous painter in Rome. Aretino described him as living "like a prince rather than a private person, bestowing his virtues and money liberally on all those students of the arts who might have need of them [especially beautiful courtesans]."

In the summer of 1517, Aretino was acting as a technical advisor on the execution of various projects Raphael and Romano were working on at the Chigi palace. Aretino was an acknowledged genius when it came to art, specifically pornographic art. I can imagine him telling Raphael, that by painting pagan gods in love, he would emulate antiquity, surpass Michelangelo, and become a demigod in the process, which is what he did. Raphael and his team of phenomenally talented assistants and the audacious courtesan models/proto-porn stars that inspired them went wild sanctifying sex, depicting pagan gods in various stages of amorous activity on the ceilings and walls of Chigi's incredible palace—officially establishing a new age of erotica in Rome.

The actual dating of Raphael's work (much as Shakespeare's work) is difficult (if not impossible) to pinpoint with exactitude, but his next pagan fresco of interest was most likely the *Apollo at Mount Parnassus,* created either during the pontificate of Julius II or after his death in 1513, when Lorenzo de' Medici's son, the celebrated Cardinal Giovanni de' Medici took over his position as Pope Leo X.

The *Apollo* fresco was the most extravagant homage to poetry (considered the language of the gods) ever created, sanctified by Raphael and Julio Romano on the walls of the pope's apartment. According to Greek mythology, Parnassus was the dwelling place of Apollo, the patron god of the arts, the deity of light and illumination, and the site of the mysterious Delphic Oracle (the same Oracle in Shakespeare's *Winter's Tale*) that led to the center of the earth goddess Gaia's vagina—the female creator of all things. Apollo was said to be modeled from Leo's lover, the strikingly beautiful Jewish musician Jacopo di San Secondo (*Jacob second to none*). The "sacred feminine form" is embodied in the nine volumetric Muses (ostensibly modeled from Rome's most beautiful courtesans) that surround Apollo: Clio, Thalia, Terpsichore, Euterpe, Polyhymnia, Calliope, Erato, Urania, and Melpomene. Amazingly, interspersed within the poetic fresco are some of Shakespeare's key literary sources. Among them stood such luminary literary figures as Ovid, Dante, Virgil, Ariosto, Boccaccio, Sannazaro, Petrarch, and the Queen mother of poetry, Sappho; but no one sees the significance relative to Shakespeare. I'm speculating, but I'm leading up to something that is beyond speculation.

There is no denying Shakespeare's poetic genius. Right now, my argument is not with Shakespeare, but with the myopic Shakespeare scholars who maintain that

he was ignorant of Italian art. Amazingly, of the countless books on Shakespeare that I have read, this very facet of his mind is missing, like a blank canvas: there is no mention, much less any critical analysis, of Shakespeare's knowledge of Italian art. (If there were, Harold Bloom would be writing this book instead of me.) Shakespearean scholars adamantly maintain there is no proof that William Shakespeare ever visited Italy, so there is no way, *they* conclude, that he could have seen Raphael's works, or his protégé Julio Romano's, or, for that matter a host of other Italian masters. What contemporary Shakespeare scholars fail to realize is that Shakespeare had access to Italian art in the form of exquisitely engraved prints, which were mass produced and available in London in his day not to mention Italian paintings and sculpture that decorated various English castles, inns, manors and brothels.

One of the greatest mysteries behind Shakespeare is: Did he visit Italy? A visit to Italy, it seemed, was a prerequisite for great English writers. Many of Shakespeare's friends and colleagues traveled to Rome and various other Italian cities, vigorously fornicating, studying and spying for the Crown in the guise of wandering humanist scholars. Notably: Thomas Watson, Anthony Munday, Christopher Marlowe, John Donne, Inigo Jones, Sir Philip Sidney, Thomas Coryat, the Earl of Oxford, Edward de Vere and Shakespeare's "ambiguously sexed" patron, the Earl of Southampton, Henry Wriothesley. (One theory even suggests that during the London plague of 1592, Shakespeare accompanied Southampton on a summer sojourn to Roma.)

Let's not forget, many of Shakespeare's greatest characters are Italians, and many of his plays are staged in Italy, which is a two month trip at the most from, London. Remember, Luther hitchhiked to Rome from Wittenberg, and it took him less than two months. Here's the dramatic irony: Even if Shakespeare never set foot on Italian soil, all he would have had to do to be an expert on the Italians is simply read Aretino's *Dialogues*, and the brilliant *disgraziato* did.

Really, what are the chances that Shakespeare might have visited Italy during his mysterious "lost years" (1585-1592), a time when no one knows where he was? Well, it's no different a hypothesis than to say that he did. My Raphael hypothesis is exactly that—a hypothesis, but it's a hypothesis that leads to a deep revelation. Raphael's Rome was the most important theatrical center in the world, an Italian version of Broadway, and a Mecca for theatrical architects and playwrights. According to Renaissance scholar Peter Partner:

## PARADIGM SHIFT

> *Under Leo X there was a court-inspired drama whose center was the Vatican itself. There was not a single theater under Leo, but three or arguably four.*

By following the characters in this work like characters in one of Shakespeare's plays, we begin to witness the evolution of modern stagecraft and the very mechanics behind all of it—lighting, props, costumes, scripts, machinery, the whole nine yards, so to speak. Let's start with Raphael, who designed the theatrical set for a comedy written by the incomparable Lodovico Ariosto (ascribed as a direct source of influence in Shakespeare's work). Raphael leads us straight to Chigi's architect, Baldassare Peruzzi, considered one of the greatest theatrical geniuses of the period. In 1514 Peruzzi designed an incredible stage set with a proscenium arch for Cardinal Bernardo Dovizi Bibbiena's titillating sexual comedy *La Calandra* (which critics maintain Shakespeare based parts of his *Comedy of Errors* upon) performed in the Vatican for the quintessential patroness of Italian theater/mayhem, the Marchesa of Mantua, Isabella d' Este-Gonzaga, a.k.a. *la prima donna del mondo* (more on this amazing virago later). Count Baldassare Castiglione, Isabella's envoy in Rome (depicted in *The School of Athens* and the *Apollo at Mount Parnassus*) wrote an amazing *editoriale* on the *produzione* of *La Calandra*, meticulously describing the intricate details of the stage production; and having read it, I believe it would make even Steven Spielberg drop to his knees in awe and wonder.

This brings us to a really important *questione*: How did the English come up with their *versione* of theatre production? Did James Burbage decide one day, out of the blue, to build an indoor playhouse, aptly calling it "The Theatre," hire playwrights to write plays, and then hire actors to perform in them, and then begin charging people money to see said plays? I mean how did the English do it? Really, did they have teachers? Was there a *formula*, a proverbial blueprint, maybe a book that they followed? Actually, there were several. The most popular was written by Peruzzi's amazing protégé, Sebastiano Serlio, titled *Architettura* (1545). In Oscar Brockett's definitive textbook *The Theatre* he writes:

> *In his book Serlio shows how a theatre is to be laid out, how the stage is to be erected, how scenery is to be arranged... and discusses*

*a number of additional topics, which formed the basis for theatre production throughout Europe for the next two centuries.*

By following Shakespeare, we discover Julio Romano, through Romano we discover Aretino, through Aretino we discover Raphael, who leads us to Ariosto, Bibbiena, Peruzzi, and Serlio. These men, collectively (to paraphrase Brockett) *established the blueprint for theatre production throughout Europe for the next two centuries.* All the critical components to the very evolution of English theatre are found in Rome. One could say the pieces are serendipitously laid out like sex-toys on a whore's bed, with all the major players in one place—like the *dramatis personae* in a Shakespeare play (or better yet, a movie directed by Spielberg).

The first scene: Chigi's pleasure palace, where we find ourselves at a lavish banquet surrounded by the most amazing people in Rome: the deviant cardinals, the decadent men of power and wealth, foreign dignitaries, sultry courtesans, painters, playwrights, set designers, actors, dancers, poets, clowns, dwarves and hermaphrodites. (Dan Brown referred to them in his *DVC* as "chicks with dicks"; they were highly sought after and believed to be descendants of the gods Venus and Hermes.) The cast includes Raphael and Romano along with their entourage as Chigi's court painters, Peruzzi as his architect, Ariosto providing entertainment, and a Jew probably doing his books. The second scene is set outside the main building on the lush garden grounds of Chigi's palatial estate that caressed the banks of the Tiber River. A spectacular fire is roasting pigs, lambs, and rabbits drenched in olive oil and rosemary. The air is scented with the sweet aroma of sizzling meat. Luscious African slave girls serve sumptuous antipastos: oysters on a half-shell, sea scallops sautéed in lemon, saffron, and butter sauce, caviar, diced halibut sprinkled with thyme and sprigs of oregano. We cut to Aretino, the comedian of the crew, sipping Frescobaldi wine and telling filthy, outrageous jokes about *Nuns gone wild* as he mingles with such luminary figures as Count Baldassare Castiglione, Cardinal Bernardo Dovizi Bibbiena, Isabella d' Este-Gonzaga, Sebastiano Serlio, Paolo Giovio, and Marchesa Victoria Colonna and many other incredible men and women who would ultimately become his close friends and colleagues. But for now, he was still a courtier, a courtier that needed a break before he would become the most famous writer in the universe. That break was about to come like a lightning bolt in the middle of the night that sets a mountain on fire.

# 14

## The Happy Pope

*Love God, and do as you please.*

—Saint Augustine

Lorenzo de' Medici had three sons. He described them as: *one is good, one is wise, and one is a fool.* Piero, the foolish son, caused the fall of the House of Medici in 1494 and died fighting for France in 1503. Giovanni, the wise son, became a cardinal in 1488 (at the age of thirteen) and fled Florence (after the fall of the House of Medici), with his little brother Giuliano (the good son), and they lived quietly in the shadows for eighteen years. During this time, the young Medici cardinal made all the right moves and in 1512 he reclaimed Florence (with the assistance of the warrior pope's army and coalition forces) and reinstated the House of Medici, placing his younger brother behind the scenes of the government while he attended cardinal matters back in Rome.

On February 21, 1513, Pope Julius II died in bed at the ripe old age of seventy and a thirty-seven-year-old Cardinal Giovanni de' Medici succeeded him as God's vice-regent on earth, known thereafter as Pope Leo X. The coronation of Leo X was held on March 17, 1513, and it was the most extravagant throne ascension ritual in the history of the Vatican. In this scene we see Leo, who bears a striking resemblance to Alfred Hitchcock (and certainly embodied his

macabre sense of humor) making his triumphant entrance. On his head is a dazzling jeweled tiara; on his back is a red velvet cloak trimmed with pearls. Glistening from his fat delicate fingers are sparkling jewels that held a vermilion laurel rein attached to a white Turkish warhorse draped in an embroidered caparison studded with semiprecious stones. Trailing behind him was a procession worthy of the Roman Emperor Hadrian. The historian Christopher Hibbert, author of *Rome: The Biography of a City* describes the fantastic scene (albeit I'll paraphrase it):

> *Thousands of people followed the papal procession cheering: "Viva Leone! Viva Leone! Viva Leone!" The streets were strewn with flowers and myrtle; triumphal arches with elaborate inscriptions in Latin welcomed and glorified the new Pope, son of a Roman mother, Clarice Orsini, greeting him as the Paragon of the Church and 'Ambassador of Heaven'. Altars with canopies of gold and red were set up at several strategic street corners; heraldic devices and Medici and Orsini crests were displayed on monuments, rooftops and over doorways; fountains ran with wine instead of water.*

Leo's biographer, Paolo Giovio, described the ostentatious event as the beginning of the "Golden Age." It was, in more ways than just a metaphor. Leo spread his fortune around like manna to the less fortunate masses. The Medici Pope did not believe that a Christian could live in a vacuum; and that faith, and faith alone, was the only perquisite for salvation (as his vociferous nemesis Martin Luther would later maintain). Leo put his money where his mouth was. As one of his contemporaries pointed out: *Leo X spent the treasure of Julius II, his own, and that of his successor,* [and then some.] Shortly before he received the "Apostolic Keys" (the ones Christ gave to Peter and the apostles), Leo had a fortune in coins disbursed like confetti to the crowd of cheering thousands as his massive papal procession was led to the Lateran Palace, where he formally took possession of the Vatican.

The world's first Medici Pope is often depicted as a fun-loving Epicurean, "the Happy Pope," as he was referred to, and that he was. Upon ascending

the Throne of Saint Peter, he made to his brother, what is considered his most famous proclamation:

*Since God has given us* [the Medici] *the Papacy, let's enjoy it.*

And they did. Leo's pontificate was a never-ending round of lavish banquets, balls, baptisms, festivals, carnivals, theatrical performances and hunting expeditions. The Medici Pope's famous legacy is that he gave, spent and burned his monstrous fortune away—all of it—following (in my opinion) Christ's declaration in the New Testament:

*Any of you who does not give up everything he has cannot be my disciple.*

(Luke 14:33)

Leo took everything Christ said to the extreme. For instance when Christ told Peter, the world's first Pope, "Thou art Peter, and upon this rock I will build my church and all the powers of hell shall not prevail on it" (Matthew 16: 18.19). These eternal words are inscribed in Latin around the base of St. Peter's Basilica, and they are the literal foundation of the cosmopolitan Roman Catholic Church.

Tradition has it, that Peter fled Rome during Emperor Nero's murderous crusade against the Christians. As he escaped along the Appian Way, Peter had a vision of Christ carrying His Cross. "Lord, where are you going? Peter asked in astonishment. Christ said, "I go to Rome to be crucified again." Peter then said, "I will go to Rome to be crucified with you." And so, the Apostle called the Rock was crucified by the Romans, upside down, at his own request, on the site where now stands the world's greatest Basilica named after him. When Christ told Peter "He would build His Church, He also said, "I say to you, whatever you bind on earth shall be bound in heaven, and whatever you loose on earth shall be loosed in heaven. If two of you agree on earth about anything they ask, it will be done for them by my Father in Heaven." (Matthew 18:19:20). I believe that means: Whatever a Christian, or in this case a pope asks, and, more importantly, *does* on earth, so it is done in heaven. This was the Medici Midrash (interpretation) of

Christ's advice to Peter: the very interpretation that sanctified the Italian Renaissance. The very interpretation that makes a good life worth living.

In Leo's mind, faith in God was a given. Christianity was about action. And Leo was all about action. He changed the course of the Italian Renaissance by making Rome the new center, whereas it was once Florence. He did this by giving Christians jobs (because a Christian without a job, as the saying goes: *Is the Devil's plaything*). The Medici Pope created an economic tidal wave of creativity by enticing hundreds of struggling artists, sculptors, painters, goldsmiths, musicians, philosophers, doctors, rabbis, playwrights, poets, printers, actors, singers, dancers, tailors, upholsterers, chefs, gardeners, carpenters, and architects to come work for him. This phenomenal Christian workforce designed, built, and maintained Leo's hospitals, gardens, convents, orphanages, hospices, theatres, libraries, and academies, whereby, in the words of Will Durant, "Leo X conquered Rome." But there was another side to Leo, a dark side. His years traveling the world and becoming general in Julius's papal army had made him a battle-scarred statesman. In fact, he could be as ferocious as a lion, and he set about securing the future of his pride by surpassing even the notorious Pope Sixtus IV in nepotism when it came to creating cardinals, thus ensuring a good chance that one of his kin or kind would succeed him as pope in the event someone tried to kill him, which we will get to.

In the spring of 1516, Aretino would finally get his big break. It was big, all right. Leo's adolescent pet elephant Hanno, presented to him by the famous Portuguese explorer Tristan da Cunha (on behalf of King Manuel I as a gift to Leo X for winning the Papacy), mysteriously died, and Leo was distraught because he genuinely loved the animal. The fact that the elephant came from India is as sublime as it is interesting. Was the Pope informed of the Hindu legend of Ganesha, the lucky elephant? The Portuguese were in India as early as 1500 and they had intercourse with Hindus. The Franciscans established a mission in Goa in 1515 and would later convert the Hindu port city into the largest Catholic diocese in the Far East. Regardless, the Medici, like most rich and powerful Italians—and I can't emphasize this enough—are very superstitious people. The death of an exotic pet elephant (an elephant that it is recorded would genuflect in front of His Holiness) would certainly be construed as a colossally bad omen, especially if it should mysteriously die at such a young age. It's a sublime *hypotheses,* as sublime

as an elephant shitting in the Vatican. What's even more sublime is that Raphael (who Leo loved as if he were his own son) painted a life-size fresco of the noble beast to commemorate his untimely passing. Ulrich von Hutten, a notorious German writer in Rome at the time of Hanno's death, reported:

> *You have all heard, the Pope had a great beast, which was called an elephant, and how he held him in high honor and loved him immensely. Now, you must know the animal has died. When the animal was sick the Pope was filled with woe. He summoned many doctors, saying: "Save my elephant." They did the best they could. They examined the elephant's urine and gave him a great purgative, which weighed five hundred ounces. But it did not take effect and so he is dead and now the Pope greatly grieves.*

I must point out that Hutten was no ordinary German writer; he was a militant soldier-scholar with a wicked sense of humor. Hutten advocated killing Catholic priests in Germany and a complete break with Papal Rome. If I had to describe him in a sentence, I would say he was part Adolf Hitler, part Bill O'Reilly.

While in Rome the audacious German writer decided to translate Lorenzo Valla's work on "The Forged Decretals of Constantine," and then he had the gall to dedicate the work to Leo X, challenging him to renounce his temporal powers over Germany. It is certain that Hutten's account of "Hanno the Elephant" and his translation of "The Forged Decretals of Constantine" reached the fatherland and, more importantly, may have wound up in the hands of his incorrigible protégé Martin Luther. I'm leading up to something.

All of Rome was gossiping about the grieving pope and his dead elephant. Many laughed behind the pontiff's back as he prepared the giant animal for ritual burial in the Vatican Gardens. Multitudes gathered for the strange spectacle. That's when Aretino and Chigi seized the moment like Barnes & Noble to make a killing. I forgot to mention, Agostino Chigi maintained a printing press in the basement of his palace.

On June 18, 1516, Hanno, "the great Elephant," was laid to rest. And then a mysterious comic pamphlet surfaced on the streets, sent like a sign from

heaven, and everyone began buying it. The work was titled "The Last Will and Testament of the Elephant." It relates how Hanno commissioned an anonymous scribe (Aretino) to make copies of his last will and testament and have it circulated so that all of Rome would know why he died. It was superbly executed, with an exquisite engraving of Hanno, created by the divine hand of Raphael's famous workshop. An official seal was attached to the document to draw attention to the authenticity of the work, which now resides in the Vatican Library.

"The Elephant of India," it began, "which the great King Manuel of Portugal sent to Pope Leo X, has lived in Rome for four years under the care of Zuan Battista Aquila. But now having fallen gravely ill because of the deplorable Roman air and the small rations that his stingy keeper, Zuan Battista, fed him, now realizes through his enormous intelligence that there is nothing more certain than his death. Therefore, he desires to make final disposition of his worldly affairs.... And he has appointed me to make copies of the same..." And then the document went on to the individual bequests:

> *Item, to my heir Cardinal San Giorgio I give my tusks, so that his hunger for the Papacy, as intense as that of Tantalus, may be moderated. . . . Item, to my heir the Cardinal Santa Croce, I bequeath my knees, so that he can imitate my genuflections, but only if he tells no more lies in Council. . . . Item, to my heir Cardinal Volterra I bestow my wisdom, if he promises to be munificent, for a change. . . . Item, to my heir Cardinal Santi Quartro I present my jaws, so that he can devour the revenues of Christ the more readily. . . . Item, to my heir, Cardinal Medici I leave my ears—so that he can hear the doings of everybody....*

On and on it went, with each cardinal getting a piece of the *elefante*. Aretino saved the best part of Hanno's anatomy for the foremost fornicator in the Vatican, Cardinal Grassi. To Grassi, Aretino left Hanno's enormous balls. Rome was in an uproar; everyone was laughing. More importantly, so was Leo; he was amazingly uplifted from his grieving.

# THE HAPPY POPE

One should not discount the superstitious element behind Hanno's death. The sixteenth century was a world ruled by *superstizione*, and the Italians, I reiterate, are very superstitious people; so if something good were to come from Hanno's death, naturally it would signify a good omen—and indeed, for Aretino, it was. Everyone wanted to know the identity of the intrepid author of the work who slandered cardinals with impunity. Under most circumstances, the author of the pamphlet would have been arrested, tortured, and probably put to death to set an example: no one denigrates the Sacred Order of the College of Cardinals and gets away with it, not in the sixteenth century.

Obviously, Aretino was willing to gamble on Leo X. It's certain that he met him at one of Agostino Chigi's lavish banquets, which he frequently attended. Aretino knew enough to know that the corpulent son of Lorenzo the Magnificent was a serious comedian himself, and he loved a good laugh as much as he loved a good blowjob—but he was still taking a big chance. If the mercurial Florentine pontiff found the testament to be offensive, there would be hell to pay. When Leo inquired who the ballsy author of the testament was, Aretino confessed. Personally, I think what Aretino did was suicidal. Mocking powerful cardinals could get a writer killed. But Aretino was no ordinary writer. He had very powerful friends in high places. In fact, I'm willing to bet it was Leo's gambling buddy Agostino Chigi who put him up to the whole thing, considering Raphael's phenomenal role in the work. Whether he did or did not, the final outcome was the pope ordered Chigi to release Aretino into his custody. If it was a gamble, it paid off. Leo duly made Aretino his personal court jester, which carried considerable cachet (considering Leo loved comedians as much as he loved the Virgin Mary). Aretino was now a *made-man* in the most powerful family in the world—"God's Mafia." The horizon for the young writer looked very promising. Everyone in Rome took *notizia* of him.

I must digress and speculate on the timing of the elephant's testament and the origin of Martin Luther's infamous *95 Theses*. Was the timing with Aretino's sacrilegious pamphlet, which was published in the summer of 1516, a *coincidenza*? Remember, Ulrich von Hutten wrote a sensational account of Hanno's death, and, no doubt, he sent his writings back to Germany. The question is, did Luther read them? More importantly, did he read them through the eyes

of a radical theology professor? Aretino's work was the first time in the history of the omnipotent Vatican that a writer, in collaboration with a great artist, mass-produced a pamphlet with such pomp and ceremony, mocking the very foundation on which it stands (the cardinals themselves) and got away with it. It was never done before on such a grand scale and, as such, would have been the equivalent to Headline News in Germany.

Through the consummate *arte* of *commedia*, Aretino indicts the cardinals (in the present tense) with the seven deadly sins: pride, envy, anger, greed, gluttony, sloth, and lust; and if an Italian could do it, why not a German? Was Luther inspired by Aretino? In 1517, on All Hallows Eve, Luther released his *95 Theses*. The original document laid the foundation for the Reformation and launched Luther's career as the most dangerous writer of the period. The *95 Theses* challenged the Papacy because Leo X was selling indulgences like lottery tickets (a volatile issue at the time) in order to finance the reconstruction of St. Peter's Basilica, as well as the last phase of the Italian Renaissance, which according to Luther was illegal and a gross violation of Scripture. Did Aretino inspire the German Hercules to take his own outrageous gamble by challenging the supreme power of the Papacy? The parallel between the two intrepid writers is startling, to say the least. When Havelock Ellis, the noted author and sex psychologist, psychoanalyzed Luther, calling him a "Teutonic Aretino," there is a lot of truth to Ellis's assessment. In fact, it's a testament to Luther's genius. Both men were iconic literary figures, and each man, in his own unique way, would bring the Papacy to its knees.

# 15

## Satanic Verses

*Guns don't kill people, writers do.*

—Writer's Guild conference topic title (1999)

Media guru Marshall McLuhan, known the world over for coining the term *global village*, maintains that Johannes Gutenberg's invention of the printing press in the fifteenth century was man's deadliest invention. McLuhan's book *The Gutenberg Galaxy* (1961) makes a strong argument to support such a claim. The author maintains that, "Print, in turning the vernaculars into mass media, or closed systems, created the uniform, centralized forces of modern nationalism."

Some might quibble with McLuhan's position, but the fact is, the mass production of affordable books created a reading frenzy. McLuhan further suggests: "Schizophrenia may be a necessary consequence of literacy." A classic example was Adolf Hitler's best-selling book *Mein Kampf*, which created a schizophrenic society and caused the death of millions. Another was Mao's *Little Red Book*, which also created a schizophrenic society and the death of millions. Deadly books no doubt, but the sickest book to ever come off a printing press has to be the *Hammer of Witches*, which we will get to in a moment.

Within fifty years of Gutenberg's invention of the printing press (technically, the Chinese invented the printing press; Gutenberg invented movable

type), well over one-hundred-thousand titles were printed. Almost all of them were exclusively religious works. Many of these works contained obscene caricatures of lecherous devils and nymphomaniac witches in the form of grotesque engravings, which sparked a wave of sexual dementia and religious fanaticism unprecedented in the annals of civilization. Print technology gave men like the maniacal Dominican friars and inquisitors Heinrich Kramer and Jakob Sprenger full advantage of the religious madness that was manifesting in Europe like a botulism toxin and about to come alive like the Black Death Plague.

In 1483 Kramer and Sprenger made a petition to the Vatican for a papal bull to extirpate witchcraft in Germany. On December 5, 1484, the bull, as issued by the Roman Curia, gave the two inquisitors the supreme authority to arrest and prosecute witches in Germany. In 1486 Kramer and Sprenger took the bull one step further by creating the world's first snuff bible, titled *Malleus Maleficarum* (Latin for *The Hammer of Witches*). On May 9, 1487, the work was submitted to the University of Cologne's Theology Department, seeking an official endorsement, based on the Old Testament's demonization of witches and the Cosa Nostra-like Mosaic laws that mandate slaying them, along with heathens, mediums, fortune-tellers, clairvoyants, wizards, homosexuals, transvestites and adulterers. Approval was duly granted. With the letter of endorsement backing them, the two inquisitors took the creative liberty of affixing the coveted imprimatur of Pope Innocent VIII to their work. Technically, what they did was illegal because the Pope never saw the work until it was published. It was too late. *The Hammer of Witches* had already became a runaway bestseller and a license to hunt and kill witches.

According to Webster's New Collegiate Dictionary, the abridged definition of pornography is: *the depiction of erotic behavior (as in pictures or writing) intended to cause sexual excitement*. The problem with pornography, by its very definition (as the courts have found) is that it is often referred to as obscenity, which is a radically different thing than pornography. *Obscene*, (a word, coincidentally, I believe, coined by Shakespeare) is something that Webster's defines as: *Repulsive and grossly offensive to the accepted standards of decency and modesty in a civilized society*.

*The Hammer of Witches* is obscene. In fact, it's the most obscene thing ever created by man. Heinrich Kramer writes: *All witchcraft comes from carnal lust, which is in women insatiable*. Inquisitors loved the satanic-snuff-bible and utilized it to target

women that they could not control or simply wanted to rape, torture, or exterminate. Dan Brown pays particular attention to the *Hammer of Witches* and points out in the *DVC*: "Those deemed 'witches' by the Church included all female scholars, priestesses, gypsies, mystics, nature lovers, herb gatherers, and any women suspiciously attuned to the natural world." It was very easy to label your wife, or your neighbors' wife, a witch, a bitch, or a stinking-ass lunatic and be rid of them. According to the *DVC*, "During three hundred years of witch hunts, the Church burned at the stake an astounding five *million* women." Whether the figure is accurate or not, a lot of *questionable women* were hideously shaved, branded, slashed, smashed, strangled and burned to a crisp because of a religious book. One of the many topics of *The Hammer of Witches* was the sexual rituals of witches, with elaborate descriptions of Lucifer's triple-headed-cock. (I'll spare the details.) If that isn't obscene, then the sky is falling.

In sum, the mass production of fanatical religious books, pamphlets, tracts and treaties gave men access to ideologies that were inconceivable, such as the concept of women having sex with the Devil. Two writers in particular capitalized on the religious madness of the day and the power of the printing press. McLuhan pays particular attention to Pietro Aretino, and points out in his *Gutenberg Galaxy*: *Aretino had been the first to seize the vernacular as the mass medium which print had made it.* Luther was the second writer to seize the vernacular as the mass medium which print had made it. Both writers would emerge as the most powerful voices of the period. Both writers, depending on how you interpret their writings, represent the most sacred and profane elements of European society during the Renaissance and the Reformation: Two diametrical forces that shaped the collective mind of the European *human*. There is a particularly powerful line in *The Merchant of Venice* that crystallized the Reformation:

> *The devil can quote scripture for his purpose.*

> (1.3.98)

The Reformation's central tenet was that the Roman Catholic Church was, albeit disguised in clerical garb, the devil quoting scripture. The Catholic Church's position was exactly the same. The Church maintained that the Reformers were

the real devils, and like the devil, they could also quote scripture for their purpose. It is fascinating to trace the development of this very diabolical argument. Ironically, both sides were right and both sides were wrong; because no matter how you twist the argument, there is something radically evil when religious men condone torture and murder in the name of Almighty God and Holy Scripture.

Luther would become the most dangerous reformer to change European civilization with the advent of the printing press. Numerous biographers of Luther point out that his vehement hatred of the Jews laid the cornerstone for Hitler and the Holocaust (it's no secret, Hitler idolized him). Although Luther began his career as a theologian first and foremost as a defender of the Jews, he later reversed his position when they refused to convert to his cause. The maniacal German monk would cultivate a vehement hatred for Jews, Catholics, Turks, Anabaptists, witches, bitches, pagans, sluts and any other religion, lifestyle or philosophy that disagreed with him and by so doing, he helped spread a satanic (adverse) state of consciousness across the European peninsula.

Today Luther is revered as one of the greatest evangelical writers on earth, and Aretino is virtually unknown. Ironically, both men were champions of the Bible and sex. Aretino utilized pornography to preach the Gospel. Luther used the Gospel to propound that God loved the sex act… denounced clerical celibacy, encouraged polygamy (Solomon had 700 wives) and demanded that the progeny of Eve screw their brains out making babies.

In 1521 Luther translated the Greek New Testament into vernacular German, and from that point on, man (in plural context) was able to interpret Scripture, any way he liked, and by doing so, challenged the very foundation of the sacrosanct Roman Catholic Church and clergy (not to mention, ironically, Martin Luther's own movement). The Church maintained a stranglehold on the divine right to interpret Scripture; anyone that dared to interpret the Bible and publish their interpretations without the Pope's approval was looking at a death sentence (maybe that makes me a Lutheran).

Luther, no doubt, was an amazing man, a heroic figure in every sense of the word; his only sin was that he loved to condemn and judge others (most preachers usually do). Be that as it may, the fearless German monk inspired other radical theologians such as Ulrich Zwingli, Philipp Melanchthon, John Calvin,

Martin Bucer and others to challenge the spiritual authority of papal Rome. These amazing reformers decided to interpret the Bible for themselves, and all of them interpreted the Bible differently. Many of the reformers utilized the printing press like a weapon of mass destruction to produce inflammatory religious works in order to convert, enlighten and incite the masses to wage war with the Antichrist Roman Catholics (as they were defined), specifically "The Prince of Hell," as Luther audaciously referred to Pope Leo X. In sum, a single German monk ignited a religious war in Germany that will lead us to our catastrophic climax.

# 16

## *Let's Get Ready to Rummmble!*

*Power is the ultimate aphrodisiac.*

—Henry Kissinger

During the Middle Ages, the peninsula of Italy was divided into two separate political parties known as Guelfs and Ghibellines. According to Webster's Dictionary:

> Guelf: *a member of a papal and political party in medieval Italy that opposed the authority of the German Emperors in Italy.*

> Ghibelline: *a member of an aristocratic political party in medieval Italy supporting the authority of the German Emperors from the 12th to the 15th centuries.*

In a nutshell, the Guelfs maintained that the Pope was the temporal ruler of the world. The Ghibellines maintained that it was the Holy Roman Emperor. The problem is the Guelfs maintained that it was God who gave the Pope his omniscient powers—powers that superseded even those of a Holy Roman Emperor. Let me put it this way: A Pope represented God. Period. An Emperor was an

employee of the Pope in charge of the military affairs of the Papacy; hence, the term Holy Roman Empire (or as the Germans refer to it: *Reich*).

In 1302, the nefarious racketeer Pope Boniface VIII demonstrated these powers by passing a papal bull known as *Unam Sanctum*, which gave to him the power to institute and judge emperors, as well as any other being on earth, and claim their property whenever he felt like. The Church versus Empire argument is traced back to Charlemagne the Great after he conquered Western Europe in the name of Christ and was crowned as the world's first Holy Roman Emperor in 800 AD by Pope Leo III. The problem throughout history is that Charlemagne's successors, a slew of German and French kings, inherited his title, as well as his hereditary claims on various states in Italy. Many Italian noblemen were by Imperial investiture vassals to the reigning Holy Roman Emperor. This meant that an emperor had the legitimate right to challenge any pope who tried to claim their Italian territories. And for centuries emperors and popes fought to decide which of them should be the temporal ruler of the world.

Fast forward: during the fifteenth century, the German emperors had basically lost their claims in Italy and the Ghibellines were a distant memory of the past (much as our American Confederate ideology is a distant memory of the past), but history has that uncanny ability to repeat itself and the Ghibellines would rise up from the dead with a vengeance. Prior to this resurrection in the sixteenth century, the five independent super-states that comprised Italy (Florence, Papal Rome, Milan, Venice, and the kingdom of Naples) independently controlled a series of smaller states and each state maintained remnants of their past Guelf and Ghibelline partisan ideologies. The Italians vehemently hated the Germans, Spanish, and the French and wanted nothing more than to be a sovereign nation—but the ruling Italian popes, cardinals, dukes, and warlords equally hated each other. They were treacherous, paranoid, power-crazed individuals who would easily kill members of their own family and race (like psychotic Roman emperors) as easily as they would kill a foreigner in their quest to remain independent rulers. In sum, the Italians refused to unify as a nation. Because of this dissension and political disparity among the five Italian super-states, the Germans, Spanish, and French were able to control and "culturally rape" much of the Italian peninsula with impunity. Now that we have a basic understanding of

the emerging political climate in Italy and we've been introduced to many of the major players of the Italian Renaissance: the popes, the warlords, the painters, the preachers, the prostitutes, the writers and so on. Now we'll meet the two men who would determine the destiny of all of them.

The first is a twenty-year-old, sex fiend, power crazed French prince with a large nose and perpetual smirk on his face by the name of Francois d' Angouleme (I suggest googling Jean Clouet's wicked portrait of him.) On January 1, 1515, Francois was crowned King of France in the Cathedral of Reims and was known thereafter as King Francis I. His royal maxim was: "Nutrisco et extinguo" ("I nourish [the good] and extinguish [the bad].") Francis's majestic emblem was a salamander engulfed in flames (according to ancient bestiary lore, the frigid salamander was able to endure any fire and extinguish any flame with its legendary coldness). Francis I had lofty ambitions; as the inheritor of the vast Valois dynasty, his primary ambition was Italy: He wanted it, and everything it contained. The French king hijacked Italian culture by the boatload: artists, whores, slaves, bronzes, jewelry, paintings, tapestries, weaponry, cutlery, wine, wheels of cheese, books, statues, coins (basically anything of value he took)—and there was nothing the Italians could do about it, except, what they did best, plot vendetta. The year Francis I assumed the throne of France he would storm into Italy like Hannibal the Conqueror and reclaim Milan, which was considered a French territory dating back to Valentina Visconti, whose grandson was Francis's uncle, the preceding king, Louis XII. Will Durant points out: "Nothing remained of his [Louis XII] once extensive Italian empire except a precarious foothold in Genoa. But Francis I proposed to recapture it all."

It was on the outskirts of Milan that the bloodiest military engagement of the Italian Renaissance took place: The Battle of Marignano (September 13-15, 1515). Francis, commanding a massive militia with the finest artillery division in the world, augmented by a large division of German *Landsknechts* (German for *land-servants*, considered the most savage mercenary force in Europe) managed to sneak down an impossibly narrow Alpine pass with heavy weaponry, duplicating the successful penetration of Italy 1700 years earlier by the Carthaginian Hannibal and his behemoth elephants. At the town of Villafranca, the French initiated a surprise attack on the Italians and managed to capture the lead papal general,

113

Prospero Colonna (—while he was having dinner no less) and took him and his men hostage. With the Italians compromised, Francis was able to bribe the pope's Swiss mercenary force stationed at Marignano, ten miles southeast of Milan, to abandon their cause. The other contingent of Swiss mercenaries to the north, nominally led by Duke Massimiliano Sforza, numbering some twenty thousand men, refused to be compromised. A ferocious battle ensued, but in the end Francis was triumphant. Sforza surrendered, and Francis's reputation as a warrior king was etched in steel forever. Francis would write to his infamous mother, Louise of Savoy, of the event:

> *There has not been so fierce and cruel a battle in the last 2000 years.*

After defeating the once invincible Swiss mercenary army, Francis I was now the uncontested master of Northern Italy. Leo X was, in essence, powerless, and the ominous threat of a massive French invasion on Florence played heavily on his mind—and that's when Francis made a power-play against the pope.

The two rulers met in secret in Bologna. According to Will Durant, "The agreements made at this meeting have remained secret to this day." Francis, accompanied by Leonardo da Vinci (who he hijacked from the Milanese and brought back to France like a precious game trophy), persuaded Leo to sanction his hereditary claim on Milan. He could be very persuasive (and he had plenty of confiscated Milanese gold bullion to induce the always cash-strapped pope to see things his way). With his army decimated, Leo signed an alliance with Francis, with the stipulation that he forgo Naples and leave Italy. With Milan firmly secured by his forces, Francis agreed and returned to Paris triumphant. In another part of the continent, a slightly mad, sixteen-year-old Flemish prince with a pronounced lower jaw by the name of Charles of Castile was shortly about to be crowned the King of Spain and regent to the vast Hapsburg Monarchy.

On January 23, 1516, at the Cathedral of Saint Gudole in Brussels, the young prince Charles, dressed in black (think Harry Potter) was escorted by a train of knights to the altar of the cathedral, where he accepted a consecrated dagger from the bishop of Badajoz. He was then made to prostrate himself on

the floor into the shape of a cross before the high altar. The bishop recited a liturgy in Latin, sprinkled Holy Water from Jerusalem over his body, and the prostrate prince rose like the dead. The bishop then placed a jeweled crown on top of his head, and the boy-king placed his hand on a Bible (soaked with the blood of Stephen the Martyr), and swore an oath to protect the Roman Catholic Church and defend the most Holy Roman Empire. The young monarch then turned toward the Gothic cross above the ornate altar and raised his shining chrome blade to the heavens. The cathedral erupted, trumpets blared, and the air vibrated with the roar of thousands heralding in unison:

*Long Live the King!*

The teenager was hence proclaimed Charles I, King of Spain, which included the kingdom of Naples and Sicily, Sardinia, and soon the kingdom of the Americas. Charles's emblem was the double Hapsburg eagle. His royal motto was *Plus Ultra*, meaning: *Beyond the meaning of beyond.*

The stage was now set for a battle royale, as Charles and Francis would fight over the Italian peninsula like crazed pit-bulls over a bitch in heat. In the background loomed Henry VIII. And in true English fashion, he would play both kings like French fiddles. Each of them, throughout their long reigns, continually sought his allegiance and persuaded him with assorted bribes and favors to stay out of Italy and their business, and for the most part, he did. Meanwhile, lurking in the shadows was the ferocious Sultan of Turkey, Selim I, sharpening his scimitar and waiting for the perfect moment to strike—ironically, with the same objective of conquering Italy.

# 17

## *Gluteus Maximus*

*On the whole history tends to be rather poor fiction—except at its best.*

—Gore Vidal

Shortly after Charles was made King of Spain, Sultan Selim I would get things rolling by invading the Middle East. In Venice, something equally stupendous occurred. Daniel Bomberg, a wealthy Christian from Antwerp, arrived in Venice (at that time the publishing capital of the world) with the intention of setting up a Hebrew printing press. Imagine the chutzpah! Bomberg wanted to publish Hebrew books in a time when Jews were persecuted as Christ killers and minions of Satan. Regardless, Bomberg saw a lucrative business opportunity. There was one catch: He needed the official imprimatur of a pope to begin printing. In this case, luckily, the pope was Leo X, and he duly granted Bomberg his coveted imprimatur; and because he did, Bomberg became the most important commercial printer of Hebrew literature in the history of Judaism.

At the same time as Bomberg's arrival in Venice, some disenchanted cardinals in Rome began to speak out (*sotte voce*, of course) against Leo X. One of them, a young Sienese dandy by the name of Alfonso Petrucci, was actually bent on killing the Medici Pope. That's when an eccentric, Venetian surgeon/part-time assassin by the name of Battista Vercelli enters the picture. Leo was complaining

about a large fistula on his ass when Cardinal Petrucci informed him that he had just the right specialist who could alleviate his rectal condition. Leo was game. And that's when Petrucci sent Vercelli to kill him. The surgeon was supposed to operate on Leo's anal fistula, and then administer a slow-acting poison into his rectum.

I can imagine the scene: Vercelli nervously twitching, beads of sweat glistening from his forehead as he examines Leo's corpulent wart-covered ass while Aretino, the papal court jester, cracking one of his famous jokes, causing Leo to convulse and let loose a thunderous fart into the doctor's face. Maybe Vercelli didn't laugh, maybe he took offense; maybe his reaction gave him away because something did. The end result was that he was exposed and charged with attempting to administer a lethal poison into the pontiff's sanctified ass. Naturally, Leo had him hanged, drawn and quartered, and then had Petrucci strangled by Roland the Moor (his Muslim executioner) for recommending him. The other cardinals involved in the plot maintained ignorance and begged the pontiff for Christian mercy. The munificent Leo decided to pardon them, but not before he made each of them pay exorbitant ransoms for their lives (with Leo, the Papacy was strictly a business, albeit God's; plus, if he found out that the cardinals were lying to him he could always have them executed for treason later on).

If Battista Vercelli had succeeded in poisoning Leo, it would have been a very sad day for the Jews. It's virtually certain that under a different pope Bomberg would have never received the coveted imprimatur that allowed him to print Hebrew religious books. (A papal bull signed in 1243 prohibited such freedom of the press.) The logic was simple: Without books, the Christ-killers would lose their heritage. But Leo X was no ordinary pope; like his father, he was a Jew lover; and as such, he circumvented the papal bull. Because of Leo, Bomberg was able to print the first European rabbinical Bible and the first edition of the Talmud, which is utterly astonishing—a miracle, when you think about it. I say this because not only did Leo help Bomberg, he also encouraged other Jews, such as the great Rabbi Elijah Levita, to teach Hebrew at the famed Sapienza (Rome's university). He also gave the reb Gershom Soncino his imprimatur, and more importantly, his blessing to create a Hebrew press in Rimini. The State of Israel should erect a monument to Leo.

Another colossal *mitzvah* Leo did was save the great Jew-loving, German scholar Johann Reuchlin's ass. Reuchlin was an iconic humanist figure in Germany and had originally studied the Kabbalah at the Platonic Academy in Florence with the Medici crew. Reuchlin's work on Judaic studies, specifically the Kabbalah, caused a major scandal with the head Dominican monk and inquisitor in Cologne, Jacob van Hoogstraten—a staunch anti-Semite who wanted to have Reuchlin burned at the stake along with his Jewish books. In 1514, the demonically possessed Hoogstraten ordered the Kabbalah scholar to appear before an Inquisition court in Mainz on charges of favoring the Jews and promoting heresy. Reuchlin wisely fled to Rome and asked Leo if he would intercede on his behalf and defend him. Leo studied the case, made some revisions, and referred the matter back to the bishops of Germany, who exonerated Reuchlin of all charges. Van Hoogstraten appealed the decision; finally the matter was resolved at the Lateran Council of 1517, in favor of Reuchlin—a momentary triumph for Judaism.

On January 12, 1519, Charles I grandfather, Emperor Maximilian I, died in his sleep, and Charles (think Harry Potter) assumed his position as the supreme ruler of the vast Hapsburg dynasty. Thereafter, Charles I was known as King Charles V. The coveted throne of the Holy Roman Emperor was now vacant, and, by German law, a successor had to be chosen by election. Meanwhile, in Wittenberg, Martin Luther was writing the most volatile political treatise of the sixteenth century: *An Address to the Christian Nobility of the German Nation Concerning the Reform of the Christian Estate*. The *Address* was an appeal to the German aristocracy to break with Rome and extirpate the "foreign tyranny of the Papacy." The German nobility loved the idea and Luther now had a very powerful fan base backing him.

There were three primary candidates in line for the Holy Roman Emperor's title: Francis I, who was foaming at the mouth, trying to buy the title with his vast fortune; Henry VIII of England, who showed moderate enthusiasm; and, of course, Maximilian's grandson, Charles V, who maintained an unlimited line of credit with the famous Augsburg banking house of Fugger, and was determined to buy the crown at any cost. For the moment, Leo X was backing Francis I, and he tried to intercede on his behalf to secure the crown for him; not because he particularly liked him, he actually despised him because he raped Italy like it

was a piece of ass; but compared to Charles, Francis was the lesser of two evils. According to Leo, no man, much less Charles—a spoiled teenager whose mother *Juana la loca* was certifiably insane—should have so much power.

On October 23, 1520, in "bad grace," Leo concurred with the electors decision and accepted Charles as the new Holy Roman Emperor (after Charles managed to out bribe Francis for the title), which ultimately would have disastrous results for the Italians, the French, and the Jews.

Charles took his job very seriously. There was to be only one religion in his realm. As the newly elected Holy Roman Emperor, his first course of action was to ensure religious stability in Germany, which meant silencing Reuchlin and stopping Luther, who threatened to convert Germany, a federation of states ruled by feudal princes, into a sovereign religious state. Reuchlin was easy. His case was reopened, and he was finally silenced, luckily with his life spared. Luther was another story altogether. On January 3, 1521, Leo X officially excommunicated "the wild boar from his vineyard," as he referred to Luther, and sentenced him to eternal damnation. Luther reciprocated by publicly burning the excommunication order in Wittenberg.

In April, 1521, with pressure from the Vatican, Charles summoned Luther by Imperial decree to the city of Worms for a showdown at the famous "Diet of Worms." Luther arrived at Worms (pronounced *Vurmz*) on April 16 and was escorted by a troop of armed bodyguards through a gauntlet of jubilant drunken fans. Thousands had come to party and cheer him on. A small group of Roman Catholics screamed for his execution as he was led to his lodgings. The situation was intense. It was the Mega Event of the millennium: *Luther versus the Prince of Hell*. One eyewitness reported that many people in attendance at Worms appeared to be in a state of frenzy. A congregation of cum-loving German nuns screamed out and frantically tried to touch Luther and kiss his hand. The intrepid monk "with his demonic eyes" knew the Lord was with him. Or was it Satan? Either way, they both had ringside seats. The next day, Luther was escorted into a large hall where the young Emperor sat on his throne with a scepter in his hand. Both men were surrounded by a delegation of German princes, Spanish noblemen, angry Catholic bishops, deadly Dominican monks, and cunning Fugger bankers looking to capitalize on the situation. Word spread that if Luther was harmed,

there would be an armed uprising. Charles realized he was now in a rather precarious situation. Drunken Germans with guns and alcohol—well, you get the picture. The krauts, specifically many of the powerful feudal princes who no longer wanted to pay taxes to papists, worshipped Luther. Charles knew this. He also knew the danger of subverting his own faith.

The court was called into session. The chief prosecutor, Doctor Johann von Eck, began the trial by introducing a stack of Luther's books as evidence of heresy. He then asked Luther if they were his books, and whether he cared to denounce any of them. A clean-shaven, thirty-seven-year-old Luther, wearing his dusty Augustinian habit, was about to answer, when his lawyer, Jerome Schurf, interjected, requesting that the titles of the books be read out in open court. Luther waited for the last title to resonate: *Address to the Christian Nobility of the German Nation* (quite possibly his greatest work), and then he addressed the court. Speaking first in German and then Latin, Luther stated that the books were his, but to the second question, he requested some time to consider whether he would recant any of them. Von Eck granted him a day.

Meanwhile the crowd continued to grow. Will Durant: "Back at his lodging, Luther received a message from Ulrich von Hutten beseeching him to stand fast; and several members of the Diet came privately to encourage him." Luther returned to court the next day and held his ground. Once again, Von Eck asked him: "Do you? Or do you not renounce your books and the errors they contain?" Luther diverted the question and tried to justify his work by going off on a tirade against the Papacy. The Emperor ordered the defiant monk to be silent. That's when Luther made his famous declaration to the court: "Since your Majesty and your lordships demand a simple reply, I will answer without distinction....My conscience is captive to the word of God. I cannot and I will not recant anything, for to go against my conscience is neither right nor safe. God help me. Amen." At that point, Charles was ready to burn Luther in the courtroom, but instead he wisely convened the proceedings to weigh his options.

Technically, what Luther did was place Charles on trial. The Emperor was now torn between the allegiance of the powerful German princes (pro-Luther) and Leo X, a.k.a. *the Prince of Hell* and his Catholic bishops who were skinning the Germans alive with rapacious property and income taxation not to mention the

rampant sales of indulgences. Charles had to make a critical decision regarding his own Roman Catholic faith—a faith he zealously maintained upon an oath and a dagger, a faith that Luther publicly mocked as a front for an organized crime network. Vastly outnumbered, and with no resolution in sight, the calculating king wisely spared Luther's life. That's the good news. The bad news is he ordered all of Luther's writings burned. And then he branded him a heretic and an outlaw of the Empire (a nice way of pronouncing a death sentence).

Luther was dismissed with a guarantee of safe conduct and began his long journey back to Wittenberg. And then, to Charles's utter astonishment, his uncle, the immensely powerful elector, Prince Frederick the Wise of Saxony, Luther's most ardent supporter, arranged to have the German Hercules secretly kidnapped in order to keep him safe from the zealous bands of bounty hunters and deadly inquisitors determined on silencing him. On May 6 soldiers disguised as highwaymen intercepted Luther on his way back to Wittenberg and whisked him away to a mountain castle at Wartburg in Thurnigia. Thereafter Luther grew a beard, changed his name to Junker Jorge, and lived incognito under the powerful elector's protection.

It was at this famous castle in Wartburg that Luther had his legendary sit-down with Satan. After meeting with "the man of wealth and taste," the fearless monk decided to translate the New Testament into the vernacular German, which had a tremendous impact on the German language and culture. Luther stated in his writings that Satan would visit him on a regular basis at Wartburg. He further stated in his writings that the Prince of Darkness chose to periodically reside inside his colon (which would explain Luther's legendary bouts with hemorrhoids, constipation, and his fixation with feces). Let's put Satan aside. Trust me; he will return. Frederick the Wise basically made Luther untouchable, and he was therefore able to continue to preach and write fire-laden scatological invectives, inspired by the Devil himself, against the Papacy, violating the Emperor's orders, further fueling the religious insanity that would overwhelm the European continent and lead to the most heinous massacre of the Italian Renaissance.

# 18

# *The Great Devil*

*The Prince of Darkness is a gentleman.*

—Shakespeare

While Leo X was literally protecting his ass and helping promote Jewish literature, Pietro Aretino developed an amazing friendship with his notorious cousin, known the world over as the illustrious *Giovanni dalle Bande Nere* (*John of the Black Flag*), a name he adopted after Leo died. Before this, he was simply known as *il Grande Diavolo* (*the Great Devil*), or *la figlia de putana* (*the son of a bitch-whore*).

Giovanni de' Medici was the most feared warlord in Italy. Before I say another word about him, I must say that the most fascinating thing about him was his mother, the Countess of Forli, Caterina Sforza (1463-1509). Alexander VI, the "devil pope," called her, "the daughter of iniquity," and for good reason—she loved men almost as much as she loved killing them. In fact, the Spanish pope was on her hit list. When Caterina learned of the pope's design on her kingdom of Forli (the birthplace of Mussolini) she attempted to pre-empt the attack by arranging to have him poisoned. The plot was foiled and Cesare Borgia set out for Forli with a vengeance. When he arrived with his killer militia he commanded Caterina to surrender her citadel or die. Caterina answered Cesare's command in classic Sforza style and screamed something in the vein of: *Mangia la fissa de tua*

*putana madre*. Cesare was stunned, not that his mother wasn't a whore (she was), but because he never anticipated that a mere woman would hamper his Emilia Romagna campaign because she refused to surrender to him. She ultimately did, but only because the explosive charge she set off to destroy her castle (with her in it) failed to explode. Then, and only then, was she finally captured. Cesare, duly impressed, instead of killing her outright, made her his prisoner and raped her for good measure. He then sent her off to the dungeon of Castle Sant' Angelo where she languished until she was finally released through the efforts of her powerful family's political connections.

Okay, now that we know a little about Caterina Sforza, we can address her equally amazing homicidal son, who is said to have committed his first murder at the age of twelve. The first thing I need to address about Giovanni is that his father (Caterina's third husband), Giovanni di Pierfrancesco de' Medici Sr. came from a junior branch of the Medici family tree. Giovanni's powerful cousin, Cardinal Giulio de' Medici despised Caterina because her first husband was the notorious Cardinal Giralamo Riario, a key member in the "Pazzi Conspiracy" and directly responsible for the murder of Giulio's father in front of the High Altar in the cathedral of Santa Maria del Fiore during the Elevation of the Host. In 1488, Riario was butchered to death by his own men during a dispute over money. Caterina hunted the killers down and personally killed them, their allies and their families, and then burned their houses to the ground to set an example: No one messes with the Sforza family without grave consequences. Giulio was afraid of Giovanni, because, quite frankly, like his mother, he was a homicidal maniac.

Leo was another story; he loved Giovanni (who by the way, had an uncanny resemblance to the actor Joe Pesci) and saw a talented Medici warlord in the making (a talent he inherited from his mother and the warrior Sforza bloodline), and gave him command of his first cavalry troop at the age of seventeen. Giovanni's rise as Leo's enforcer was tremendously rapid. By the time he reached his twenty-first birthday he had fought fearlessly in over a dozen battles for the Papacy, and was never defeated. Giovanni set a precedent by changing the way the Italians fought. For starters, the Medici madman introduced guerilla warfare to the Italian infantry and the swift Arab Barb to the Italian cavalry. Giovanni did not believe in fighting wars the old fashioned way with heavy body armor and linear battle

confrontations. He stripped his men and horses of unnecessary armor in order to increase their speed and mobility. Stealth and espionage were everything and it made him, as Machiavelli articulated, seemingly *invincibile* in battle.

Aretino met Giovanni on Leo's watch and the two men bonded together like the biblical warriors Jonathan and David. They made quite a team, riding through the streets of Rome with Giovanni's train of henchmen in tow (warriors like Paolo Luzzasco, Cesare Rangoni, Annibale Naldi, Lucantonio Rimini, Cecchino Cellini and Francesco Ferrucci, among other notable soldiers of fortune), striking an image of fear and awe like conquering conquistadors, which enhanced Aretino's reputation immensely. The two hot-blooded Italians attended the grandest parties and savored the finest luxuries Rome had to offer. With Giovanni and his cousin Leo at his side, Aretino's star would continue to rise, all because of a lucky elephant.

In October 1521, Leo X broke his allegiance with Francis I and formed a Holy League with Charles V and they chased the French out of Lombardy. Upon learning that Milan was no longer a French possession, the Happy Pope went into a state of ecstasy, which rapidly turned into pneumonia.

On December 1, 1521, Leo X passed away in the Vatican. He was forty-six-years-old. The news of his untimely death hit Rome like a massive earthquake (a rumor spread that Francis I had him poisoned). The city was shocked and paralyzed; never before and never again would a pontiff do so much for so many. Thousands of mourners gathered in St. Peter's Square upon news of his untimely death. Many were seen weeping on their knees as they waited for their turn to kiss Leo's pontifical feet, which were left protruding from the grille of the mortuary chariot as it was led to the Sistine Chapel.

I wonder what Leo's last moments were like as his life passed before him. Were his famous Jewish doctors by his side? Maybe Jacob ben Emmanuel? Was he taking his pulse? Were Leo's last moments experienced as a Roman Catholic, a Jew, or a pagan? Or was it the best of all worlds? I imagine the pontiff's great body lying on a velvet-draped catafalque positioned in the center of the Sistine Chapel flanked by glowing tapers. I envision the Swiss Guard glistening in their distinct blue and gold uniforms (the colors of the Della Rovere family; Leo later added the Medici red) standing at *attenzione* by the pope's sanctified

corpse as the crème de la crème of Italy came out to render homage to a papal Maecenas.

In attendance for the funeral were Aretino and the Great Devil Giovanni, with his deadly band of mercenaries dressed in solemn black… the stunning Marchesa Victoria Colonna in her solemn mourning gown and lace mantilla… Count Baldassare Castiglione (Leo's confidante) leading an endless train of aristocrats and noblemen past the phenomenal pontiff's body. Trailing behind the Italians was Leo's beloved musician, Jacopo di San Secondo, leading a quorum of rabbis whispering the *kaddish* to a man who helped save their sacred literary heritage. The Basilica's five organs bellowed like bull elephants—and then stark dead *silenzio*. It was *finito*. The Happy Pope was buried along with the best part of the Italian Renaissance.

# Part IV

# 19

## The Chameleon

*We declare, say, define, and pronounce that it is absolutely necessary for salvation that every human creature be subject to the Roman Pontiff.*

—Pope Boniface VIII

After Leo X was interred in the Vatican, the cardinals convened a conclave to elect a new pope, and everyone in Rome believed that Leo's cousin and right-hand man, Cardinal Giulio de' Medici, the bastard child of Giuliano de' Medici slaughtered in the Pazzi Conspiracy, would be elected by the College of Cardinals as the next pope.

Giulio de' Medici was born on May 26, 1478, and was the classic Gemini character—unpredictable. Aretino referred to him as "a Chameleon that takes its color from whatever it is touching." Cold, calculating, and capable of anything, the Romans were certain that the slick Medici cardinal would steal the election. And, of course, all the great artists, sculptors and literati in Rome wanted to believe that, as a Medici, he would have kept their positions, as well as their lucrative commissions alive; but it didn't work out quite that way. In fact, the election would become one of the strangest nominations of a pontiff in the history of the Vatican.

After a week in conclave, the cardinals were hopelessly deadlocked. The resourceful Romans, never ones to miss a gambling opportunity, gathered at St Peter's Square and set up betting tables to begin wagering on who would be the next cardinal to hold the throne of Saint Peter. Everyone bet on the Italian cardinals. According to Frederic J. Baumgartner, author of *Behind Locked Doors: A History of the Papal Elections*, "The bookmakers accepted bets on as many as twenty cardinals. Cardinal Medici had the best odds at 25 to 100." Cardinal Farnese was a close second, third came Cardinal Colonna, then Orsini….. Some bet a few coins, others small fortunes. Aretino, the consummate hustler, was doing a little bookmaking himself. Naturally he bet on Cardinal Giulio de' Medici. Aretino's biographer, Edward Hutton, pointed out:

> *He threw the immensity of his voice into the cause of his candidate and he became the first journalist of the modern world.*

Kings, queens, princes, lords, ladies, dukes, courtiers, bankers, beggars, businessmen, statesmen (in essence, everyone) wanted to know what was happening in Rome on a day-to-day basis. As such, they needed a continuous supply of information. Thus sprang forth the first organized news-gathering network in Europe, with the first primitive form of a newspaper or newsletter, called *avviso*, meaning "advice" or "public announcement". The *avvisi* (plural of *avviso*) were written by aspiring writers, known as *menanti*, the forerunners to modern-day journalists. The *menanti* gathered intelligence, ranging from the sublime to the ridiculous. There were even scouts, like modern literary agents, that hunted for the most savvy and reliable scribes and they were paid fixed salaries to continually supply their wealthy patrons with a steady stream of information. Others were free agents who sold their *avvisi* on street corners in the form of *gazetti* (or broadsheets), which everyone loved to read and paid whatever they could for the privilege.

At the Piazza Navonna in Rome stands an ancient statue from the time of the Caesars, called *Pasquino*. The statue served as a communal bulletin board (think of it like the Times Square Jumbotron). Aretino by this time was a *cause célèbre*, and, like clockwork, his writings would appear on the statue and everyone

would read them. As such, he became known as the "Master of Pasquino." The Maestro knew all of Rome's secrets; his expertise was uncovering scandals. The classic muckraker had cultivated an amazing network of spies and informants. The best in the business were the courtesans of Rome, who adored him and continually furnished him with an inexhaustible supply of inside information. He would take this *informazione*, assess it, add his own political slant, and then publish his writings on broadsheets, pamphlets, letters, or postings on the statue of *Pasquino*. There is a particular scene in Aretino's scathing political comedy *La Cortegiana* that captures the news events of his day: A news vendor stands on a crowded street corner hawking papers, calling out the latest gossip:

> *Extra, extra, read all about it! The Turkish war in Hungary, the splendid sermons of Father Martin Luther, the Council, stories, stories—Read all about it! The English Affair. The Pomp of the Pope and the Emperor, the circumcision of Valvoda, the Sack of Rome, the Siege of Florence. The Royal Wedding....Fine Stories! Fine stories! Read all about it!"*

Aretino didn't just write the news; to borrow a line from William S. Burroughs—*he made the news*. Professional scribes and up-and-coming *giornalista* followed him like the pied piper of Rome, sending editorials reporting his daily gossip column to all of the major centers of power in Europe. Aretino understood the commercial value of gossip. Will Durant points out: "In Rome, where his favorite victims lived, his writings were sold out on the day of their publication." Aretino's voice was literally heard throughout Europe, and he developed an amazing following (I believe Luther and Hutten were his biggest fans). Being that there was a pivotal election going on, the Maestro tailored his intelligence into a powerful political commentary targeting the cardinals running against Giulio de' Medici. In the interim, the frustrated cardinals were hopelessly deadlocked like prisoners in their chambers. There was internal dissension, and political futures were on the line. The cardinals were the ones with the most to gain and, more importantly, the most to lose. The very meaning of the cardinalship—the massive fortunes in the form of papal benefices along with monstrous estates and the obscene

power that came with them—was now under a proverbial microscope because of Luther. The wrong pope would spell disaster. The whole city was buzzing with excitement. Everyone was nervously waiting for the city's church bells to ring accompanied by a fusillade of cannon blasts from Castle Sant' Angelo to signal that a new pope had been elected. But the signal never came.

Something was stalling the election. Francis I had ordered the French cardinals (and any cardinal that he could bribe) to vote against Giulio de' Medici because Leo X had switched his allegiance to Charles V earlier; perhaps that's why it was taking so long. Another version of the election has it that Charles V promised Henry VIII (married to Charles's aunt, Catherine of Aragon), that he would endorse the treacherous English cardinal Thomas Wolsey. This may have also stalled the election because it would be a cold day in Hell before the cardinals (the majority of whom were Italian) would ever vote an Englishman to the throne of St. Peter.

The Vatican version of what actually happened is almost as strange as Charles endorsing Wolsey. Cardinal Giulio de' Medici decided to break the deadlock and did the unthinkable by proposing a non-Italian, an obscure sixty-three-year-old Dutch cardinal from Tortosa (a Spanish coastal city), by the name of Adrian Florisz Dedel of Utrecht, whom he had never met. Further, Adrian wasn't even in attendance for the election, because, quite frankly, he knew it that would be a cold day in Hell before he was even considered. James Cleugh, Aretino's biographer, maintains that Giulio figured that no one would vote for a non-attending cardinal, much less a draconian Dutchman with a severe reputation as the Grand Inquisitor of Spain. Let me put this way, what Giulio de' Medici did was the equivalent of nominating a Turk to the throne of St. Peter. Most of the cardinals were corrupt and all of them would be scrutinized by someone as severe as Adrian. Some of them might even be excommunicated or worse, the Church, God forbid, might be reformed if an austere, by-the-book pope were ever elected. It was a bold Medici move that would send shock waves through the Vatican.

According to Cleugh, Giulio figured he could intimidate the opposing cardinals and force the majority of them to accept the lesser of two evils; thereby he, being the favorite (or one of his allies) would win the election. It should have

worked, considering that there were only thirty-nine cardinals involved in this particular conclave. I forgot to mention that after Cardinal Petrucci tried to have Leo X poisoned in 1517 and Leo had him strangled like Luca Brasi, the perspicacious pontiff made the unprecedented move of nominating, in one day, thirty-one new cardinals. Each carefully handpicked by him as a Medici ally to absolutely ensure that the Papacy went to his cousin Giulio, in the event that he should accidentally die from an arsenic enema. Something definitely wasn't kosher. Adrian, coincidentally, was Charles's childhood tutor, personal confidante, and the omnipotent regent of Spain. If Adrian became the new pope, Charles basically could control the Papacy, something he desperately wanted and needed to do.

Giulio's nickname wasn't *Chameleon* for nothing, since he was no longer in good standing with Francis I. Maybe he threw the election because Charles bribed him with an outrageous fortune—that is, if he got his man Adrian elected. It's conceivable, and not the first time a cardinal would gain the papal tiara through bribery. Or maybe the real reason was Luther. Charles and Giulio were brilliant statesmen, and each man knew that the Church was spiraling out of control because of corruption. Both men were on the same page when it came to Luther. The only way of fixing the situation with the German Hercules who was spearheading the Reformation, would be to ostensibly reform the Church with a pious, by-the-book pope. Technically, Luther wasn't against the Papacy (at least, not at first); he was against corruption within the papal court. The only way Luther would ever reevaluate his position with Rome would be if something drastic happened within the Holy See—something as drastic as Adrian, who could reform the Church. Giulio, the way I see it, threw the election for Charles.

On January 9, 1522, a massive crowd gathered in St. Peter's Square to hear the papal nomination announced on the balcony of the Apostolic Palace. When the Romans heard that a Dutch cardinal (who didn't even show up for the election) was now the new pope in Rome, the crowd went wild. Pandemonium broke out in the streets. Many Romans lost fortunes betting on the Italian cardinals who sold them out to a foreigner and now the crowd wanted blood, screaming out to the cardinals on the balcony: "Traitors!" The Roman poet Telbaldeo captured the seismic moment as the terrified cardinals stood in silence:

> *Like ghosts from limbo, so white and distraught were their faces, almost all repent already of having chosen a stranger, a barbarian and a tutor of the Emperor.*

In utter disbelief, Aretino began writing vicious diatribes against the cardinals, ordering them "buried alive" and then he brazenly went after the "drunken janitor pope" (as he aptly referred to Adrian, because he was supposed to clean up the Vatican); his wrath knew no bounds. Bad move. Adrian despised men like Aretino and when he found out that the fearless journalist was flaming him, he ordered his immediate arrest, forcing Aretino to flee Rome for Bologna, where he monitored the situation from a distance.

Adrian was Rome's worst nightmare. In his first speech to the cardinals, he informed them that he would eradicate corruption in the Church and clean up the Papacy. He immediately began by dismantling Leo's papal empire. Thousands lost their livelihoods and purpose in life with the stroke of his pen, especially the artists. The puritanical Pope ended the sale of indulgences, outlawed gambling and prostitution, and even suggested whitewashing Michelangelo's *Sistine Chapel* because he felt it was obscene. Then he tried to gag Rome by ordering the famous statue of *Pasquino* destroyed, but wisely changed his mind after his advisors pleaded with him not to as it might incite a riot. Literally, the Romans might burn the Vatican down if they knew it would rid them of him. The cardinals behind the scenes laughed. The supreme masters of deceit began wagering among themselves: How long would this *figlia de putana* last? The odds were *he wouldn't last a year.*

Aretino further distanced himself as word spread that Adrian wanted his head. Instinctively he headed north to the sanctuary of Florence, where the Chameleon had recently taken up residence and his former position of power at the helm of the Florentine government. When Aretino arrived, he begged his Eminence to stay on at his court, but Florence was far from a sanctuary for Aretino. There were papal spies everywhere, and Giulio could not accept Aretino's plea for safe haven without jeopardizing his own position with the new pope. He had to get rid of Aretino, and fast; so the Chameleon did the next best thing: He sent him to Mantua, to the court of the celebrated warlord-literary critic Federico Gonzaga II, and that's when things started to get really interesting.

# 20

# *Christ's Blood*

*The story is extant, and writ in choice Italian.*

—Shakespeare

*The Da Vinci Code* is based on the Holy Grail. Anyone who has had the distinct pleasure of reading Dan Brown's novel knows that every character in the story is obsessed with finding it, and yet the author Kate Simon did. Actually, let me rephrase that. Simon found what came to symbolize the Holy Grail: The "Royal Blood" (*Sang Real*) of Jesus Christ Superstar. In her thought-provoking book, *A Renaissance Tapestry,* Simon addresses the legend of Dionysius Cassius Longinus. Longinus was the Roman centurion who pierced Christ's side with his lance while the King of kings was nailed to the cross and collected His blood in a vial. Longinus was ultimately cursed to wander the earth for the rest of his life, and somehow amazingly landed in Mantua in a temple dedicated to the pagan goddess Diana. Simon writes:

> *Early Christianity replaced the temple with a hospice, which sheltered Longinus after his long wanderings, carrying the vial of the blood of Christ he had drawn with his lance.*

When Mantua became Christian, the city converted the hospice into the Church of Sant' Andrea to house the vial of Christ's blood. The church was designed by the legendary Leon Battista Alberti (Lorenzo de' Medici's favorite architect) and is considered to be his greatest architectural achievement. Alberti writes in a letter, dated October 1470, to his patron, the Marquis Ludovico Gonzaga, regarding the interior design of the church:

> *The chief aim is to have a large space where many people can see the vial of Christ's Blood*

Simons continues:

> *That vial became the most sacred passion of Mantua and honored with an annual religious procession.*

Mantua is one of Italy's best kept secrets. The city has a rich mystical history and is the birthplace of the necromancer Virgil. In the sixteenth century Mantua was an Imperial territory situated between the states of Milan and Venice and was ruled as a feudal kingdom anciently pledged to the Holy Roman Emperor. In 1328 the Ghibelline warlord Luigi Corradi (1268-1360) became the absolute ruler of Mantua and its provinces; like most warlords, he gained the position through war, assassination, and espionage. Corradi adopted the name Gonzaga from a nearby castle in the town of Gonzaga, and the family was known thereafter as the Gonzaga. Their reign lasted until 1708, making them one of the longest running dynastic families in Europe. Unlike the other celebrated Italian dynastic families such as the Sforza, Albizzi, Medici, Pazzi, and Borgia, the Gonzaga were never conquered during the Italian Renaissance. They were innovative warlords who married their children to scions of the most powerful political families in Europe. Their genes ran deep like the roots of olive trees that were planted by their ancient Etruscan ancestors. The Gonzaga bloodline was mixed with Spanish, French, and the Royal Bavarian houses of the Hohenzollern, Wittlebach, Brandenburg, and Habsburg. The illustrious family was second only to the Medici when it came to sponsoring

groundbreaking works of art. Their ornate palaces, temples and tombs were designed and adorned with iconic masterpieces created by the most spectacular stable of artists the world will ever know: Alberti, Cellini, Correggio, Da Vinci, Donatello, Mantegna, Perugino, Pisanello, Romano, and Titian are just a few of the phenomenal Italian masters who worked for the Gonzaga family in their endless quest to immortalize themselves in oil, bronze, marble and stone.

One of Mantua's most famous citizens was the distinguished writer/007 statesman, Count Baldassare Castiglione. Castiglione was born in 1478 in the province of Mantua, and counted the most celebrated men and women of his age as intimate friends. Castiglione's wrote, *Il Libro del Cortegiano (The Book of the Courtier)*, which was considered second only to Machiavelli's *Il Principe (The Prince)* as the most important book written during the sixteenth century. First published in Italian in 1528, *The Book of the Courtier*, better known simply as *The Courtier*, became an instantaneous bestseller, and the phenomenal Italian success was repeated in more than a dozen different languages throughout the world. In 1561 Sir Thomas Hoby translated *The Courtier* into English thus providing the foundation for the English Renaissance.

*The Courtier* is based on Castiglione's service at the court of the illustrious Duke of Urbino, Guidobaldo da Montefeltro (1472-1508). The work was crafted into a series of stimulating conversations between some of the most famous figures of the Italian Renaissance, including Giuliano de' Medici, Bernardo Bibbiena, Elisabetta da Montefeltro, and the eminent poet Pietro Bembo, regarding the edification of the ideal courtier, as well as a female version of a courtier and their respective positions in court society. The discussions between the characters encompass a dazzling range of cultural subjects from fashion to statecraft. *The Courtier* became the quintessential Renaissance manual that instructed men *how* to be men and manifested as the premier philosophy of the elite military aristocracy of the Italian Renaissance. Later it acted as the blueprint for the English military aristocracy. Incidentally, Queen Elizabeth I made the book mandatory reading for all her courtiers, including Shakespeare's patron the Earl of Southampton.

Let's see what Castiglione has to say about his cousin, the stylish and very perfidious fifth Marquis of Mantua, Federico Gonzaga II (1500-1540), who he

includes as one of the amazing characters in his book (I suggest Googling Titian's arresting portrait of him holding one of his prized bitches):

> *Today in Italy you will discover certain sons of illustrious lords who may not have the power of their ancestors but make up for it in talent. The most enterprising of these young men is Federico Gonzaga, eldest son of the Marquis of Mantua. In addition to his character, family origin, education and excellent manners he shows at so tender an age to be wonderful in wit, honor, courtesy, and love of justice. From such a beginning one can only anticipate the most admirable of ends.*

Castiglione was describing his cousin at twelve; at twenty-two Federico Gonzaga II was the absolute ruler of Mantua and a totally self-absorbed, vainglorious psychopath prince capable/willing to do anything when it came to maintaining his power. He held important sociopolitical connections with the four most potent rulers/megalomaniacs in Europe: the Pope, the Emperor, King Francis I, and King Henry VIII. All of them held a deep reverence for him and all of them rode his prized Gonzaga stallions steeped in legend, which he bred and which were considered the greatest racehorses in the world. (Julio Romano would later create the world's first Mannerist building, the *Palazzo Te* as a monument to them in the form of a stable worthy of Pegasus.)

Federico was obsessed with power and he gravitated toward men who could further enhance the prestige and status of his rapidly rising court. Men like Aretino were men after his own heart. The Marquis maintained an extensive network of spies in Rome and had been following Aretino's career from the beginning. Federico, in fact, was Aretino's biggest fan and he was utterly ecstatic that a writer/publicist of his caliber (a writer already considered great) was now gracing his royal presence. In true Gonzaga fashion the enterprising Marquis honored his stellar catch with a banquet worthy of the poet-god Apollo. *Imagine*, as Shakespeare said, when he wanted to convey a particular moment. In this scene, a fantastic sculpted garden leads us inside the Gonzaga's monstrous five-hundred-room *Palazzo Ducale*. The palace is decorated in decadent opulence. Let

your mind run wild! Envision a large group of distinguished guests entering the main dining room and being greeted by members of the illustrious Gonzaga family. Listen to the sound of music provided by the world-class Gonzaga orchestra as it flows in waves through the great chamber. Feast your mind's eye on luscious slave girls serving endless trays of antipastos.

In the center of the room, atop a low throne of black velvet trimmed in gold tassel, sits the most powerful woman in Italy, the regal Gonzaga matriarch, Isabella d' Este-Gonzaga. Voyeuristically scan her silk gown embroidered in pearls and the sparkling diamonds that exemplify her well-preserved body. Smell her sweet ambrosia scent (concocted by her ingenious alchemists) as it wafts through the air. Move along and meet her libidinous ladies in waiting, the most beautiful spies in Italy. Coifed and scented, their laced chiffon bodices pushing their sumptuous breasts up and out like glistening-white-orbs of buffalo mozzarella. Their deadly counterparts, Gonzaga courtiers, join them in toasting the satanic gods of Mantua who reside in Dante's *Inferno*. Taste the moment with the mussel soup and oyster ravioli, accentuated with the shrill sounds of string vibrations. "Thus," as Shakespeare said, "with imagined wing our swift scene flies." Sink your teeth into roasted fillet of *bistecca* splashed with white truffle sauce; snatch from a plate of fine porcelain a plump porcini mushroom. Amaze yourself with the antics of Isabella's world famous dwarves as they frolic in medieval pools and Gothic fountains spattering their guests with buffoonery. Imagine the stimulating conversations between deadly, black-as-Satan characters, and some of the most gifted literary figures in Italy. Aretino writes to his step brother, Gualtiero Bacci:

> *At my table there are always great gentlemen, and in short he* [the Marquis] *could not have done more for me if I had been a mighty nobleman. As a result all his court now bows down before me, and any member of it who can even get one of my verses calls himself 'lucky.' And as fast as I can write them, the Marquis has them copied....*

Listen in as Isabella's favorite scribe, Matteo Bandello, discusses Platonic Venus-like love with his devilish patroness. Hear Master Battista Spagnoli recit-

ing a poem, bewitching the ears of a young maiden (Bandello and Spagnoli are ascribed as two important Shakespeare sources indigenous to Mantua). Move on toward the head of the table and hear the hearty laughter of a Gonzaga cardinal telling a joke to his bishop nephew. Catch Federico's diabolical uncle, the excommunicated Duke of Ferrara, Alfonso d' Este, whispering something into the ear of his sultry mistress Laura Dianti. Cut to Aretino, the idol of Mantua, seated next to the Marquis, both men lost in *conversazione*. All the room's admiring eyes focus in on them: excited sexual innuendos fill the air. At the stroke of four, the afternoon banquet ends. Everyone retires to lavish quarters in the colossal palazzo; the custom of the day was to nap and then resume at seven (as we say, in tuxedo).

That evening, after a change of costume, the lavish banquet resumes. The women come fluttering out, scintillating like new-born butterflies. Young boys and succulent slave girls fill their guest's goblets with wine and their plates with sweet-laced pastries. The conversation at the dinner table invariably turns to erotic art (Federico's favorite subject) and Aretino's friend—*that rare Italian master, Julio Romano*. At the time, Federico was completely obsessed with getting Romano to work for him, and he continually besieged his ambassador in Rome, Castiglione, to procure him for his court by any means necessary. But no matter how hard Castiglione tried, Romano politely refused the Marquis' numerous invitations and enticements. And that's because when Romano's mentor, the great Raphael Sanzio died in 1520 at the age of thirty-seven in seemingly perfect health (did Michelangelo hire a courtesan to poison him? He definitely had the motive), Romano took over his coveted position as court painter to the pope—and he was not willing to give it up (at least not yet). As the night slid by to the sound of music the decadent Marquis announced his surprise for the evening festivities: a group of scantily clad dancers were to perform a *moresca* (Moorish dance) to the sound of reverberating drums. Shrills, drinking, crystal clanging, eating, laughing, vomiting, farting, and on and on it went....

By the end of the evening, Federico asked his idol for a special favor: He wanted Aretino to somehow persuade *the rare Italian master* to come to Mantua to work for him. Aretino, the preeminent hustler, informed the Marquis that Cardinal Giulio de' Medici inherited Romano after Pope Leo X died, and the Chame-

leon would never give him up. The cunning Marquis was well aware of this and suggested something clever... some sort of *incidente* that might induce Romano to come to Mantua posthaste. Aretino listened and said he would see what he could do. He then asked the Marquis for a favor. The evening festivities came to an end and everyone retired to their lavish quarters. The Marquis sent a young dancer to attend to Aretino in his room. He was famously known for doing such things and Aretino was famously known for appreciating such favors.

As the weeks turned into months, Aretino became restless. He just couldn't seem to find himself in Mantua, maybe because the city was tiny compared to Rome, or maybe because Federico was too *aggressivo* for his taste. In any event, Aretino could never be under the thumb of any man, no matter how much they had in common. Nonetheless, necessity forced him to stay in the Virgilian paradise, hunting, writing and fornicating with the very decadent Marquis and his stable of stunning crew sluts: the most beautiful people in Mantua.

When spring came Aretino made plans to return to Florence. Federico took offense, had a tantrum, and tried to dissuade him from leaving. Aretino was insistent. The Marquis tried to stall, and explained that he had to follow bureaucratic protocol before he could release him—and that meant he would have to dispatch an envoy to speak with his Excellency, Cardinal Giulio de' Medici in Florence, regarding Aretino's vociferous request to return to that city. Word came back, (possibly fabricated by Federico to keep Aretino at his court) and it was unfavorable. Giulio's position, as well as that of his advisors, was that Aretino was trouble and not welcome in Florence. Aretino was deeply offended, and got Federico to write another letter, praising him and his immense worth to the Papacy. It was sublime how the son of a whore and a shoemaker managed to play the most powerful men in the world off each other, using their own passions and weaknesses to get what he wanted.

Ultimately, the brazen Aretino returned to Florence against Federico's wishes to confront Cardinal Giulio de' Medici, demanding an explanation. Giulio, the crafty tactician, acquiesced and duly gave his publicist his opinion on the exigent matter:

> *You must realize that I can't openly defy His Holiness* [Adrian] *orders. But I'm willing to recommend you to the protection*

*of a member of my own family, whom I believe you know the great Giovanni dalle Bande Nere. I dare say you would like to see him again.*

Aretino salivated, and off he went to meet his beloved sidekick at Reggio in the Emilia-Romagna, where *il Grande Diavolo* was doing what he did best: savoring the spoils of war. Aretino writes about his arrival in Reggio:

*Joy filled the hearts of everyone. For the young leader* [Giovanni] *had given his soldiers a night of liberty. Torches were blazing everywhere. The whores of the city had flocked to the camp in great numbers. Some of the soldiers were leaping from their horses, having just returned from a foraging expedition. Casks of wine, well-cured hams, baskets of fruit and even bleating lambs were slung across their saddles. Such provisions had cost them nothing, for they had plundered everyone for ten miles around.*

Aretino stayed with Giovanni in Reggio for several weeks, quenching his insatiable lust for life in a series of festivals, banquets and hypersexual orgies. And then the Devil, as usual, went off to fight another war, and Aretino, once more, went underground.

# 21

# *Rumor*

*Enter Rumor, painted full of tongues.*

—Shakespeare

On September 14, 1523, Adrian "the janitor pope" died in his sleep. The rumor around Rome was that his doctor poisoned him. N. Brysson Morrison, in his superb biography on Henry VIII, writes of the event:

> *The Pope died his only popular act since he became pontiff less than two years ago, and the citizens of Rome in their gratitude for his death erected a statue to his doctor.*

Did a doctor kill a pope? It wouldn't be the first time! Some historians say it never happened; others say it did. Why would the Romans erect a statue to the pontiff's physician and send lavish gifts and letters to his residence? One note stood out, proclaiming him the "liberator of Rome." Again, this is the challenge of interpreting history, notwithstanding Italians love to poison their enemies. The bottom line is the detested pope was dead, and two months later Cardinal Giulio de' Medici was elected as Pope Clement VII. The rumor (history is full of rumors) has it that he bribed various key cardinals for their ballots, whereby he

143

gained the majority vote and the throne of St. Peter. Either way, the consensus is that he bought the Papacy (at least, that's what Luther maintained).

The ever-calculating Aretino was ecstatic at the news of Giulio's victory and went to Milan to meet with Giovanni dalle Bande Nere. Both men were elated over their unbelievable luck; another Medici Pope would be a windfall, or so it seemed. Aretino had a reputation as a psychic and sensed that something wasn't kosher. Instead of running back to the Eternal City like an obsequious sycophant, he decided to do a little reconnaissance. He traveled extensively, surveying the new political landscape, listening to the street, the tavern talk and the whores' gossip. Rumors began to spread that Clement VII was going to re-ally with Francis I after Leo X broke all ties with him. Aretino's biographer, Thomas Caldecot Chubb, sheds light on the situation:

> *A fierce battle of intrigue to gain influence over Clement was now being fought in the complicated chambers of the Vatican, for like it or not, the last scion of the elder line of the Medici was prince temporal as well as prince spiritual, and the two forces which opposed each other with armies in north Italy, in Naples, in the Low Countries and along the Pyrenees, each tried to win him as their ally.*

Aretino was a master at gathering intelligence, which is just a nice way of saying that he was a spy. And he was a spy—an ingenious double-agent who worked for anyone he carefully selected who was willing to pay him for his valuable services. Charles V would later give Aretino a healthy pension, and not because he wrote sonnets. I'm not saying Aretino was spying for Charles—at least not yet. For now, Aretino made the long journey back to Rome anticipating greatness. In his mind's eye, he could see a plush cardinal robe draping his intense body, a shimmering gold crucifix embedded with Indian emeralds around his chiseled neck… beautiful servants attending his every whim….

Upon arrival in Rome he sought an appointment with H.H. Clement VII to pay him his obligatory obeisance, kiss his Fisherman ring, and offer his loyal services. Aretino was told that the pontiff was not available, and was instructed

that he would be notified when His Holiness would receive him. Days turned into weeks, and the audience he sought with the new pope never materialized, much less the coveted position he anticipated at his court as a cardinal (or at least an ambassador). Clement had turned Aretino into his own version of Shakespeare's degenerate pariah Falstaff. Now that he was Christ's ambassador on earth, maybe he thought he had to maintain the image of a sacrosanct ruler, which meant that he could not be connected to Aretino, much less his scandalous writings and escapades. This outright snubbing by Clement humiliated the great writer. Once Aretino realized he had no chance of directly getting to Clement, he began writing flattering sonnets and letters to his personal secretary (papal datary), but his efforts were rejected. Undeterred, he contacted the most famous woman in Rome, the stunning twenty-eight-year-old blond bombshell Marchesa Victoria Colonna to act as his liaison. Not even she could get past the pope's formidable watchdog, the devious twenty-seven-year-old papal datary, Gian Matteo Giberti, who just happened to be the head of the French faction in the Vatican—clearly indicating that Clement VII was going to side with Francis I, rather than Charles V.

Why would the most famous woman in Rome act as an ambassador for a radical writer? They say opposites attract; Victoria had a thing for Aretino. Were they having an affair (her husband was never around)? We'll never know; but we do know that the Maestro was playing three sides up the middle, something he was a master at. Maybe Charles sent Victoria a metaphorical e-mail telling her to help Aretino get reinstated into the Medici circle as a mole where he belonged, and where he could act as a double agent; or maybe Aretino suggested the idea to Victoria. It was no secret that the Colonnas were fervent Imperialists; Victoria was married to one of Charles most powerful generals, the Marquis of Pescara, Francesco Ferrante d'Avalos. Clearly, the powerful Colonnas were comfortable with Aretino and wanted him strategically placed where he could serve them best in the Emperor's interest. Giberti surmised what was going on behind his back and rejected the Marchesa's efforts on Aretino's behalf, and that's when things got nasty. Aretino audaciously went after Giberti, denouncing him as a "French puppet" and then he called upon the archbishop of Capua, Nicholas Schomberg (Charles German connection in the Vatican) to endorse his

position—and indeed he did. Giberti went ballistic and hissed to his secretary, Francesco Berni:

> *That lewd speaker* [Aretino] *can praise the German* [Schomberg] *but I will find a way to cut his tongue from his loud mouth.*

The natural question is: why not cut his tongue out? This is what these people did (all the time, I might add), and Giberti was, in fact, relishing the idea of having Aretino assassinated; he was just waiting for the right *momento*.

# 22

## *Kama Sutra, Italian Style*

*A standing prick has no conscience.*

—Italian proverb

Determined to destroy Aretino, the question for Giberti became, how? And that's when Aretino did the most outrageous thing in his career as a writer, which ultimately pushed Giberti over the edge and gave him the perfect excuse to have him assassinated and removed from Clement's life. While Aretino was playing his very dangerous game of politics, he found time to reconnect with Julio Romano; and that's when the two men launched the commercial porn industry as we know it today, with a book they created, now known as *Aretino's Postures*.

There are different versions of how the book came to be. One version has it that that Romano was working on a fresco at the Villa Madama (designed by Raphael as a 'country house' for the Medici) and was infuriated with Clement because he was late or outright didn't pay him for his valuable services; and when he told Aretino, who had his own beef with the pope, he may have come up with the idea to humiliate him. It probably went down like this. The two men got to talking and, more importantly, drinking. In this scene there are two beautiful courtesans joining them in libations, and Aretino, the master manipulator, says, "Let's teach this sanctimonious prick a lesson." An inebriated Romano

starts laughing and says, "How?" Aretino replies, "Pippi, get out your pencil," and then he starts screwing one of the courtesans and commands Romano to begin sketching them as his models. It's certainly conceivable. After all, a painter paints, and a writer writes, this is what they did; they also drank like elephants and screwed whores like devils and painted them (in this case, the first documented porn stars in history).

When it was all said and done and Aretino feasted his eyes on the pornographic sketches, he may have exclaimed *"Putana Santisima!"* The consummate hustler had an epiphany! He suddenly realized that dirty pictures were just another word for gold. Certainly everyone agrees money was the principal motive behind the work, but I think the initial motivo was honor. Clement definitely snubbed Aretino and almost certainly stiffed Romano; more importantly, he embarrassed *la prima donna di Roma*, Victoria Colonna. Once Romano put the final touches on his X-rated sketches, Aretino went out searching for a sponsor. Taking into consideration publishing a book that included meticulously detailed engravings wasn't something that came cheap. I'm willing to bet it was Victoria Colonna's cousin, the obscenely wealthy Cardinal Pompeo Colonna, who despised Clement and would do anything to bring him shame (including possibly orchestrating the work). The other possibility was Federico Gonzaga II. Earlier the Marquis besieged Aretino to get Romano for his court *by any means necessary*. Aretino most likely set Romano up—seducing him with gold in order to induce him to create the outrageous work of art, knowing all the while it would cause an outrageous scandal and *the rare Italian master* would (in all likelihood) have to flee Rome in order to avoid a very nasty prosecution. Speculation, but that's exactly what happened. Romano left Rome and went to straight Mantua where he became Federico's court painter, architect, and premier theatrical art director.

The accepted version on the origin of *Aretino's Postures* never answers the question of *who* came up with the idea. Or *why*. It only provides the answer to *how* it may have happened. We know that Julio Romano drew the most shocking pornographic images in the history of Western civilization. Aretino provided the text or "lust sonnets," as they were called, which are hilarious X-rated dialogue between two consenting adults, with the punch line often given to the woman.

# KAMA SUTRA, ITALIAN STYLE

In one image Romano illustrates a man preparing to perform cunnilingus (that's Latin for cunt-lapping) and Aretino adds the woman shrieking:

> *What extreme pleasure you're giving me....Devour my chamber of love!*

Aretino made the woman of his *lust sonnets* an equal sexual partner (reconfiguring the meaning of the female in their submissive Biblical gender role) which was unheard of and would have been considered sacrilegious in the sixteenth century—creating the very mechanism that would open the door for the women's sexual liberation movement. Feminist scholars fail to realize that Aretino (a bisexual man) was instrumental jumpstarting the modern sex age by giving women a voracious sexual voice that had been ball gagged the day Moses set the law down. According to Moses, women have no sexual freedom. And then came Aretino.

The world's first graphically illustrated porno book was given to Marc Antonio Raimondi, Italy's greatest engraver (who may have been involved in the drunken orgy), and he meticulously etched the sixteen sexually-explicit images into plates (called *modi*, meaning *modes* of having sexual intercourse) officially reintroducing the Pagan joy (and worship) of sex to Western civilization. *Aretino's Postures*, originally titled *I Modi* (*The Positions*), was published in 1524, and the work became an overnight sensation—Front-Page-Fucking-News! No pun intended. Every scribe in Rome was writing their own penetrating version of the seismic event that shook the Vatican. The French writer and historian Brantome would later write a titillating editorial on how ecstatic the Romans were to receive such a work, which celebrated the act of coitus rather than making it a mortal sin out of wedlock. *The Positions* was the most groundbreaking work of art to depict sexual bliss to come out of the Italian Renaissance. It broke every taboo and rule regarding sex and morality, creating an utterly new perspective in *femminismo* art and literature.

When Clement eventually came around to seeing the *fenomenale* lovemaking book, he was stunned. Not that he was a prude; he probably enjoyed the work as much as any hot-blooded Italian. It was no *segreto* that he occasionally loved to partake in the pleasures of the flesh. In fact, he had his illegitimate son Alessandro

with an African slave girl who worked in the Medici household (identified in documents as Simonetta Collavechio). To avoid a terrible scandal, the little *Africano bastardo* was passed off as Lorenzo II de' Medici's son. Nonetheless, to have such a *scandaloso* work created by his own court painter, right under his nose (let's not forget Luther was watching and most likely jerking off to the work in Wittenberg), was too much, even for a Medici. It disgraced him as the new pope. At the urging of Giberti, Clement ordered Raimondi arrested. Aretino was spared because (obviously) he never signed the work and denied any hand in creating it. Romano avoided the whole *fiasco* because he was already living in Mantua. Raimondi wasn't as wise, and he was arrested and placed in the dungeon at Castle Sant' Angelo; his plates were confiscated, and then papal agents frantically began the insurmountable task of trying to retrieve and destroy all available copies—but it was too late. The work had already crossed the Alps, and clandestine copies were being copied and printed because of the insatiable demand.

With Raimondi in jail, Aretino immediately interceded and went straight to Clement to protest his illustrious friend's arrest, which further enraged the pope's datary Giberti. As usual Aretino made a great argument, stating that Raimondi was a national treasure and therefore he should be immediately released from prison; and so, through the efforts of Aretino and several other powerful men in Rome who vouched for him, Raimondi was finally set free. Aretino provides his own *versione* of the event in one of his amazing letters written to his friend, the physician Battista Zatti, on what actually might have happened. The letter in part read:

> *Since I obtained from Pope Clement the release of Marcantonio Bolognese, who was imprisoned on account of his engravings, there came over me the desire to see the figures, which caused that troublemaker Giberti to exclaim that the great craftsman should be crucified. Seeing them, I was inspired by the same spirit that caused Giulio Romano to design them. And since it is well known that poets, artists, and sculptors, ancient and modern, saw no harm in allowing their genius to entertain by writing, painting or carving once in a while such lascivious trifles as the marble satyr trying to violate a boy*

> *which is in the Palazzo Chigi, I amused myself by writing the sonnets which you now see under each picture. I dedicate their indecencies to all hypocrites, for I am quite out of patience with their scurvy strictures and their villainous judgment and that dirty custom that forbids the eyes to see what most delights them. What harm is there to see a man possess a woman? Are the beasts freer than we?*

The Zatti letter was published as an editorial and Giberti read it, and now he had the *evidenza* to prosecute Aretino to the fullest extent of the law (anyone promoting sodomy—i.e., any sexual position other than the "missionary position"—especially cunt-lapping—was looking at a biblical death sentence, or at least a stint on the wrack), because, prior to the letter, there was no way to connect Aretino to Romano's pornographic images. If we are to believe the Zatti letter, Aretino created the *lust sonnets* because he was outraged after Raimondi was arrested. Either way, however noble his intentions were, the Maestro was *fottuto* (that's colloquial Italian for fucked) and he was forced to flee Rome for Arezzo. As soon as he arrived, he received another letter written by his beloved sidekick Giovanni dalla Bande Nere, whom Clement had recently sent like a bishop on a chessboard to reinforce Francis I as he prepared to retake Milan away from Charles V. The Devil was well aware of the events transpiring in Rome, and writes:

> *I beg you to leave Arezzo and come to me now. This is something I desire greatly. I admit I should not do this, but should be furious with you; you who could give laws to the world have now ruined your own prospects. You have insulted me too; for while you were at the Roman court I had a friend there who would have defended you with all his heart the rightness of what you did, what you have done, and what you will do. Yet, I do wish to see you very much. King Francis I bade me to write you to come and he made me swear you would obey.*

Aretino dutifully obeyed his lover and saddled up (with a copy of *The Positions*) and rode off into the sunset to meet Giovanni. That's how the Maestro

came to meet the satyr King Francis I (and his entourage of "gay little girls and pretty darlings" that accompanied him wherever he went), who fell under his powerful spell, and would ultimately become one of his most important patrons. "You will be rewarded according to your works"(Matthew 16:27). Francis made it known to Rome, in no uncertain terms, that Pietro Aretino was in perfect standing with him, a man *par excellence*, which must have totally perplexed Giberti, and more so Clement. Confident that his reputation was intact and cocksure as ever, Aretino returned to Rome triumphant. The Pope had to acknowledge the strange, albeit royal friendship between the King of writers and the King of France and show due respect to Francis.

According to Aretino's biographer James Cleugh, "Clement, for his part made Aretino a Knight of Rhodes," (the Knights of Rhodes were a monastic military order that originated in Jerusalem in the eleventh century) presumably, as a sublime gesture of acknowledgement to Francis I; there is no other logical reason for such an astonishing action on the Pope's part, especially since the porno fiasco was still fresh in his mind. Making someone a knight was an extremely high honor (something Shakespeare could only dream of). Cleugh further maintains, "Papal policy was now, under Giberti's influence, more distinctly favorable to France and the poet's [Aretino's] gracious reception by the king of that country could not be ignored at the Vatican."

Giberti's personal secretary, Francesco Berni (1496-1535), a well-known writer himself, and one of Aretino's bitterest rivals, wrote his firsthand account of Aretino's arrival back in Rome:

> *He now struts about Rome dressed like a great Duke. He takes part in all the wild doings of the lords. He pays his way with insults couched in fancy tricked-up words. He speaks well, and knows all the scandals of the city. The Estes and the Gonzagas walk arm and arm with him, and listen to his gossip. He treats them with reverence, others with contempt. He lives on what the former give him. He is feared for his satiric wit and he revels in hearing himself called a cynical, impudent slanderer. The Pope has bestowed upon him a fixed*

*pension as the reward for having dedicated certain second-rate verses to His Excellency.*

On October 24, 1524, Francis I took possession of Milan without a fight and without entering the city, as it was ravaged by the plague. It was a symbolic victory: Commanding a mercenary force of 40,000 soldiers, the French king had an army, but no battle to fight. Against his mother, Louise of Savoy's wishes and sublime wisdom in such matters, Francis, full of himself and with Giovanni dalle Bande Nere riding shotgun, proceeded to attack the nearby city of Pavia. Big mistake. A massive defensive force, led by Victoria Colonna's husband, the formidable Marquis de' Pescara, was waiting for him and struck Francis and Giovanni's troops hard. Francis counter-attacked and nearly overtook Pescara's forces, when backup divisions arrived in the form of Francis' duplicitous uncle, the Duke of Savoy, and his cousin, the deadly Duke of Bourbon (both of these men were monumental traitors having switched sides to Charles V earlier). The two Dukes' regiments circled behind with their legions and massacred their own countrymen in the most decisive military engagement of the Italian Renaissance: "The Battle of Pavia" (February 24-5, 1525).

An estimated twelve thousand soldiers were slaughtered on the battlefield, including the crème de la crème of the French high command. Giovanni was severely wounded in the leg but managed to escape with his life. Francis wasn't as lucky; wounded, and now a captive in a prison in Pizzighettone, he wrote to his mother:

*All is lost save honor—and my skin, which is safe.*

With Francis I in custody and much of his army destroyed, Charles V was now the uncontested master of Italy. Will Durant trenchantly pointed out, "All of Italy felt itself at his mercy, and one Italian state after another presented him with diverse bribes for permission to remain in existence." However, the tides were changing: the Emperor's triumph would be momentary. The threat of global war hovered over Europe like the plague. Luther's followers were plotting a religious revolution in Germany; Suleiman the Magnificent was preparing for another jihad on Christians; and the Medici Pope was planning the ultimate *coup d'état*.

# 23

# *David*

*Faith may be defined briefly as an illogical belief in the occurrence of the improbable.*

—H. L. Mencken

In Venice, a curious development manifested itself. The author Max Dimont writes in his book *Jews, God and History*, "One sunny day in Venice, in 1524, an incongruous figure appeared on a glittering, prancing, white Arabian Stallion. Atop the horse was a dark gnome-like dwarf, David Reubeni." The dwarf announced he was on a diplomatic mission and was sent by his brother Joseph, a Hebrew king, who led an army of Jewish warriors in the desert of Arabia, known as the Tribe of Reuben (allegedly one of the lost tribes of Israel). Reubeni arrived on his own ship, which had sailed from Alexandria in order to solidify a military alliance with the Italians for a crusade against the Ottoman Turks.

The Venetians were intrigued. Word spread across the peninsula: A crazy Jewish dwarf prince had arrived and would help save Italy from the dreaded Ottoman Turks. Venetian ambassadors were immediately dispatched to the Vatican seeking an audience with Clement VII; naturally, the Chameleon was intrigued and granted the request.

Reubeni arrived in Rome in late 1524 (right about the time Aretino was meeting with Francis I). The Medici Pope was bubbling with excitement; he saw

the little Jew as a proverbial blessing in disguise. Here was the perfect way in which he might, in one fell swoop, galvanize Charles V, Francis I (even though he was in prison, he was still in the picture), Henry VIII, as well as King John III of Portugal; all of them, Clement prayed, might be able to put their differences aside and align themselves as one giant Christian Crusade against the Ottoman Turks. It should have been the crowning achievement of his Papacy.

The Turks were the biggest threat to Europe, and they were clearly on everyone's mind. In 1521, the year Leo X died, they had already conquered Belgrade, Semlin, and Rhodes: the last castle and colony of Christianity in the Levant, the famous fortress that the Knights of Rhodes held since the eleventh century. The fall of Rhodes was a declaration of war against Christendom. After meeting with Reubeni, Clement contacted Cardinal Egidio di Viterbo, a leading expert on Middle Eastern affairs, and they convened a council of Rome's most famous rabbis. The rabbis confirmed the charismatic little Jew, was, in fact, the brother of a Hebrew king who commanded an army of Jewish warriors who would gladly slaughter the Turks in order to reclaim the Holy Land. There was one catch; there always is. Reubeni needed warships and the latest high-tech weaponry to arm his tribe of Bedouin Jews, numbering some 300,000 (making it, technically, the largest army in the Western hemisphere), back in the desert at the rear of the Turkish lines which meant he needed serious financing. Every Crusade to date (and there were many, spanning centuries) had failed to take back the Holy Land, but everyone agreed it could be done. The Pope's advisors, as well as his astrologers, suggested backing the little Jew; and so a holy war plan was put into motion. Clement contacted King John III of Portugal, who agreed to assist Reubeni's Crusade against the Turks.

At the time of Reubeni's arrival, Rome had one of the oldest settlements of Jews in the world. Thousands lived there in the sixteenth century, much as they do today (incidentally, the Jews were living In Rome before the Christians), and many of them pitched in, begged, borrowed, stole, and I would even wager, some of them sold their flesh in order to help finance Reubeni's quest to take back the "Promised Land" (according to Aretino, some of the finest courtesans in Rome were Jews). There was no doubt about it: If the little Jew with the King Kong balls pulled it off, it would be the biggest coup d'état in the history of civilization.

The crusade slowly moved forward and gained momentum. In the interim, Reubeni and his lieutenants attended military meetings with Italian *condottiere* (contract killers), who taught them how to mix explosives and use the latest high-tech weaponry, all necessary things Reubeni had initially requested that would ensure success in the apocalyptic battle with the Turks. But it wasn't all work. The Italians, although masters of warfare, loved to party, and they treated Reubeni and his men like celebrities, holding lavish parties which the Jews gratefully attended.

On March 15, 1525, a month after the Battle of Pavia (while Francis I languished in a jail cell reading Aretino's letters), Reubeni made his triumphal departure, setting sail for Portugal; he flew the Star of David from his mast along with Clement's Papal Coat of Arms. Meanwhile, in Lisbon, King John III awaited Reubeni's arrival, and, like Clement, when he finally met him he was impressed by the little prince. And then, everything backfired when Murphy showed up: Murphy's Law, that is, "If anything can go wrong, it will," and it did. News of Reubeni's arrival in Lisbon stirred considerable excitement in the Marrano community. Hebrew scholar Curt Leviant: "The Marranos [Jews living in the Iberian Peninsula who were forced to convert to Christianity or face death or exile] in Portugal gathered about Reubeni and considered him a savior. This ferment naturally irritated the king, who began to suspect that Reubeni had come to bring the Marranos back to Judaism. Reubeni was ordered to leave the land."

The intrepid little Jew realized he was now in grave danger and immediately left Portugal for Spain where he tried to align his cause with Charles V. Bad move! When Reubeni arrived to meet with him, Charles betrayed Clement like Judas betrayed Christ and had Reubeni arrested by Inquisition agents, and the little warrior with the King Kong balls was never heard from again.

# 24

## *Vendetta*

*Blood will have blood.*

—Pietro Aretino

Shortly after David Reubeni sailed for Portugal, Clement VII abandoned his allegiance to Francis I and realigned with Charles V. Behind the scenes, the Chameleon orchestrated a plot to diminish the Emperor's power in Italy. He did this by making his most formidable Italian general, the Marquis of Pescara (who had earlier defeated Francis I at the Battle of Pavia) an offer he seemingly could not refuse. The pope's envoy offered Pescara the coveted crown of Naples if he would betray his allegiance to Charles. Pescara was tempted by the pope's tantalizing offer, but he changed his mind after his wife, Victoria Colonna, informed him in a letter that she would rather be married to an honest general than a devious king. That's when Pescara revealed the plot to the Emperor. It was the beginning of the end of Medici Rome, and blood would flow like the Tiber.

In the early morning hours of July 28, 1525, Pietro Aretino was leaving a friend's home (most likely a Jewish courtesan) when a masked assailant clutching a dagger came out of the darkness like Jack the Ripper and thrust a large blade into the vicinity of his heart. The first thrust was miraculously deflected by Aretino's Herculean hand; but the second thrust went into his chest. Aretino's

thunderous voice screamed bloody murder, and the would-be assassin vanished into the night. Left for dead, but born under a lucky star, Aretino's screams were heard. A crowd gathered, and a doctor arrived to save him. We can only surmise what thoughts must have raced through Aretino's mind as he convalesced in his apartment: *How? Who?....Why would some cocksucker do this to me?* Was it a jealous husband, a disgruntled cardinal, a desperate thief, a debt never paid, or maybe a message from God. Like any man marked for murder, he must have feared the worst and surmised that whoever it was, they might try again. I'm sure he prayed to God for insight; he was a very spiritual man, especially after the attack.

If Aretino prayed for insight, his prayers were answered. According to James Cleugh, a few days after the savage attack, a mad poet by the name of Achille della Volta came to visit him. I say mad because it's one thing to bushwhack someone in the middle of the night with a dagger, and quite another thing to confess and ask to be forgiven—especially from a man as politically connected as Aretino was. Perplexed, the Maestro may have said: *Are you crazy? Why should I have to forgive you?* Della Volta went on to explain that he stabbed him because he (Aretino) wrote a slanderous sonnet about a woman he was in love with, and he felt that Aretino had disrespected her good name. I would surmise that Aretino had his tribe of followers that followed him around like John Gotti acting as his bodyguards in his apartment, and he could have had the crazy poet beaten and dragged to a prison cell to face prosecution. Instead, the brilliant psychologist decided on another tactic, concluding that there had to be more to the poet's story than a slanderous sonnet. To gain Della Volta's confidence, Aretino may have plied him with wine, money, perhaps a courtesan; that's not to say he didn't also threaten to have his throat cut and his body dumped in the Tiber. Whatever Aretino did, it worked, and he learned that his would-be *assassino* was employed as a servant for none other than his nemesis, Gian Matteo Giberti. Della Volta (most likely after a few drinks) went on to inform Aretino that it was Giberti who encouraged him, blessed him, and then sent him to commit sacrificial homicide. Aretino was being played at his own game. After putting all the pieces together, Aretino realized that it was Clement who was actually behind the attack because there was no way Giberti would have ordered the hit without risking his own life—unless the pope gave him his blessing and approval.

Once Della Volta left Aretino's apartment, the master scribe reflected, and with newfound energy, he began writing with his left hand. Frustrated, he gave up and wrote with his mangled right hand, the hand he nearly lost to Della Volta's dagger. The rage inside of him fomented like venom and he began firing poisonous letters off to Roman magistrates demanding the arrest of Giberti and his poet-assassin-servant. It was futile; Giberti was an untouchable—above the law. Aretino knew this, but he made damn sure the rest of Rome knew it as well—more Headline News! Everyone was now talking about the attempted murder of the beloved celebrity writer. All the while, the Chameleon, remained indifferent to Aretino's predicament. Mortified by the pontiff's duplicity and enraged by his datary's brazenness, Aretino must have stared at the scar near his heart and drifted into a haze from the powerful spirits that were given to him for his excruciating pain.

On October 13, 1525, the fugacious scribe left Rome for Mantua. Along the way, he plotted his own demonically-fitting vendetta; a vendetta that would have made John Gotti proud.

It was around this time that Aretino wrote his first comedy, *La Cortigiano (The Courtier)*. *The Courtier* is an annihilating satire on court life based on Aretino's escapades as a courtier in Rome with cardinal intentions. It is beyond the scope of this work to explain every minute facet of the play, but I will address the important features. First, the work sheds a blinding spotlight on the buzzing theatrical scene in Rome, when Rome was the theatrical capital of the world. Second, it is one of the most important Italian dramas ever written because it accurately documents urban life in Rome and provides a penetrating vision into the devious courtier mindset passionately vilified in the works of Aretino's dedicated English disciples (Jonson, Donne, Nashe, Greene, Marston, Middleton, Dekker, Webster....) Third, it disregards *all* the rules of classical playwriting that were established by Terrence and Platus, and strictly followed by playwrights of the sixteenth century. Aretino made his own rules. He embeds fact and fiction into the fabric of the plot as the chief digressive mechanism to convey his primary intention in reporting the important headline news events of his day. We witness *gonzo journalism* in the making. We experience Rome live—the way Aretino did—like the perverted soul-devouring-bitch-goddess-whore that she was.

*The Courtier* begins with a prologue recited by a stranger visiting Rome and a native gentleman of the city. The first scene: the curious stranger witnesses a great commotion taking place in front of a palace and surmises that some sort of festival is about to take place. Intrigued, the stranger gets closer to the action to ascertain the nature of the pompous spectacle and asks a gentleman nearby what the commotion is about. The gentleman tells the stranger that the commotion is over a comedy that is about to commence. The curious stranger asks the gentleman the name of the author of the comedy. At this point, the gentleman engages the stranger in a guessing game. "Is it by Ariosto?" "No!" "Is it by Signora Veronica da Corregio?" "No!" "Tell me, is this something by the most gentle Molza, or by Bembo, the father of the muses?" The gentleman replies, "It is the work neither of Bembo nor of Molza." "Is it by Guidiccione?" "No, he would never write such silly things." "Is it by Ricco?" "No!" "Tasso?" "No!" On and on they go, and the stranger gets nowhere. Finally the gentleman acquiesces to the curious stranger's request and says it's a comedy written by none other than the great Pietro Aretino. Once Aretino finishes his theatrical anthology on famous Italian playwrights, he has the stranger ask the gentleman what is the nature of the play. The gentleman replies, "It is the gulling of two imbeciles."

The two imbeciles are a lovesick Neapolitan aristocrat by the name of Parabalano and an affluent Sienese sycophant by the name of Maco. Parabalano sees himself as God's gift to women and is determined *by whatever means necessary*, to win the love of a virtuous Roman beauty by the name of Livia, who doesn't even know he exists. Parabalano instructs his devious Roman servant Rosso to set up a date with Livia; but instead, the prick orchestrates an elaborate ruse and sets his master up with an ugly-ass beast whose husband nearly kills him. Maco on the other hand, comes to Rome with the tremendous intention of becoming a cardinal in order to acquire the obscene power and fantastic sexual privilege that comes with the title, only to find himself (much like Parabalano) screwed in every sense of the word. Maco is informed that in order to become a cardinal, he must first learn the ways of the courtier, whereupon he seeks a competent

teacher and the madness begins. Aretino points out the first valuable lesson a courtier must learn:

> *The main thing a courtier must learn is how to deceive; he should be a gambler, spiteful, a whoremonger, a heretic, a slanderer, an ingrate... he must know how to boast, connive, and mince around or either be the doer or the done.*

Sound familiar? Think Iago! What is particularly intriguing about *The Courtier* is the parallel with Shakespeare's comedy *Twelfth Night*. The central theme of *Twelfth Night* also revolves around the actions of two lovesick imbeciles: Malvolio and Orsino. Malvolio's objective is to marry his powerful mistress, the great countess Olivia. He does this in order to become a great count and acquire the prestige and privilege that comes with the title, much as Aretino's character Maco desires to become a great cardinal for the same reasons. Harold Bloom states in his epic work, *Shakespeare: The Invention of the Human*: "To be Count Malvolio!—is one of Shakespeare's supreme inventions, [it's not] permanently disturbing as a study in self deception, and in the spirits' sickness." Although Maco and Malvolio are (obviously) different characters, they both share the same psychic propensities: Both desperately seek to rise above their social status, both are obsessed with a woman's love, and each character as a result becomes the butt of a cruel practical joke. Shakespeare's "outrageous lover of love," Orsino, is a virtual clone of Aretino's hopeless romantic Parabalano. In fact, when comparing the two lovesick imbeciles, it's impossible not to see Aretino's powerful influence on Shakespeare.

For starters, *The Courtier* and *Twelfth Night* are comedies that parody the madness of romantic love. Each play includes cross-dressing characters, excessive drinking of alcohol and love missives that get into the wrong hands. Both plays utilize captivating word-riddles and elaborate anagrams (one in particular on the word *cunt* is embedded in *Twelfth Night*, 2.5.77). Each play involves parallel plots. Both involve practical jokes perpetrated on the principal characters. Each play maintains a core message: Love is a form of madness ruled by Fortune rather than design.

In between the gulling of the two imbeciles, Aretino embeds the most astute political perceptions of the day regarding the affairs of the Pope, the Emperor and the King of France. He also provides a remarkable analysis on the literary scene in Italy during the height of the Italian Renaissance, establishing the beginning of his career as the greatest literary critic of the sixteenth century (think of him as the Harold Bloom of his day).

While Aretino was busy writing *The Courtier,* something equally groundbreaking occurred in Wittenburg. On June 27, 1525, Martin Luther was battling his insatiable sex drive and spiritually fist-fucked the Vatican (at their own game) by marrying a renegade red-headed, sex-crazed nun by the name of Katherine von Bora. Citing Scripture, Luther concluded, after sleeping with the Prince of Darkness (and emphatically admitting that he won his greatest battles with temptation in bed with him), that mandatory celibacy for the priesthood had no foundation in the Bible and that it was a sin for priests and nuns not to marry and procreate. And from that point on, marriage for the clergy would become legal within the Protestant faith. Hallelujah!

# 25

## Cognac

*One who deceives will always find those who will allow themselves to be deceived.*

—Machiavelli

While Francis I was languishing in a jail cell, his infamous mother, Louise of Savoy, was holding court, acting as the regent of France. In his absence, she made every attempt to have her son released, including a secret pact with the great infidel Suleiman the Magnificent. Louise, like any good mother with means, was prepared to do anything—and I mean anything—to liberate her son, including staging a jailbreak invasion with the Turks. Charles V made her sweat as he shuffled Francis around different prisons in his realm. Once Charles had his royal prisoner finally secured in Spain, he set forth the impossible conditions of his release. Francis spent months in a Spanish prison cell where he nearly died going stir-crazy. According to the historian A. J. Grant in his book: *A History of Europe: From 1494 to 1610*, "Francis tried to escape, disguised as the Negro who tended his fire." I can imagine the King of France putting boot polish on his face, ala Al Jolson, trying to give his captors the slip. It was only after her arrival in Spain that Francis' sister Marguerite de Navarre, a hot, vivacious brunette with a wicked tongue was able to persuade her brother to accept the terms set forth by Charles as a condition of his release (we'll get to them in a minute).

I can envision the very bitter-sweet-moment: Five hundred French gendarmes escorting a royal racing coach rambling across the landscape. Inside the coach sits an amber-scented princess—her inner being tingling with the bumps of anticipation—wet at the thought of being reunited with her inseparable soul mate. A Spanish knight's contingent receive the royal train at the gates of Alacazar…they drop to their knees in obeisance before they lead the striking princess to a cell to see her brother, spit-shined and polished, equally tingling with emotion. The two embrace and share kisses. The royal couple are then led to a chapel where they hear Mass and receive the sacraments. At night they play backgammon, drink wine, and share tender moments together. And so, I surmise, this vivacious princess with a wicked tongue persuaded her insatiable brother, as only a beautiful woman can (use your imagination), to accept the humiliating terms that Charles set forth as a condition of his release.

First, Francis had to forfeit all of his Italian territories, specifically his claim to Milan, and agree to never challenge Charles when it came to controlling Italy. Next, he had to surrender his claim on Burgundy and then reinstate the traitorous Duke of Bourbon (who had earlier switched sides to Charles, and was instrumental in helping Pescara defeat the French at the apocalyptic Battle of Pavia), and give him back his title and his land. Francis had to further agree to ransom his two small sons; and if that were not enough, he had to agree to marry Charles's sister, Eleanor of Austria. With no alternative, the Salamander King finally agreed to the terms set forth by the Emperor, in what is now known as the Treaty of Madrid.

On March 17, 1526 at seven in the morning, Francis was finally released from his prison cell and escorted to the banks of the Bidossa River, which separates France and Spain. There, he awaited with his Hapsburg guardians for a boat containing his two young sons, the dauphin Francis and his younger brother Henry, Duke of Orleans, who would later go on to marry the notorious Catherine de' Medici and procreate three future French kings with her. The boat arrived. Francis embraced his sons, spent an eternal moment with them, kissed them good-bye, and then he handed them over to the Imperial Viceroy of Naples, Charles de' Lannoy, giving him his solemn oath that he would abide by the terms of the treaty. The French King was then allowed to depart from Spain.

Once back on French soil, there was a drastic change in plans. Francis, now free and as wily as ever, was determined to neutralize (or at least amend) the terms of the Treaty of Madrid. Francis stated that he was under duress and out of his mind when he agreed to the terms, and thus the treaty was null and void. The Roman Curia and the French Parliament agreed. Charles literally went ape-shit, which brings us to the League of Cognac, created in May of 1526, and possibly the most important league of the sixteenth century because it would ultimately trigger the destruction of Rome.

Now this is where it gets interesting. And once again we come to the challenge of interpreting history. There are different versions of how the League of Cognac came to be. Some historians maintain that Francis came up with the idea and created the League of Cognac as a way to pressure Charles into disbanding or modifying the terms of the Treaty of Madrid. Others maintain that it was Clement who created the league. Burke Wilkinson, a biographer of Francis I, maintains, "Alarmed at the increasing power of the Emperor there [Italy], Pope Clement VII, the eternal waverer, for once took sides. He organized a new Holy League against Charles and persuaded Milan and Venice to join it. France and England, less openly, signed on as well."

Desmond Seward, also a distinguished biographer of Francis I, maintains that it was Francis who created the league and writes, "In June 1526, he [Francis] inaugurated the League of Cognac, with Venice, Milan, Genoa, Florence, and the Papacy. Its declared purpose was to liberate Italy from the Emperor."

Edward Crankshaw, author of *The Habsburgs: Portrait of a Dynasty*, also maintains it was Francis who orchestrated the league. Jasper Ridley, author of *Henry VIII: The Politics of Tyranny*, maintains it was Clement VII, and writes, "The Pope became alarmed at Charles's complete domination of the whole Italian peninsula, and with encouragement and promises of financial support from Henry, he formed a Holy League to resist the Emperor."

Interpretations vary; we have four different versions of the League of Cognac, and those are just the ones I cited. My interpretation is this: Clement seized the moment as the perfect opportunity to kill two birds with one stone. Charles had gotten rid of Francis for him, and now he was going to get rid of Charles—or so it seemed. The object of the league was "to protect the peace

of Christendom," but the real reason behind the league was to break up the Hapsburg hegemony over Europe and drive Charles V out of Italy. Personally, I think Clement was also adding revenge to the mix—his way of getting back at Charles for sabotaging his Crusade with David Reubeni.

The league consisted of the combined forces of Rome, France and Venice, as well as Florence and the duchy of Milan, and (some say, depending on what book you happen to be reading) England. All joined forces to protect Christianity. But protect Christianity from what? Charles was perplexed and immediately demanded an explanation. The Pope answered the Emperor's interrogatory with an official letter written on June 23, 1526, stating that Charles was the direct cause of disunity among the Roman Catholic kings and princes in his realm, and that he had the divine right as Christ's vicar on earth to thwart his utter enslavement of the Italian peninsula, adding an addendum, the *Dictatus Papae*: "No man may judge a Pope." Charles went black with madness and screamed to his Italian secretary, Mercurino Gattinara, "I will destroy this false Pope." He then summoned Clement's papal nuncio (ambassador), his favorite Italian statesman, Count Baldassare Castiglione, who was equally brain-fagged by the Pope's defiant conduct. Charles, in no uncertain terms, told Castiglione to talk some sense into Clement and persuade him to dismantle the league before it was too late and he declared war on the Papacy. Castiglione immediately sent a dispatch to the Vatican imploring the Medici Pope not to act rashly:

> *Blessed Holy Father, I do not see that we have sufficient resources, nor yet do I recognize any just cause for making war with the Emperor.*

Castiglione further pointed out in his missive to Clement that Charles was in a position to wreak absolute havoc against the Holy See and leaning towards Luther, possibly abetting an insurrection against the Roman Catholic Church in Germany. The Emperor then summoned the deadly Duke of Bourbon to put the fear of God into the Pope.

# Part V

# 26

## *Lucifer Rising*

*General: A man quite capable. He can fly and he can kill.
But he has one defect: He can think.*

—Bertoldt Brecht

Charles de' Montepensier, duc de' Bourbon, was the personification of a megalomaniac Renaissance warlord: recklessly brave, flamboyant (he wore a silver cape in battle and a diamond pendant around his neck), pretentious, vain, and utterly unrestrained in both action and word. Bourbon was once the richest man in France; that is, until he switched sides to Charles V. There was intense rivalry between the arrogant Duke and his supercilious master Francis I dating back years before the switch. A primary reason for this was that Francis was always borrowing money from Bourbon to finance his military campaigns, and paying him back whenever he felt like it, which was oftentimes never—but that is not why Bourbon betrayed him. The main reason Bourbon switched sides to Charles was over a woman. The woman in this case was a French version of Lady Macbeth: Louise of Savoy. Louise, consumed by flaming ambition and her own sense of power, had her sights locked on Bourbon, and when Bourbon's wife, Susanna, died in 1521, she made overtures toward him to marry her. Bourbon despised Louise, and he audaciously insulted her integrity, sealing his own fate when he

stated for the record what he thought of her: "The worst woman in the realm, the dread of nations." He further stated, "I would not do this thing [marry her], no, not for the whole of Christendom." Louise was the wrong woman to scorn, and the chronicler Maquerieau writes how she reacted: "The matter shall not rest here, by the Creator of souls his words shall cost him dear." Louise, who many believe was Satan's mistress, screamed:

*My son you shall avenge me!*

And he did. After Bourbon insulted his mother, Francis ordered Bourbon arrested for treason. That's when Bourbon switched sides to Charles. Naturally, Charles, taking into consideration Bourbon's expertise as a battle-scarred general (not to mention his vehement hatred of Francis I) made him his lead Imperial commander in northern Italy. When Clement refused to disband the League of Cognac, Charles declared war and dispatched Bourbon into Italy to re-conquer Milan. The city quickly capitulated to the imperialists, and Bourbon usurped Francesco Maria Sforza as the titular ruler of the State. Will Durant writes "Now, to raise and pay another army for Charles, he [Bourbon] taxed the Milanese literally to death. He wrote to the Emperor that he drained the city of its blood. His soldiers, quartered upon the inhabitants, so abused them with theft, brutality, and rape, that many Milanese hanged themselves or threw themselves from high places into the streets." Clement counterattacked by sending his deadly cousin Giovanni dalla Bande Nere, and his terrifying band of mercenaries to reinforce the Duke of Urbino, Francesco Maria della Rovere, who was leading the papal-allied Venetian militia (numbering some twenty thousand soldiers) to retake Milan from Bourbon.

The Duke of Urbino was a deadly character in his own right; he once stabbed a cardinal to death because he crossed him, and got away with it because his uncle was the "Warrior Pope" Julius II. He also killed his sister's fiancée in a fit of rage because he felt the man disrespected her. The homicidal Duke despised the Medici because Leo X had him ousted from his duchy (in essence, stealing it and making it a Medici state). Urbino was in collusion with Charles in his campaign against the Pope (albeit Clement never realized it—until it was too late).

Urbino stalled the siege of Milan, and thwarted every effort on Clement's part to gain the upper hand on Charles. And that's when Aretino, on the sidelines, growing fat in Mantua, made his move: grabbing his double-edged sword and pen and the fastest Gonzaga racehorse he could find, sped off like Wyatt Earp to meet with Giovanni on the outskirts of Milan. Thomas Caldecot Chubb, Aretino's biographer, states what happened next: "Now at last Aretino saw a chance for action. Things were happening in the great world. Italy was being carved, and the one man he genuinely loved [Giovanni] would do the carving."

Ecstatic to see his old friend alive (after the Della Volta incident), Giovanni made Aretino a solemn promise:

*If I live through this year, I'll make you Marquis of Arezzo.*

Meanwhile Machiavelli, the Sun Tzu of his day, showed up on the battlefield like Donald Rumsfeld and offered to demonstrate his military skills to Giovanni. The Devil obliged and gave him a squad of troops to command, but to everyone's comic relief, Machiavelli could not get the soldiers to march in the right direction. Be that as it may. Three of the greatest political minds in Italy, Aretino, Machiavelli, and Guicciardini (who was leading his own papal militia in the war against Charles V) agreed that the time was ripe for the Vatican to make a decisive move. Guicciardini implored Clement to replace the Duke of Urbino with Giovanni as supreme papal commander in an attempt to finally unite the Italian states against the despotic Charles and his hordes of barbarians (or as Machiavelli called them—"wild animals who only have the faces and voices of men") but Clement refused to listen to reason. He had his own reason—he despised Giovanni.

And then Francis I raised the stakes and aligned with the ferocious Sultan Suleiman the Magnificent. Central Europe was about to suffer a Turkish invasion unparalleled since the fall of Constantinople. Payback is hell; the way I see it— Karma came back in spades for Charles because he sabotaged Clement's crusade with David Reubeni.

On August 29, 1526, five months after the creation of the League of Cognac, Charles's brother-in-law, the King of Hungary Ludwig II of Jagellon,

was slaughtered along with 20,000 of his men by the Turks at the horrific Battle of Mohacs. The Turks (100,000 strong) then advanced and took Budapest, and were now on their way toward Vienna. Charles was royally screwed: Suleiman the Magnificent had put the fear of Allah into him, and he now was forced to rethink his position with both Clement VII and Francis I. Meanwhile, intense negations were still going on in the Vatican. Charles's ambassadors begged, cajoled, and threatened Clement to cease and desist with his campaign against Charles and to align with him against the Turks. Again, Clement refused to listen; as far as he was concerned, the Turks could wait. Charles then demanded a council of cardinals to overrule the "illegitimate bastard Pope," as he referred to Clement VII (off the record), but it was thwarted. The Pope sent word back to Charles, to whom he referred as his "mad vassal Caesar," that he would allow the conclave, but only if it convened in Hell.

Charles was now faced with the dilemma of whether to fight the Turks or the Italians. The Turkish problem was being temporarily dealt with by Charles's brother Ferdinand, the Archduke of Austria, with the added blessing that the Turks hated cold weather, and as soon as winter came, they packed up their tents and headed back to the desert, only to return three years later to repeat their hit-and-run conquer tactic—a very effective tactic that would persist for the next century and a half, and only came to an end in 1683, when Grand Vizier Kara Mustapha was completely defeated and the Turkish menace of Europe finally ended outside the walls of Vienna. With the Turks being taken care of, Charles proceeded to outdo Francis in treachery.

In September of 1526, Charles sent word to his Imperial henchman in Rome, the vicious Hugo de' Moncada, (one of Cesare Borgia's favorite captains) "to stir up the powerful family of the Colonna." And stir them up he did: like a deranged Waffen-SS division, the Colonna mercenary force went on a rampage and plundered the Vatican and grabbed hostages, forcing Clement to take refuge inside the impenetrable walls of Castle Sant' Angelo. The mercenaries threatening to kill the hostages and burn the Apostolic Palace to the ground if Clement did not renounce the League of Cognac, make peace with Charles, and absolve them of their actions as a condition of withdrawal. The Pope had no choice; Moncado acted as the peacemaker and presented the jewel-encrusted papal tiara

back to him, because the Colonna forces stole it and everything else of value not nailed down when they took control of the Vatican.

For once it looked like an unnecessary war would be averted. Clement agreed to the terms the Colonnas set forth, absolved them of their actions; and the minute they left, he gathered an army, tore up the truce with Charles, declared the Colonnas outlaws, and then sent his militia to devastate their estates. The Emperor, not to be outdone by the Chameleon's brazen duplicity, would shortly make the Colonna raid on the Vatican seem like a mere act of vandalism, because his actions, (or inactions depending on how you interpret them) would ironically fulfill every Lutheran and Turk's dream, ultimately surpassing the horrors of Dante's *Inferno* and lead to the destruction of Rome, the holiest city in Christendom; or as Luther referred to it—*God damn Babylon*.

# 27

## *The Devil's Nightmare Regiment*

*Terror is transmuted coitus.*

—Wilhelm Fliess

The whole peninsula of Italy was in a state of electrified tension. The battle between the Pope and his "mad vassal Caesar" was beginning to reach a critical mass. The situation in Milan was a stalemate because the Duke of Urbino refused to lay siege on the city. The Devil Giovanni recounts: "My darling chief, the Duke of Urbino. He's no more a fool than my holy cousin too. But he acts too much like one, and like a coward too, for my taste. If only I could get him, for once to act like a soldier!" According to James Cleugh, "In any case, owing to the Duke's vacillations or deliberate blocking of all schemes in the Mediciean interest, no more serious fighting occurred that summer."

Meanwhile Charles V was getting his famous "second wind," and it came thundering down the Alps like an avalanche in the form of a monstrous army of fourteen thousand fanatical Lutheran *Landsknechts*. The Landsknecht, also known as the *devil's nightmare regiment*, were led by General Georg von Frundsberg, a maniacal anti-papist who carried a silk cord in his pocket specifically for Clement's neck. Frundsberg pawned his castle and lands not to mention his wife's jewels in order to aid Charles V, who historians say was bankrupt when it came to finding

funds to finance his army. This critical action on Frundsberg's part (the pawning of his property) clearly illustrates he was well aware of what he was getting into: *there was no money to finance his men*. The long-term ramifications of Frundsberg's awareness of the financial situation meant that the maniacal general and his devil's nightmare regiment would have to improvise and make do with whatever they could pillage from the Italians (much as Bourbon did in Milan).

Plundering Italy held a phenomenal attraction for the Landsknechts. Putting aside outrageous material gain, the idea of being able to rape beautiful Italian girls with huge breasts, and rape them on a regular basis, was a key factor behind the German expedition. Make no mistake about it: War is the ultimate aphrodisiac. If you doubt it, I suggest reading James Hillman's provocative blood/cum soaked masterpiece, *A Terrible Love of War* and Howard Bloom's *Lucifer Principle*.

In November of 1526, Frundsberg's devil's nightmare regiment crossed the Alps and descended into Brescia like an adrenaline-driven Panzer division. By December the Germans had reached the outskirts of Mantua and were crossing the River Po when they encountered the Devil Giovanni dalle Bande Nere and his ferocious band of mercenaries. The fight was on. The Germans engaged the Italians in battle with lethal projectile cannons (*mezzo cannone*) supplied by the duplicitous master cannon maker Duke Alfonso d' Este I, who was also in collusion with Charles V in his campaign against Clement VII. Giovanni was severely wounded in the leg (the same leg shattered at Pavia) and was rushed to Mantua. Aretino never left his side, save for the moment when an expert Jewish surgeon furnished by the Marquis Federico Gonzaga II amputated his leg (without anesthesia) while a dozen men held him down on his bed.

What is particularly fascinating about this gruesome scene is that Aretino was able to persuade the devious Marquis to save Giovanni's life, as well as his large battered company of dangerous mercenaries, demonstrating the position of power that he had when it came to getting what he wanted. The Marquis was a general in the Pope's papal militia, but at the same time he was also an Imperial vassal to the Emperor Charles V, which made him, technically, Giovanni's enemy. Such was Italy in the sixteenth century. The amputation of the Devil's leg was successful, but two days later, on December 10, 1526, "the savior of Italy" died in Aretino's arms of septicemia. It was one of the saddest days in the history of

a growing embattled nation, and the dream of unifying a ravished country was buried along with the Devil, dressed in black armor along with his severed leg in Mantua. Aretino was devastated, along with Machiavelli, Guicciardini, and the rest of Italy. Julio Romano, as a tribute to the fallen hero, cast Giovanni's death mask in bronze. Aretino reflected upon his loss in one of the most moving tributes ever written to a close friend and national hero, which was published and circulated throughout the peninsula. He concludes his testament with prophetic words:

> *And Florence and Rome — God make me a liar! Will soon find out what it means to have lost this man among the living. Already I hear the Pope's shout of joy. He believes that he is better off by losing him!*

Aretino stayed the winter in Mantua, while the Imperial forces, like bears, went into hibernation. To deal with his monumental loss, he went on a writing spree. Among the many things he wrote was a play entitled *Il Marescalco* (*The Stablemaster*). *Il Marescalco* is a psychosexual comedy about the vicissitudes of marriage based on actual people living in Mantua.

The central theme of the play revolves around the actions of a misogynistic homosexual stable master by the name of Marescalco, who has a morbid fear of wedlock (one of the first openly gay plays ever written). The stable master's powerful lord (the Marquis) decides that he should stop screwing boys and marry a young maiden of the city with a respectful dowry that he has carefully chosen for him. The bride in question is actually a gorgeous young man disguised as a woman. The panic-stricken stable master does not know this. Terrified at the thought of disobeying his powerful master (because if he does he could lose his job, and maybe even his life), and absolutely horrified at the mere idea of being tied down to a nagging, menstruating wife who will transform him undoubtedly into a *cornuto* (cuckold), he begins to lose his mind, which sets the tone for the whole play.

After Aretino masterfully sets up the plot with the first "faggot dialectic" (an American term coined in the sixties to stereotype a homosexual point of

view) in Italian comedy history, he introduces a cast of supporting characters: a bombastic Latin scholar (think Holofernes), a nurse, a servant, a jeweler, a peddler, a count, a knight, a page, an old woman, soldiers and so on. Each character has their own unique opinion regarding taking on a wife. The general consensus is that marriage can be a heaven or it can be a living hell. Each character goes out of his or her way to give an opinion to the stable master, which drives him even crazier than he already is (all the while Aretino interpenetrates the text with his trademark embedded journalism). The stable master's servant, Giannicco (Johnny boy) is a devilish "ass-scissoring" sodomite whose sole purpose in the play is to drive his dick-loving master into a state of rage… taunting him every chance he gets, *you will take on a wife or lose your life—you will take on a wife or lose your life* . . . .

In one scene Johnny boy meets up with two noblemen hired by the Marquis to make sure that his master shows up in church on time for his wedding:

Count: What is your master Marescalco up to?
Giannicco: Oh, he's fine. He's just despairing, killing himself like a criminal [sodomite] who doesn't want the infestation of a wife. At the moment he is after his Balia [nanny] to give him some evil arm to use against the Marquis's command to make him take one.
Count: I think you mean to say, evil charm.
Giannicco: Yes, yes, one of those.
Count: Ha, hah!
Giannicco: Would you like to hear the advice I gave him, my lords?
Count: Go ahead, my fine young man.
Giannicco: I told him that if she [the bride to be] is beautiful and rich, as they say she is; why not take the maiden half way, and that way we all luck out.
Count: What do mean by half-way?
Giannicco: It's like this, sir; he'll have to put out for a few days after the honeymoon, but soon the usual handsome young men will begin flocking around like roosters; then he will have his fill

|          | of the cocks and I'll have my fill of the hen. What do you think? |
|----------|---|
| Count:   | King Solomon himself could not have given better advice. |

<div align="right">(II. VIII)</div>

The stable master reluctantly shows up for his grand nuptial (albeit at dagger-point); reluctantly marries the beautiful girl (after nearly having a nervous breakdown) and then kisses his bride and finds out that she is actually a beautiful drag queen. Everyone in the cathedral laughs. *And thereby hangs a tale.*

# 28

## *Prelude to a Massacre*

*Rome will fall.*

—Pietro Aretino

With Giovanni gone, Aretino became paranoid. That's when he asked Federico Gonzaga for two special favors. The first was for a permanent position at his court. Federico was ecstatic at the request and happily granted it to him. The second favor was a bit trickier. Aretino asked the Marquis to write a special letter to Clement in an attempt to smooth things out between them. Federico pointed out that writing directly to the Pope was a mistake and proffered to write to one of his main advisors, their mutual friend and the lieutenant general of Clement's papal forces, the celebrated Francesco Guicciardini. The letter begins:

> *To the Lord Lieutenant, who I consider like a dear brother to me, I would be very unthankful to the devotion, which Messer Pietro Aretino has always shown to me, and I would play the part of one unfriendly to his genius, if I did not, in every way, try to strive to make the world pleasant for this inimitable man. Indeed, I myself have witnessed him do miracles. In a month, he has composed more things in verse and in prose than all the talents of Italy have in ten*

*years. For that reason, and, more importantly, because he is an excellent man and has dedicated half his life in serving two Popes, and with what affection and faith everybody knows—I feel indebted to help him. . . I shall be glad to hear from you as to how this matter should be disposed of, and when I hear from you I will act accordingly.*

A fascinating *documento* in and of itself; *specificamente* the line where Federico states that Aretino *wrote more things in verse and prose than all the talents of Italy have in ten years*. Whether it's a bit of an *esagerazione*, or not, it clearly reveals what Aretino was capable of (in fact, when you quantify Aretino's total body of work, no writer of the period, Italian, English or otherwise, can match him). Guicciardini sadly wrote back to Federico that he brought the delicate matter up with the Pope, and had tried with all his power to make peace between them, but there was nothing to be done. Clement refused to forgive Aretino, and furthermore, made him a *persona non grata* in Rome. That's when Aretino mounted a counterattack and began writing like a woman scorned. In sum, he spewed forth a fusillade of venomous sonnets, invective-laced letters, and then his famous annual predictions, called *pronostici* (prognostications). He wrote them whenever he needed money or wanted to address a particular pertinent issue for an ever-attentive public that could not get enough of his writings. In this particular *pronostici*, Aretino prophesized the sack (destruction) of Rome by German Imperial forces signing off as—"The Prophecy of Master Pasquino, the Fifth Evangelist." And then, like a madman, he dedicated the work to Federico, which placed the Marquis between a rock and a hard place, and ultimately sealed (once and for all) Aretino's fate with Rome—and for that matter, with Mantua.

Clement was mortified after Aretino wrote his scathing commentaries, especially when he denounced him as *a sourer wretch than Adrian*—and now he wanted him banished from Mantua. The Marquis treasured Aretino, and to banish him would be like asking him to give up his prized Gonzaga stud *El Serpentino*. The Marquis had a *grandisimo dilemma*. For starters, his Mata Hari mother, Isabella d' Este-Gonzaga, was in Rome with Federico's younger brother, Ercole, a highly esteemed bishop waiting in line for his coveted cardinal's hat. And if *Il Bello*, as Isabella referred to Federico, didn't banish Aretino, let's just say that Ercole would

never get it. In true Machiavellian fashion Federico had his chancellor write back to Clement and offered to have Aretino permanently exiled from Mantua; or if Clement preferred, made to vanish off the face of the earth (like his shoemaker father). The letter was a smoke screen. Federico never had any intentions of killing Aretino and feeding his flesh to his famous hunting dogs; his safety was paramount to his own cause. However, he could not afford to disrespect the Pope. No, not when a cardinal hat was on the line.

Federico's allegiance was to Aretino, because his actions spoke louder than his words—but he still had to get rid of him, and fast, so he gave him a letter of commendation, a racehorse, and a bag of gold coins that would last him several months on the lam. In March of 1527, Aretino left Mantua posthaste and went to Venice; shortly thereafter, all hell broke loose, exactly as Aretino predicted it would.

Did Aretino have anything to do with the Sack of Rome besides accurately predicting it? He definitely had the *motivo* to seek vengeance on Clement. What I am proposing is something that makes *The Da Vinci Code* a misdemeanor scheme in a world of outrageous conspiracy theories. What I am proposing is something diabolical. The Duke of Bourbon's mother was Federico's aunt Chiara Gonzaga, making Bourbon part of the Gonzaga family. Federico's brother Ferrante (Federico had two younger brothers) spent his formative years as a knight in training in Spain with Charles V, and was one of his most trusted confidantes and now a major general in his army. Federico's uncle was the duplicitous Duke of Ferrara, Alfonso d' Este, who had earlier supplied Frundsberg with the artillery that ultimately killed Giovanni dalle Bande Nere. Should I continue? Federico's brother-in-law was the deadly Duke of Urbino, Francesco Maria della Rovere, who despised the Medici and would have gladly sold his soul to Satan in exchange for vengeance against them. Federico's warlord cousins, Alessandro, Fernandino and Luigi Gonzaga were captains in the Emperor's army. All of them were in Mantua when Aretino was there, and all of them were deeply involved in the Sack of Rome. *Coincidenza? Coincidenza* is being struck by a lightning bolt twice in one day.

There is no doubt that Charles V sanctioned the Sack of Rome. Think of him as George W. Bush sanctioning the sack of Iraq. The question is, did he

initially come up with the plan on his own, or did his Italian advisors, specifically Gattinara and Castiglione (another famous Gonzaga cousin), inspire him? I'm not talking about declaring war on a pope; that was something done on a regular basis. I'm talking about specifically overthrowing the most powerful religious institution on earth, the Vatican, with fourteen thousand German landsknechts and ten thousand Spanish tercios, in a country filled with millions of die-hard Roman Catholics, without the most powerful Italian warlords assisting him. I don't think so.

Did Aretino, the Dick Cheney in this particular *scenario*, persuade Federico Gonzaga and his power-crazed clan to support the Emperor rather than the Pope? At his best, Aretino could have easily painted Clement as a traitor; at his worst, an instrument of Satan. The sky was the limit when it came to playing this tune. Aretino was the shrewdest political thinker of his day (although Renaissance scholars fail to apprehend this), and much like Mephistopheles, he could have turned the battle between Charles and Clement into a cosmic struggle between the forces of good and evil. Did a group of audacious warlords meet in Mantua and make a pact to overthrow the Papacy in order to create a *Dominium mundi* (New World Order) under Charles V? In this case, all I will say is actions speak louder than words.

# 29

## *The Setup*

*If any man defile the temple of God, him shall God destroy.*

—1 Corinthians 3:16

The Sack of Rome is one of the greatest mysteries of the Italian Renaissance. The blame was firmly placed on the Imperial foot soldiers of Charles V's army, who staged a mutiny and went wild and decided to take it upon themselves to attack Rome. Rome was sacrosanct; no practicing Catholic king would ever dare sanction the destruction of the City of God. Sanctioning an attack on Rome would be the equivalent of the prophet Mohammed sanctioning the destruction of Mecca. But Charles did. Naturally, he denied having any part in the Sack of Rome, and when he learned of it, he was at Valladolid and about to enter a tournament. After listening to the report, he ordered the tournament to be resumed. It was only later, when the clergy called on him to protest, that he seemed suddenly concerned, and the tournament was cancelled.

According to acclaimed historian Jasper Ridley, one of the prevalent rumors of the day regarding what happened was this:

> *Charles's sympathizers spread the story that the Spaniards in his army had been secret Moslems who retained their infidel*

*beliefs after the Moorish kingdom of Granada was conquered by Ferdinand and Isabella. . . and that the German mercenaries were Lutherans.*

The accepted theory behind the Sack of Rome is that Charles V had nothing to do with it; or, at best, was marginally involved. *Scheissdreck!* (That's German for Bullshit!) The fact that he let loose a battalion of deranged Lutheran mercenaries led by the maniacal anti-papist Frundsberg, who professed to strangle the Pope with his silk cord, proves, beyond a reasonable doubt, that he was behind a well-planned conspiracy to overthrow the Papacy. Every journalist in Rome knew this, and *avvisos* were written on a daily basis reporting the war between the Pope's papal forces and the Emperor's army of Lutheran landsknechts and lethal Spanish tercios. In fact, Frundsberg's famous silk cord was described by different journalists as red, silver, and then gold—until finally it mutated into several different colored strands added for certain members of the Sacred Order of Cardinals. Let's assume that Charles never had any intentions of sacking Rome, as historians vociferously suggest. Let's assume that he was just using his monstrous army to scare the hell out of Clement in order to make him renounce the League of Cognac. As they say, *all is fair in love and war!* When you add the powerful Gonzaga clan and their deadly allies the Colonnas into the mix, you now have a recipe for a New World Order; literally, the goal all of them shared was controlling Italy—and then like Charlemagne, the rest of the world. The only thing stopping them was the Pope.

The way I see it, Charles knew better than anyone that the papal claim to temporal supremacy was a myth. As Emperor of the Holy Roman Empire, Charles's main objective was protecting Christianity, and that meant destroying the Turks and taking back the Holy Land. And if that meant destroying Papal Rome in order to do it, then so be it. The fact is, once the Turks invaded Hungary and killed Charles's brother-in-law King Ludwig II and Charles besieged Clement to renounce the League of Cognac and help him fight the Turks, and Clement refused, well, then it just proved that Martin Luther was right: The Medici Papacy was ruled by the Antichrist, or so it *seemed* to Charles and his very Machiavellian Italian advisors.

## THE SETUP

In February of 1527, Frundsberg's devil's nightmare regiment combined forces with the Duke of Bourbon's regiment, while the formidable Spanish general Antonio de Levya maintained military control of Milan. And then, as luck would have it, the maniacal Frundsberg had a massive stroke from all the excitement and he was now totally out of the picture. According to Desmond Seward, biographer of Francis I, "By March 1527 the Imperial army, unpaid for months, was in a state of murderous mutiny. Bourbon hailed the mutineers as his brothers and promised to make them rich—by sacking Rome."

The main theory behind the Sack of Rome is that the Imperial foot soldiers were starving and shoeless, and that's why they went berserk and staged a mutiny. Historians want people to believe that the largest military campaign since the battle of Pavia was on a march through the Italian peninsula, and the soldiers were starving and shoeless. Granted, war is hell, but as the Emperor's monstrous army came thundering down the Alps like Nazi storm troopers they sacked every Italian town and village in their paths. The ones they didn't plunder were forced to pay indemnities for the privilege of existing. In the pandemonium, the Pope had the foresight to dispatch Francesco Guicciardini and his papal militia to Florence to protect the city from sacking. I'm sure some of the Imperial soldiers were shoeless, and some may have been starving; but not Bourbon, and not Ferrante Gonzaga, and certainly not the primary troops. If any of the soldiers were shoeless and starving (shoes are always brought up) it would have been the grunts and the renegade Italians who eagerly joined the Imperial army along the way as they marched on to conquer Rome. Again, even if the Imperial army was shoeless and starving, as historians of the event insist, why didn't Charles do something? To say that the most powerful man in the world, with the richest banking firm in Europe, the Fuggers, backing him, lacked funds to finance his own army is an outrageous lie—no matter what the books say—and in this case someone was definitely cooking the books.

Let's pause for moment to put things in forensic perspective. The notorious Spanish conquistador Hernado Cortes conquered the mighty Aztec Empire in 1521. And we know that he was sending back boatloads of Aztec gold/silver to Spain where it was deposited into the Emperor's bank vault in El Escorial. In the summer of 1526, when the battle between the Emperor and the Pope began

189

to reach a critical mass, Charles conveniently married his first cousin, Princess Isabella of Portugal, and he inherited her multimillion-crown dowry (a dowry that could have easily financed several Roman legions). Shortly after marrying his cousin, Charles began building his monstrously expensive five-hundred-room palace at Alhambra. But historians overlook this, and insist that Charles was bankrupt when it came to finding funds for his army. The point is, he wasn't bankrupt. He was demonically possessed with bloodlust and purposely starved his army like Doberman pinschers, leaving them no choice but to conquer Rome and plunder her bank vaults. (Bourbon did the same thing in Milan. Saddam Hussein did the same thing in Kuwait. That's how warlords subsidize their income.)

Meanwhile, out in the field, League agents were sending daily dispatches back to the Vatican reporting the advance of the Imperialists. On May 1, a communiqué reported that the devil's nightmare regiment was less than a hundred kilometers away from Rome and was now marching toward the Eternal City with the intentions of destroying it. The Duke of Urbino and his formidable Venetian militia carefully followed the Imperialists at a safe distance.

The Pope's advisors suggested leaving the Vatican with Mercuric haste. Others suggested blowing up the bridges along the Tiber that led into Vatican. Others recommended putting together a civilian militia to augment the Swiss Guard. Clement refused to listen; the manic pontiff was convinced that Charles was bluffing. And even if his "mad vassal" wasn't, the Pope was confident that the League forces would intercept the Imperial army before they reached the walls of Rome. Ironically, the vast majority of the Romans were indifferent to the Pope's plight, and many looked forward to a change of government. And that's when the Gemini came to his senses. At the proverbial last *minuto*, Clement summoned the Imperial Viceroy of Naples, Charles de' Lannoy (who commanded his own army and outranked the Duke of Bourbon), to meet with Bourbon and his commanders in the field in an attempt to negotiate a last-minute truce. Lannoy, representing the Pope (i.e., God), attempted to pay off Bourbon and his men with a measly 150,000 gold ducats. The Duke told the Viceroy to get out of his sight before he had him drawn and quartered for insulting him (and I would imagine have his flesh fed to his starving soldiers). Why didn't Lannoy at that point, combine forces with the other papal warlords in the region, all of whom were sworn to protect

the Pope and try and stop Bourbon from committing a sacrilegious attack on the Vatican? Or at least make an attempt. Where the hell was Francis I, who started the whole fiasco in the first place? If you must know, he was busy building his own monstrously expensive Chateau de Chambord in the Loire Valley, screwing courtesans, and laughing at the two fools waging a ridiculous religious war against Christians rather than Turks. For that matter, where was "The Great Defender of the Catholic Faith," as Leo X referred to that fat fucking prick Henry VIII? The point is, none of them were around, and none of them did anything (of substance) to save the Pope not to mention the thousands of innocent men, women, and children who were shortly about to be slaughtered in the most heinous massacre of the Italian Renaissance.

Lannoy reported back to Clement that Bourbon refused to make a deal. The ransom was increased to 300,000 ducats. Again, Bourbon rejected it; he never had any intentions of accepting a payoff. The primary objective, as Frundsberg had clearly pointed out with his silk cord, was to strangle Clement. And with the Pope conveniently out of the way (of course it would look like an accident), a New World Order would be established under Charles V, but it didn't work out that way.

# 30

## *Massacre of the Innocents*

*Religion's done more harm than any other single idea; every war since the beginning of time was the fault of religion. I mean, ask the Jews what they think of religion.*

—Larry Flynt

Before we proceed with the Sack of Rome, I would like to give my opinion on what I believe is the true definition of obscenity. (It has nothing to do with she-males, transsexual divas, pig-fuckers or Jerry Falwell's mother.) It's war! Specifically man's demon-like glorification of genocide in the name of God and Scripture. Okay, now that I have given my humble opinion, let's proceed with the world's most horrific sex massacre.

It is well known that the best time of year to visit Rome is in the month of May. The city shakes off its winter coil and the ground comes alive with spring flowers. May is also the best time to stage an invasion. On the morning of May 6, 1527, at dawn, the Sack of Rome commenced. An estimated thirty-thousand deranged Christian soldiers led by the Duke of Bourbon descended on Rome like a swarm of locusts. Rome was a fortified city that had been attacked several times through the millenniums. For that reason, it was surrounded by a massive wall. Legend has it that Clement watched in dismay from his Vatican apartment as a large shimmering beam of light in the distance approached his capital. The light

slithered across the landscape like an iridescent cobra. The alarm was sounded. The Pope's Swiss Guard and papal militia, led by Renzo da Ceri, estimated at five thousand men, took their positions. Many of them were on their knees praying to God that the Duke of Urbino and his formidable Venetian militia would arrive in time to reinforce them. Urbino had other plans.

According to Vincent Cronin, author of *The Flowering of the Renaissance,* "The attack came, in dense fog, on the morning of 6 May, Caesar's army, part German, part Spanish, advanced to the foot of the scantily-defended walls nearest the Vatican and Janiculum, the soldiers set up ladders made of vine-poles, and began to scale them." The Pope and his papal train along with the vast majority of the cardinals hastily made their escape into the impenetrable forty-foot walls of Castle Sant' Angelo (originally built as a tomb for the Roman Emperor Hadrian), through a fortified passageway created by "the devil pope" Alexander VI just for such occasions. A second surge commenced on the wall between the Porto del Torrione and the Porta Santo Spirito. Waves of savage Spanish horsemen and suicidal German infantry units (Bluhfahnen) came thundering down the Janiculum Hill—screaming for the blood of the Pope. The Swiss Guard hit the Imperialists hard with artillery fire. Undaunted, Bourbon continued advancing, firing his own canons as his division breached a dilapidated portion of the massive defensive wall. The Armageddon commenced. The legendary Florentine artist Benvenuto Cellini reported in his spectacular autobiography, that he was leading a troop of papal mercenaries in a fog that had descended upon the city like death, and that he and his men were manning the Leonine Wall when they fired their deadly harquebusiers down into the rushing horde of invaders, and as Fortune would have it, the silver-caped Bourbon was hit square in the chest by a round from Cellini's rifle. The Duke's last words were said to be:

*Ah, Notre Dame! Je suis morte.*

Another account maintains that Bourbon was accidentally shot by his own men in the crossfire and was then carried away to the Sistine Chapel, where Baldassare Peruzzi was forced at dagger point by Imperial troops to paint their leader's deathbed portrait. Regardless who fired the fatal shot that killed the Duke of

Bourbon, he was dead, which only made a bad situation worse. All of the history books I have read report that with Bourbon gone, his troops were now without a leader. Absurd! There were other competent leaders. There was still Frundsberg's successor, the little Hessian Conrad Bemelberg, as well as Bourbon's cousin Philibert de Chalon, Prince of Orange, and, more importantly, there was the Emperor's favorite Italian contract killer, Ferrante Gonzaga, not to mention his deadly captain cousins leading their own shock troops policing the siege. The point is there were still capable leaders among them. Nonetheless, I quote one of the history books: "Without a forceful effective leader, the Imperial forces were free to do as they pleased." And they did. After the Swiss Guard and militia were annihilated, the rest of Rome was set up like sacrificial lambs for a slaughter.

The Spanish soldiers were extremely savage. Gian de' Urbina, the vicious commander of the Spanish infantry was enraged by a wound inflicted to his face by a Swiss Guard, and went on a rampage like an avenging angel of Lucifer. Urbina and his fallen angels pillaged the Borgo, killing everyone in sight, they then stormed into the hospital of Santo Spirito and killed the patients, and then they proceeded to slaughter the Orphans of the Pieta with their bayonets because they didn't want to waste their valuable bullets on children. "Blessed is the man who takes your babies and smashes them against rocks." (Psalm 137) The Spanish Tercios were masters at selective-mass-killing. They massacred the poor, the sick, the injured, and the mentally challenged: in sum, people who served them no purpose. The only Roman citizens that were apparently spared were beautiful women and the super wealthy citizens who could afford to pay enormous ransoms in exchange for their lives. Many paid and were still executed. Churches and convents were transformed into Abu Ghraib-like prisons into which the posh ladies of the city were dragged in their designer gowns, stripped, and then gang-raped by trains of voracious Spanish officers and transformed into sex slaves and concubines for the remainder of the occupation.

The German troops were equally savage. They crossed the Ponte Sisto as the avenging angels of Martin Luther, and proceeded to tear down the doors of churches, synagogues, and convents—raping and splaying nuns open like they were sides of beef. Renaissance historian Christopher Hibbert: "Some priests were, indeed eviscerated. Others were stripped naked and forced to utter blasphemies on

pain of death or to take part in profane travesties of the Mass." Jews were hunted down and slaughtered with particular relish (an estimated six thousand lived in Rome at the time of the invasion); their synagogues burned to the ground. Their pregnant wives were clubbed to death like mad dogs and their children raped and slaughtered: In the name of the Father, the Son, and the Holy Ghost. "The Lord is a man of war. The Lord is His name." (Exodus 15: 3)

The devil's nightmare regiment stormed into St. Peter's Basilica and transformed the holiest temple in Christendom into an abattoir. Nuns were sodomized on the marble floor before the High Altar—their virgin walls ripped apart by flesh and steel. Old women were bludgeoned to death on their knees as they cried out to Christ to save them. Many Romans seeking sanctuary in the basilica were thug-fucked by the soldiers and then hacked to pieces. According to one eyewitness account, "A thousand people were brutally massacred inside the Basilica." Cardinal Giovanni Salviati (present during the attack), wrote: "Burned is the great chapels of St. Peter and of Sixtus… the statues of the Apostles are desecrated…. Sacrament thrown in the mud, reliquaries smashed to pieces…papal bulls, letters, and manuscripts burned. I tremble to contemplate this for Christians are doing what even the barbarian Turks never did." The Germans not only killed the living—they killed the dead. The maniacal landsknechts descended into the papal crypts searching for treasure and broke into the sepulchers—ramming their spears into the dead bodies of popes, and then donned their gold rings, bracelets, chains, and ornate vestments. Dressed as mock popes the drunken terrorists began parading around the Vatican like it was a macabre version of a Mardi Gras carnival—smashing statues, destroying frescos, burning ancient manuscripts, pissing in holy water; circumventing God—chanting Martin Luther's name as the next pope to rule the world.

Luigi Guicciardini (brother of Francesco Guicciardini), a senior official in the Vatican, present during the horrific siege, stated in his writings that the Spaniards were convinced that many wealthy Roman citizens had hidden their jewels and cash in the cesspools of Rome and they rounded up the haughtiest ones they could find and forced them at dagger-point to descend into the muck to dig up their assets with threats of evisceration. Guicciardini:

> *Many were suspended by the arms for hours; others were led around bound by ropes tied to their testicles. Many were branded with hot irons . . . others were forced to eat their own ears, or nose, or their roasted testicles; and yet more were subjected to strange, unheard of horrors that affect me too much even to think of, much less describe in detail.*

Meanwhile Clement watched the destruction of his city from inside the impenetrable walls of Castle Sant' Angelo, as his main gunner, Benvenuto Cellini, rained a barrage of artillery upon the barbarian invaders. Across the Tiber, the Pope could see his flock being corralled like sheep—drove upon drove of them—beaten—whipped—and then driven into makeshift prisons to be exploited, extorted, and then killed like livestock. Guicciardini:

> *Great numbers of captives of all sorts were to be seen groaning and screaming...many noblemen lay there cut to pieces, covered in mud and their own blood, and many people only half-dead lay miserably on the ground.*

A Franciscan friar present during the siege estimated that over ten thousand people were slaughtered in the first days of the invasion. A Spanish soldier claimed that three thousand corpses were thrown into the Tiber because it was too labor-intensive to bury them. Paul Dolstein, a landsknecht officer stated, "We put six thousand to the sword, seized all that we could find in churches and burned a great part of the city." Another eyewitness wrote: I know nothing wherewith I can compare it, except the destruction of Jerusalem." Guicciardini continues his account:

> *One can imagine the anguish and plight of the Pope, seeing and hearing such a scourge of punishment raided against himself and Rome. Like the rest of those under siege, he is suffering in fear that he will soon fall into the hands of the cruel invaders, obviously thirsting for his blood.*

In another part of the city we pan to the cold, calculating eyes of Isabella d' Este-Gonzaga watching the siege as the distinguished guest of the mighty Colonna clan from inside their heavily fortified Palazzo dei Dodici Apostoli. The Colonnas had their own private army and were making a killing themselves by extorting money from wealthy Roman citizens in exchange for their protection. In fact, the biggest haul of the Sack wasn't the priceless artifacts that were stolen; it was the enormous ransoms extorted from wealthy Romans seeking sanctuary or taken prisoner and made to pay up or die.

Isabella d' Este-Gonzaga knew that an attack on Rome was imminent, and she had ample time to leave the city like any sane woman would have, but she chose to stay. It is my contention that she stayed for a reason. A really good reason; besides doing a little ransacking herself, directing her warrior clan to procure her favorite *objets d'art* to add to her world-famous art collection. The premiere woman of the Italian Renaissance was a schemer par excellence. Her primary objective in life, if you study it, is clearly revealed in a line in a letter written to her brother-in-law, Cardinal Sigismondo Gonzaga:

> *My deepest desire is to attain the Papacy and the profit and glory for our House; in this quest we should pledge our very souls.*

Although the letter was written years before the Sack of Rome, it clearly reveals the mind of a power-crazed politician. Every drop of blood in this amazing woman's being was focused on securing the Papacy for the House of Gonzaga—at any cost—even if it meant killing a pope. The reason Isabella stayed in Rome is that she believed that her nephew, the great constable Bourbon, her formidable general son, Ferrante, her warlord brother Alfonso d' Este, and her cunning son-in-law, the Duke of Urbino (on the sidelines ten miles away) would have succeeded in initiating the overthrow of the Vatican (using the German and Spanish troops as pawns), capture the Pope, terminate his life with extreme prejudice (of course it would like an accident), and Ercole Gonzaga would ultimately take over Clement's position as the titular ruler of the universe. Albeit he would have been a puppet pope for Charles; as far as Isabella was concerned, it didn't matter. Her son would still be the most powerful prince on earth: Christ's vicar on earth.

And her family would survive another generation. Of course this is speculation, but Isabella was in the Vatican with the express purpose of gaining the coveted cardinal hat for Ercole as the final step for him to ascend the throne of St. Peter. And she managed to purchase the hat from Clement because he was desperate for cash and was planning on buying his way out of Rome with a king's ransom. Once Isabella got what she came for, she was quickly escorted out of Rome by her Imperial bodyguards and taken to the port of Ostia where a small armada was waiting to take her home. Weeks later she arrived in her Virgilian paradise and was accorded a reception by her subjects worthy of Cleopatra. A contemporary reported: "She seemed rejuvenated by the sack."

Meanwhile the whole continent was learning of the atrocities that were being committed in the Eternal City. And yet not a single Catholic king did anything of substance to save the Pope. From Venice, Aretino made the first bold move. On May 20, twelve days after the devastating invasion, the master scribe published one of history's most important letters, imploring the Emperor to rescue the Pope. He then wrote another letter, imploring the Pope to pardon the Emperor. And both men dutifully obeyed him: Clement forgave Charles, and Charles initiated the rescue of the Pope; but not before they worked out all the details.

During the siege, Clement screamed one of the most ironic lines in recorded history to Giberti:

> [Stronzo] *If Pietro Aretino had only been with us, we would not be here in what is worse than a prison.*

If ever a sentence could distill the influence of Aretino's life on the stage of world affairs, the pontiff's declaration to his devious datary did.

After the initial siege, which lasted eight days, and claimed over half the population of Rome (either as murder victims or displaced refugees), the Pope was now a prisoner in his own castle. And the only way he was going to get out of Rome, with his head attached to his neck, was to pay the exorbitant indemnity mandated by Charles, because his Satanic Majesty felt he needed to teach Clement a lesson: Italian Popes should never fuck with Holy Roman Emperors. To make

matters worse, a plague of biblical proportion descended upon the Eternal City. The stench of death permeated the Seven Hills of Rome as the seven eyes of the Lord (described by Zechariah) watched from the seven heavens contemplating.

Florence, upon learning that Rome had fallen, banished the Medici for a third time. Francis I declared war on Charles V. Machiavelli died in Florence and voluntarily committed his soul to Hell. (He said he wanted to spend the afterlife with his friends and mentors.) Hugo de' Moncado was killed fighting the French in Naples and joined Machiavelli in Hell. Baldassarre Castiglione passed away in Spain and went to Purgatory. Francesco Guicciardini retired from public office (at least for the time being). Plague breaks out in Wittenberg. Federico Gonzaga II was elevated by the Emperor to the rank of duke for his invaluable service to the Holy Roman Empire. Federico's uncle, the Duke of Ferrara, Alfonso d' Este, reclaimed the lost territories that Clement had dispossessed him of. Federico's brother-in-law, the Duke of Urbino, Francesco Maria della Rovere, also reclaimed his lost territories, laughing at the fate of the Pope sitting in his castle thinking that he would actually come to rescue him. The Colonnas partied in their summer villas like decadent Roman senators—drunk with power—counting their stolen shares of fortune from the greatest art heist in history. And Aretino, the virtuoso of vengeance, was living like a prince in Venice, surpassing his own wildest dreams as the world's greatest hustler.

On June 7, Clement VII signed a humiliating treaty with Charles V, and paid the first installment of the indemnity, including surrendering key Papal States to the Hapsburg Empire, theoretically ending the thousand-year-old Reich-like reign of temporal power of the Papacy. Three months later the second installment was paid. And the Pope's "mad vassal Caesar" was finally satisfied. The Vatican was shattered, in shambles, and for all intents and purposes—out of business!

On December 7, 1527, the Medici Pope was secretly escorted out of Castle Sant' Angelo, disguised as a common peasant, and taken to the Episcopal palace at Orvieto where he languished like a coma victim. Martin Luther distilled the situation in a sentence: "Christ reigns in such a way that the Emperor who persecutes Luther for the Pope is forced to destroy the Pope for Luther."

## MASSACRE OF THE INNOCENTS

The author Luigi Barzini crystallized the Sack of Rome in his book *The Italians*: "The destruction of the city, like the destruction of Jerusalem, was taken to be a clear sign of the wrath of God in retribution for the sins and vices of the people. It destroyed their soul." The great Dutch theologian Desiderius Erasmus stated more succinctly: "The Fall of Rome was not the fall of the city, but the fall of the world."

Although I respect their opinions. I disagree. The Pope was not destroyed. The world did not fall. And the soul of the Italian people is indestructible. The Sack of Rome was? How shall I put this. . .? Okay, if we are to believe Luther, that God was calling all the shots, then think of the Vatican (the official residence of the pope) like the Biblical House of Job. The House of Job was destroyed because Satan informed God that it was a house of hypocrisy built upon material wealth—exactly as Luther proposed the Vatican was. God mandated that the House of Job be laid to waste because Satan said that he could prove that Job's faith (in God) was bogus. Actually, he said, "No wonder he worships' you! But just take away his wealth, and you'll see him curse you to your face" (Job 1:11). The cunning angel, as always, made a very convincing argument. God, never one to back down from a challenge, specifically from His appointed Justice Administrator on earth, allows the Prince of Cocksuckers to devastate the House of Job as a test (with every conceivable misfortune except Job's death), and it is reduced to nothing—exactly like the Vatican was. After Job's estate is wiped out, his ten children slain, his body wracked with sores, his insolent wife tells him to—"Curse God, and die!" (I can imagine what else she said.) But like Clement, Job endures the ruin of his House. He never forsakes his faith in God and his House is restored in ever more glory and splendor—exactly like the Vatican. The moral of the biblical story is: That which does not destroy our faith in God only makes it stronger.

The proof, *como si dice*, is in the pudding. The Vatican was thrust into the jaws of a demonically possessed army bent on obliterating it—but "despite all the powers of hell," it survived the horrific massacre, only to emerge as the most powerful religious institution on earth. As far as Luther was concerned, he had to deal with chronic constipation, head lice, acute depression, a domineering wife, and a very stingy congregation. Clement, on the other hand, rose like a Phoenix

from the ashes of Rome; became Charles V most important ally (and the Protestants worst nightmare); reclaimed Florence with his assistance and returned to Rome where he lived out the rest of his pontificate rebuilding the Eternal City. On September 25, 1534, Clement VII died. Legend has it he committed suicide.

As far as Aretino was concerned, he would live out the rest of his life like Hugh Hefner in a palace on the Grand Canal, surrounded by beautiful whores, and go on to create the greatest body of literature the world will ever know. He passed away on October 21, 1556, at the ripe old age of sixty-four, an extraordinary age for the time, and was reincarnated as William Shakespeare. An anonymous writer wrote his epitaph:

> *Here lies Pietro Aretino, the Tuscan poet. He slandered everyone but God; excusing himself by saying, he never knew him.*

Okay, let's wrap this tragicomedy up with a happy ending. In the spring of 1528, Francis's mother, Louise of Savoy, and the Emperor's aunt, the Archduchess Marguerite of Austria (Charles' most trusted advisor), came up with an ingenious plan to end the abortive war between France and Spain. Marguerite convinced her nephew to let her take care of the situation with Francis I; Louise convinced her volatile son to be complacent in the matter (especially since Charles had her two precious grandsons locked up in a rat-infested dungeon in Madrid). It was agreed that the ladies would meet in the neutral city of Cambria to work out a treaty that would serve everyone's interests. On July 5, 1529, at five o'clock in the afternoon, two women would determine the destiny of Europe in what is now known as "The Ladies Peace of Cambria." After a formal dinner the ladies got down to business. It was agreed by Louise that Francis would honor the terms mandated by the original Treaty of Madrid (the one he broke), except that he would not concede Burgundy to the Emperor. In exchange, Marguerite would have Francis's two sons released from prison and returned to Paris (contingent on payment of an enormous fine for the inconvenience of breaking the Treaty of Madrid). The proverbial icing on the cake: Louise promised Marguerite that Francis would honor his pledge to marry Eleanor of Austria. All parties agreed. "The Ladies' Peace" was formally concluded on August 5, 1529. On July

4, 1530, Francis married the Emperor's sister and peace reigned on Paris like a golden shower.

Addendum: In 1533, Clement VII orchestrated the ultimate coup by cementing the House of Medici to the House of Valois. It was arranged that the Pope's niece, the future Queen of France, Catherine de' Medici, would marry Francis's son, Henry, Duke of Orleans—the future King Henri II. And the rest is French history.

In 1538, the Duke of Urbino died (legend has it that he was poisoned to death like Hamlet's father), and he now sits next to Lucifer on his throne, replacing Loyola.

On February 13, 1539, Isabella d' Este-Gonzaga died. Fifteen months later, *Il Bello*, Federico Gonzaga II, joined his mother in the ninth circle of Hell.

In the early morning hours of February 18, 1546, (I'm paraphrasing Luther's biographer Marius) Luther, after a long illness blamed on the Jews, died from heart complications. "His death, like everything else about his life, was controversial and remains so."

January, 28, 1547, King Henry VIII died at Whitehall Palace. Two months later, King Francis I died at Rambouillet Palace and joined him in Hell.

In 1556, a tormented, gout-ridden, delusional Charles V abdicated his throne and various titles to his son, Philip II, and his brother, Ferdinand I. He then retired to a monastery in Extremadura, Spain, where he spent the last days of his life rehearsing his own funeral. On September 21, 1558, the pope's "mad vassal Caesar" passed away and went straight to—I don't know. Where do insane people go when they die?

# Epilogue

*Truth will come to light....*

—Shakespeare

Literary critics credit Miguel de Cervantes with creating the world's first novel, *Don Quixote* (1605). Aretino beat him to the punch with his *Dialogues*.

Critics have crowned Francois Rabelais as the king of sixteenth-century satire, but that crown also rightfully belongs to Aretino. Hunter S. Thompson is considered the father of *gonzo journalism*. Well, in my book that makes Aretino Hunter's great grandfather. The preeminent literary critic, Camille Paglia, proclaimed in her lurid masterpiece, *Sexual Personae*: "He [Shakespeare] is the first [author] to reflect upon the fluid nature of modern gender and identity." Although I would be honored to shine her patent leather stilettos, Paglia (an Italian no less) should be flogged for giving credit to an Englishman when an Italian rightfully deserves that credit. The celebrated American poet laureate and literary critic Karl Shapiro crowned Henry Miller—"The King of Erotica." Shapiro stated: "It is possible that he is the first writer outside the Orient who has succeeded in writing as naturally about sex on a large scale as novelists write about the dinner table or the battlefield. I think only an American could have performed this feat." Obviously, Shapiro never read Aretino.

# Bibliography

The great polymath scholar Samuel Johnson (1709-1784) once said, "A man will turn over half a library to make one book." Johnson said a mouthful. It would be futile to list individually the thousands of books, encyclopedias, essays, journals, articles and websites that I have utilized in creating this work. To be honest, the bibliography would be longer than the work. What I will do is list the two most important research tools invented by man: *Google* and *Wikipedia*. I could have never done it without them.

Addendum: Send comments, suggestions, and hate-mail to mrkprnstr@aol.com

# Acknowledgments

My gratitude to Patrick McCulley for his critical role in this project. Big J and Al Caruso for being in my corner throughout it all. Randolph Lautsch for his ability to positively incite me throughout this project. Patrick Facemire for believing it could be done. Harold Bloom for his unyielding commitment to Shakespeare. Howard Bloom for his unyielding commitment to Aretino. Jeremy Iacone for his insight and patience. And the nine Muses for inspiration and comfort. Last but not least, my two Pit-bulls, Buddha and Lakshmi, whose teaching by silence surpasses the written word. Or as Nietzsche once said, "The world was conquered through the understanding of dogs; the world exists through the understanding of dogs."

www.ingramcontent.com/pod-product-compliance
Lightning Source LLC
Chambersburg PA
CBHW030005190526
45157CB00014B/442